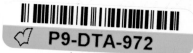

Impressionism
Beneath the Surface

Impressionism
Beneath the Surface

Paul Smith

PERSPECTIVES

HARRY N. ABRAMS, INC., PUBLISHERS

For Astrid

Frontispiece CLAUDE MONET *Impression, Sunrise*, page 8 (detail)

Series Consultant Tim Barringer (Victoria and Albert Museum)
Series Director, Harry N. Abrams, Inc. Eve Sinaiko
Editor Jacky Colliss Harvey
Designer Karen Stafford, DQP, London
Cover Designer Miko McGinty
Picture Editor Susan Bolsom-Morris

Library of Congress Cataloging-in-Publication Data
Smith, Paul, 1956–
 Impressionism : beneath the surface / Paul Smith.
 p. cm. — (Perspectives)
 Includes bibliographical references (p.2) and index.
 ISBN 0-8109-2715-2
 1. Impressionism (Art) — France. 2. Painting, French.
 3. Painting — 19th century — France. I. Title. II. Series :
Perspectives (Harry N. Abrams, Inc.)
ND547.5.14S65, 1994
759.4'09'034 — dc20 94-32974

This book was produced by Calmann and King Ltd., London

Printed and bound in Singapore

Contents

INTRODUCTION *Defining Impressionism* 7

Impressionism and the Impressionists 8 Traditions of Interpretation 11
Impressionism and the Impression 19 The Sensation 21
Impressionist Vision and Sketchiness 24

ONE *Manet, Baudelaire, and the Artist as Flâneur* 33

The Flâneur as Detective 36 The Flâneur and the Crisis of Modernity 40
The Philosophical Flâneur 42 Manet and the Representation of Women 46
Memory and Experience 55

TWO *Impressionist Women and Women Impressionists* 59

Gender and Sexual Difference 62 The Male Gaze 65 Women's Spaces 66
Women's Femininity 70 The Private Self 74 Degas and Women 77

THREE *Monet and the Moment of Art* 83

Making a Sensation 91 The Series 93 "More serious qualities" 100

FOUR *Pissarro's Political Vision* 113

The Painter as Theoretician 122 The Political Colour of Pissarro's Vision 128
The Anarchist Subject 134 Pissarro and the City 137 Unity and the City 142

FIVE *Cézanne and the Problem of Form* 145

Cézanne and Psychoanalysis 148 Cézanne's "Optic" 153
Colour and Drawing in Cézanne 154 A Harmony Parallel to Nature 155
Finishing the Painting 158 Cézanne as Art 163

CONCLUSION *Impressionism as Art* 165

BIBLIOGRAPHY 170
PICTURE CREDITS 172
INDEX 173

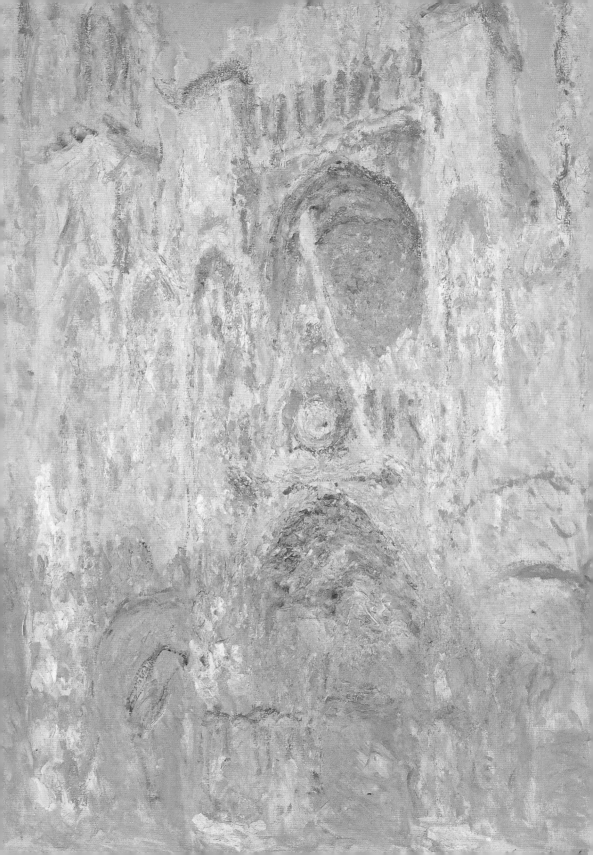

Defining Impressionism

"I have very strong sensations." *CÉZANNE*

1. CLAUDE MONET
Rouen Cathedral, Sunlight Effect, End of Day, 1892. Oil on canvas, 39 x 25¹/₄" (100 x 65 cm). Musée Marmottan, Paris.

This is a concise history of Impressionism which also takes account of new approaches in art history, whose methods will be described below. Each of the five chapters focuses on one artist to exemplify one idea or argument, except for Chapter Two, which addresses women and Impressionism. Chapter One is on Manet and the artist as *flâneur.* Chapter Three on Monet contains a more general discussion of the relationship between painting and class, while Chapter Four, on Pissarro, explores the more specific question of the relationship between art and radical politics. Varieties of psychoanalytical theory have been used in Chapter Two and Chapter Five on Cézanne. A consideration of the concepts of impression and sensation is woven into the last three chapters.

I have also tried to relate Impressionism to perception, especially to the way an artist's perception appears to alter in response to ideas encountered by that artist. In the conclusion I have tried to show how Impressionism is an art. By this I do not mean to deny that it is vital to see Impressionist paintings in their social, psychic, and intellectual context and history. But I do want to maintain that if we do only this, we shall miss the esthetic dimension of these works, or the way they transform experiences by imaginatively recreating them in their own terms. This is not to slip back into an outdated approach where Impressionism is viewed as "surface" or "paint"; rather, it is to maintain that the surface of a painting is a vehicle which can carry an imaginative world.

Impressionism and the Impressionists

In April 1874, Claude Monet showed *Impression, Sunrise* (1873, FIG. 2) at an exhibition by a group calling itself "Painters, Sculptors, Engravers etc. Inc." This was the first of what we now know as the Impressionist exhibitions. Monet's painting and its eccentric title helped give Impressionism its name and, indeed, for many people, have come to exemplify Impressionism in general. The critic and friend of the Impressionists, Théodore Duret, wrote in 1878: "If the word Impressionist was... accepted to designate a group of painters, it is certainly the peculiar qualities of Claude Monet's paintings which first suggested it. Monet is the Impressionist painter *par excellence*." Duret then went on to give his reasons:

2. CLAUDE MONET
Impression, Sunrise, 1873.
Oil on canvas, 19 x 23¹/₂"
(48 x 63 cm). Musée
Marmottan, Paris.

Claude Monet has succeeded in setting down the fleeting impression which his predecessors had neglected or considered impossible to render with the brush.... No longer painting merely the immobile and permanent

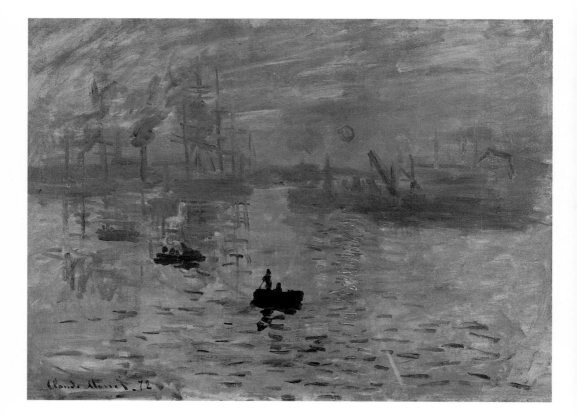

aspect of a landscape, but also the fleeting appearances which the accidents of atmosphere present to him, Monet transmits a singularly lively and striking sensation of the observed scene. His canvases really do communicate impressions.

Duret was arguing that what made a painter an Impressionist was that he or she pursued transient atmospheric effects, which he seems to suggest were also the painter's impressions. However, Duret's definition of Impressionism, and the idea deriving from it that Monet was the archetypal Impressionist, are not without their problems. For one thing, as we shall see, an impression was not just the record of transient effects of light and atmosphere. For another, the Impressionists were a group whose members' work was far more diverse than Duret suggests.

This, of course, raises the questions who and what were the Impressionists? One familiar answer is that they were a group of painters, some of whom first met between 1860 and 1862 at an informal studio, the Académie Suisse, and the rest of whom shared time together between 1862 and 1864 in the studio of the painter Charles Gleyre at the Ecole des Beaux-Arts. Monet, Camille Pissarro, and Paul Cézanne (who met at the Académie Suisse) and Auguste Renoir, Alfred Sisley, and Frédéric Bazille (who met Monet at Gleyre's) are said to have united in opposition to a conservative, classical training and, under the example of the landscapists Eugène Boudin and Johan Barthold Jongkind, went to paint nature in the open air in a novel, bold, and "sketchy" manner.

The Impressionists were indeed dissatisfied with the classical training given at the Ecole des Beaux-Arts, or the state-run school of fine art, and especially with its emphasis on historical and mythological subject matter and "correct" drawing in the manner of the antique or Renaissance masters such as Raphael. Examples of such work are Alexandre Cabanel's *The Birth of Venus* (c. 1863, FIG. 3) and Gleyre's *Minerva and the Graces* (1866, FIG. 51, see page 85). Their dissatisfaction was not just with the esthetic standards of the Ecole, but with the fact that it was governed by an institutional structure which maintained these standards, to which artists had to subscribe in order to be successful. The Ecole was governed by the Académie des Beaux-Arts, itself governed by the Institut de France. The professors at the Ecole were chosen from among the members of the Académie, and the same body also dominated the jury

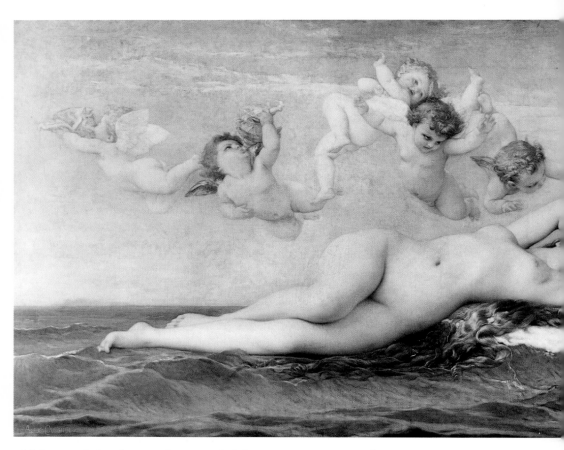

which awarded prizes at the annual Salon, or state-sponsored exhibition, where an artist could hope to gain critical recognition or official patronage. (At the Salon of 1863, Cabanel's *Venus* was awarded a gold medal, which indicates the prevailing attitudes.) However, many young artists of the period opposed the Ecole and its stranglehold on art. Moreover, all the Impressionists mentioned so far had work accepted at the Salon in the 1860s, Monet, Renoir, and Pissarro even enjoying some success with theirs. One reason for this was that the Salon was not entirely dominated by classicism. It had been "liberalised" as a propaganda manoeuvre by the autocratic Emperor Napoleon III and even if landscape and genre scenes did not enjoy the same institutional prestige as history and mythology, they were none the less exhibited and given serious attention by critics and the public.

While the artists named above formed the core of the 55 painters who showed their work at the eight Impressionist exhibitions between 1874 and 1886, this is not justification

3. ALEXANDRE CABANEL
The Birth of Venus, c. 1863.
Oil on canvas, 51¹/₈" x 7'4⁵/₈"
(130 x 225 cm). Musée
d'Orsay, Paris.

enough to designate them "the Impressionists." For one thing, they did not all exhibit at every show. After 1879 Monet exhibited only in 1886, while Renoir showed between 1874 and 1877 and in 1882. Impressionist artists have to be defined by a mix of many factors, which differed from artist to artist – such as their choice of scenes of modern life or of atmospheric effects on landscape and cityscape for subject matter; their practice of *plein-air* painting (they painted outside in front of the motif); a "sketchy" manner; or their gender. According to this view, Impressionism was the art made by women painters such as Mary Cassatt and Berthe Morisot, and by such "forgotten" artists as Jean-François Raffaëlli and Norbert Goeneutte. It was also practised by Edgar Degas, even though he preferred to think of himself as a Realist; and there are elements in Edouard Manet's work which link it to Impressionism.

Traditions of Interpretation

Impression, Sunrise, like many other paintings in the first exhibition, was hotly discussed by the critics and, probably, by the public. It is perhaps difficult to appreciate this now, since Impressionist painting has become familiar through a vast number of reproductions. But it is not just the familiarity of reproduction which has tamed Impressionism; it is also the kind of interpretation it has received. Broadly speaking, this has taken two forms until comparatively recently. According to the first – the Formalist and Modernist view – Impressionism's interest lies largely in its "flatness," or the way it draws attention to its own "surface," or its nature as "paint" laid upon a support, as if this were somehow expressive in itself and in some way that, say, the paint on a wall is not. According to the other kind of interpretation – the biographical – Impressionism is interesting because of the Impressionists' determination to pursue a new style in the face of opposition from the reactionary institutions of art and the conservative press and public. On this view, Monet's painting is interesting because it attests to the courage of the artist, his "genius," and the triumph of progress over stagnation.

These approaches have many shortcomings. Modernism has very little to say about just what it is that makes paint expressive. Biographically based accounts of Impressionism tend to emphasise the personality behind the picture at the expense of the picture itself. Moreover, both approaches also tend to obscure the relationship between a painting and its

wider history simply by writing this issue out of consideration. In particular, the idea that art owes its virtue to the heroic individual who made it eliminates from Impressionism any account of its determination in the wider world, and any account of its political meanings.

Because of these shortcomings, art historians have looked for other approaches with considerable vigour in recent years. These new perspectives on Impressionism – or revisionist histories – are roughly of four overlapping kinds: social-historical, feminist, psychoanalytical, and what I shall tentatively call anthropological.

Social-historical interpretations mostly fall into two varieties, anecdotal and theoretical, sometimes crudely labelled "Marxist". By and large, the anecdotal, social history of art is interested in analysing the contents of works of art in terms of what went on in the everyday social life they represent. Sometimes it tries to find significance in a painting as though its contents symbolised some value or belief. Thus, *Impression, Sunrise* might be seen as an interesting painting because of what it tells us about the social life in the docks at Le Havre, or because its imagery of the day breaking over the thriving port could be seen as a symbol of the regeneration of France after its defeat in the Franco-Prussian War of 1870–71.

In the main, theoretical social histories of Impressionism try to estimate the extent to which Impressionist paintings issued from, served, or resisted dominant ideology – the middle-class, white, and masculine beliefs that posed or were accepted as truth at the time (see Chapters Two and Three). Using this sort of thinking, we might want to ask of *Impression, Sunrise* whether or not it challenged conservative and authoritarian conceptions of artistic merit, such as the Academic doctrine which held that a painting's value lay in its ability to aspire to timeless (classical) beauty and the unique moral order that this supposedly exemplified. In Academic theory, beauty was nearly always connected with morality, some theorists claiming that this was because beauty was Divine in origin, which might seem a very strange claim when confronted with an Academic painting such as William Adolphe Bouguereau's *Nymphs and Satyr* (1873, FIG. 4) or Cabanel's *Venus*. Equally, we might want to ask whether or not Monet's painting expressed other beliefs about artistic quality which might be tied to the ideologies being consolidated by the emergent bourgeoisie from which he came. For instance, we could ask whether or not it expressed sympathy with the idea that the individual could choose his or

her own subject matter and standards of beauty and, if so, whether this links the painting with ideologies of individualism held to be central to the identity of the bourgeoisie.

Of late, social historians of art have emphasised how many Impressionist paintings are staged from the physical and psychological standpoint of a particular social type, and how they attempt to make the experience of modernity vivid by inviting the spectator to enter the painting imaginatively by adopting the standpoint of this type. The character in question is the casual, male urban observer, known as the *flâneur*. However, the *flâneur* was much more than that. First of all, as the writer Jules Janin put it, *flâneur* was "a wholly Parisian word for a wholly Parisian passion." Secondly, the *flâneur* was as much a creation

4. WILLIAM ADOLPHE BOUGUEREAU
Nymphs and Satyr, 1873.
Oil on canvas, 7'2⁵/₈" x 70⁷/₈"
(220 x 180 cm). Sterling and Francine Clark Art Institute, Williamstown, MA.

of fiction as a real person, and the two types fed off one another. *Flâneurs* abound in literature, from Balzac to Zola. Thirdly, *flâneurie* was a pose; it involved trying to make a serious profession out of the casual occupation of looking. Monet's early works sometimes involve the spectator as a *flâneur*, but most often it is Degas's and Renoir's works that appeal to the spectator to become this character. In some ways then, it is only by knowing about, and imaginatively taking on, the psychology of the *flâneur* that we can understand (or "enter") many Impressionist paintings. This raises many questions about the kind of spectatorship Impressionist paintings demand. The implication that Impressionist paintings were done for men has become the object of much recent critical attention, particularly among feminist writers.

Feminist art history combines a good deal of what is best about both social and psychoanalytical art history (see Chapter Two), although at times it imposes a rigid kind of redescription on an artist's intentions and paintings at the expense of historical accuracy. *Impression, Sunrise* is not an obvious candidate for this kind of interpretation, as feminist histories of Impressionism have concentrated on how beliefs about gender (and psycho-analytical factors) might have affected what and how men and women painted. For example, it emphasises how the subjects painted by men and women were different because the social spaces available to them were different, and that men and women viewed one another differently.

Looking at a number of paintings, it is obvious that beliefs about gender affected the range of subjects that men and women Impressionists were likely to paint. The men were free to go more or less anywhere (including the café and the brothel) without breaking taboo, and the paintings of Degas, Renoir and other male Impressionists show the wide variety of places they entered and used for motifs or subjects. On the other hand, beliefs about what was considered respectable behaviour for women greatly restricted the movements of the middle-class women Impressionists. The fact that Morisot and Cassatt chose their subject matter mainly from the domestic environment could indicate that it was considered their proper and only sphere. Impressionist paintings also show the attitudes which men often took towards each other and, more crucially, towards women. Drawing on developments in psychoanalysis, many feminist writers argue that the majority of works by the male Impressionists contain or represent an active, male way of looking which also involves a relationship of power over the

passive, female recipient of that gaze. In contrast, many paintings by the women Impressionists exhibit a more complex set of attitudes about looking and being looked at. Sometimes they conform to stereotype and show women as "natural" objects of male attention, but others break the rules and show how women experience looking and being looked at in ways that men do not, with very occasional exceptions.

For the most part, psychoanalytical approaches have sought to extract the latent (or hidden) content beneath the manifest (or obvious) content of pictures by reading their imagery, and sometimes technique, as evidence of the artist's repressed desires or fears. Even if *Impression, Sunrise* hardly calls for such treatment, analysing a picture in this way, rather like a dream, has elicited fruitful interpretations of the work of many artists. For instance, Cézanne's early work, with its erotically charged imagery and what he called its "spunky" technique, only too easily lends itself to psychoanalysis.

Like many a radical departure, yesterday's revisionist histories of Impressionism have become today's orthodoxy, all the more readily since they are dignified by seeming radical or politically correct. And while this is not always the case, some of the more recent attempts to revise our view of Impressionist paintings have tended to reduce them to little more than examples of ideology or resistance to it, or to mere reflections of how they might have originated in the flux, speed, and alienation of contemporary social life.

What I have called the anthropological approach to Impressionism attempts to explain the meaning of paintings as if they were artefacts in an unfamiliar culture. Normally, an anthropologist will explain an artefact by asking what set of beliefs and what series of decisions led an agent to make an object in a particular way, and with what end in view. Some recent work on Impressionism does something similar in that it seeks to explain the intended meanings of Impressionist paintings in terms of the artists' attempts to give shape to their impressions and sensations. The paradox to which this kind of account points is that the Impressionists made it a rule that they should realise in paint their sensations, and followed specific philosophical and scientific ideas about what sensations were, even though sensations were supposed to be personal, spontaneous, and untouched by culture. In these terms, therefore, *Impression, Sunrise* was about Monet's search for spontaneous expression, but was guided by definite and historically specific ideas about what spontaneous expression was.

Overleaf
5. CAMILLE PISSARRO
Hoarfrost: The Old Road to Ennery, Pontoise, 1873.
Oil on canvas, 25½ x 36½"
(65 x 93 cm). Musée d'Orsay, Paris.

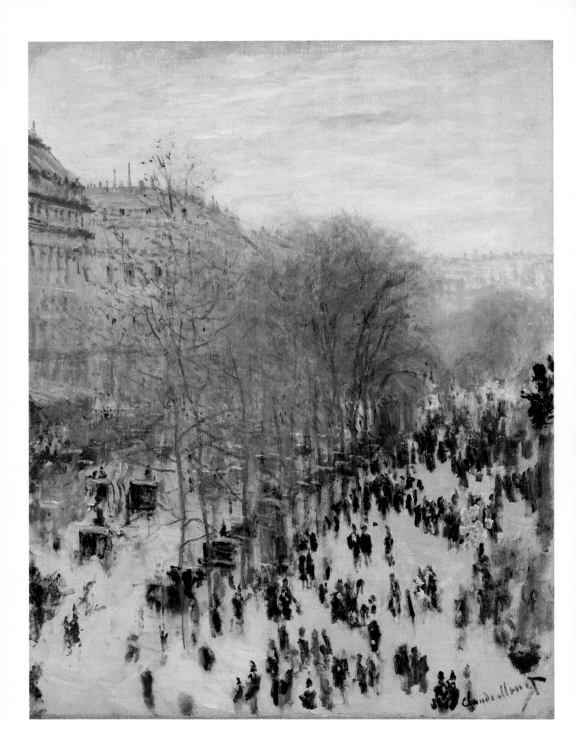

Defining Impressionism

Impressionism and the Impression

It is incontestable that the concept of the impression was of central importance to a good deal of Impressionist practice: after all, many artists were happy to call themselves Impressionists, and to exhibit at exhibitions which were known or advertised as "Impressionist." Most importantly, many are on record as saying that their art was about impressions.

Reviewing the 1874 exhibition, the conservative critic Louis Leroy poured scorn on the idea that paintings such as Pissarro's *Hoarfrost: The Old Road to Ennery, Pontoise* (1873, FIG. 5), Monet's *Boulevard des Capucines* (1873-4, FIG. 6) and *Impression, Sunrise* represented impressions. Despite his cynicism, a relatively longstanding tradition held that an impression was either the initial impression a scene made on the mind, or a kind of rough sketch, normally made on the spot, which corresponded to this. For most critics, therefore, an impression was not suitably detailed or finished enough to be exhibited, so the Impressionists were accused by contemporary critics of fobbing off hasty and unworkmanlike paintings on the public. Ironically, Monet gave the title *Impression, Sunrise* to his painting because he knew "it really couldn't pass off as a view of Le Havre." In other words, in part at least, his title was meant to excuse his painting from accusations of being unfinished or of lacking descriptive detail.

However, there was a more positive dimension to the term impression which also influenced Monet's choice of it. According to his biographer, Antonin Proust, Manet had used the word frequently from the late 1850s to describe what he painted. Perhaps more importantly, Camille Corot had used the phrase "the first impression" in such a way as to imply that to paint this was to be sincere or honest to the appearance of a motif under a single, unified light. In much the same way the friend of the Impressionists, Jules Castagnary, used the term in 1863 in the influential journal *L'Artiste* in order to praise the work of Jongkind: "I love this fellow Jongkind... I find him a genuine and rare sensibility. With him, everything lies in the impression."

It is possible to shed more light on what Castagnary meant by looking at two near-contemporary paintings by Jongkind, *The Seine and Notre-Dame* and *View of Notre-Dame* of 1864 (FIGS. 7 and 8). In these, Jongkind was clearly interested in recording how light and atmosphere alter the appearance of a motif as they change during the course of the day, rather as

6. CLAUDE MONET
Boulevard des Capucines, 1873-4. Oil on canvas, 31⅝ x 23¾" (80 x 60.3 cm). The Nelson-Atkins Museum of Art, Kansas.

This may be the work exhibited under this title at the first Impressionist exhibition in 1874, although there is also a version of the same subject with the same date in horizontal format. The exhibited work was described by a critic: "At a distance, one hails a masterpiece in this stream of life, this trembling of great shadow and light. But come closer and it all vanishes. It is necessary to go on and transform the sketch into a finished work. What a bugle call for those who listen carefully, how it resounds far into the future!"

7. JOHAN BARTHOLD JONGKIND
The Seine and Notre-Dame,
1864. Oil on canvas, 16$\frac{1}{2}$ x
22$\frac{3}{4}$" (42 x 56.5 cm). Musée
d'Orsay, Paris.

8. JOHAN BARTHOLD JONGKIND
View of Notre-Dame, 1864.
Oil on canvas, 16$\frac{1}{2}$ x 22"
(42 x 56 cm). Ashmolean
Museum, Oxford.

Monet was to be later on. It seems to have been the case that in painting an impression, an artist was trying to record how the atmospheric effect of a particular moment produced a particular impression on him or her as an individual. Certainly, the criticism produced by the novelist Emile Zola confirms this interpretation of what it meant to paint an impression. For

example, when he discussed Jongkind in 1868 he wrote: "He sees a landscape at a single glance... and he translates it in his own manner, while keeping its truth and also communicating the emotion he has felt.... Here, everything is original, the craftsmanship, the impression." Similarly, many of the Impressionists spoke of their impressions as if these were personal and subjective; never did any Impressionist claim that their art was objective. Monet, for instance, used the phrase "my own impressions" to describe what it was that he was trying to capture.

The foundation on which this conception of the impression rested was that of Positivist philosophy, and especially the work of the philosopher Auguste Comte, Emile Littré, editor of the enormously influential *Dictionnaire de la langue française* (1866), and Hippolyte Taine, art theorist and author of *De l'intelligence* (1870). The Positivists argued that an impression was subjective in two senses: it belonged to the consciousness of the individual who experienced it and hence was not an accurate account of the world. But more importantly, they argued that an impression took a form unique to the individual having it: because every individual was made differently, and because every individual brought her or his personal stock of memories, associations, and feelings to what she or he saw. Equally importantly for Taine, the impression was the "primordial fact" of perception. By this he meant it was the raw impact of the world on the senses, not a fully formed perception, but something untouched by knowledge and experience. Hence, in Taine's view, an impression was not shaped by these into a developed picture of the world of things and events and phenomena. Instead, it was to some degree unformed.

To sum up: when the Impressionists spoke of their interest in impressions, they meant they were interested in painting the unique effect that nature produced in them, or the experience that marked the meeting place of the individual, interior self and the outside world. Most importantly, when they claimed to paint their impressions, they implied they were recording the primal impact nature made on their senses, or the raw, unarticulated appearance things had when seen without prejudice.

The Sensation

In addition to impression, the Impressionists used another word to describe what they saw and painted. This was the word "sensation." Sometimes they, or their critics, used the two words almost interchangeably. In French, "sensation" is cognate

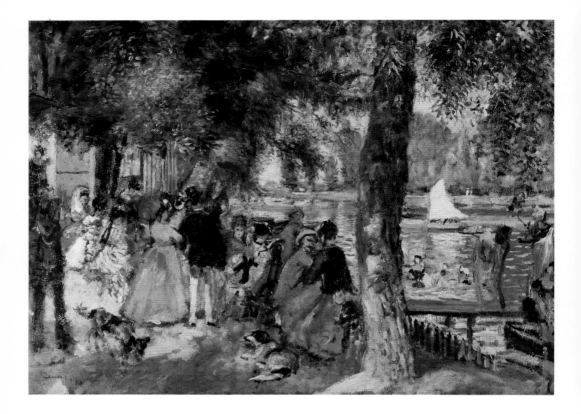

La Grenouillère, 1869. Oil on canvas, 26 x 33⁷/₈" (66 x 86 cm). Pushkin Museum, Moscow.

with the verb *sentir* ("to feel"), and thus implies a feeling as much as a perception. So, for example, in 1870 Cézanne tried to justify his recent paintings by saying "I have very strong sensations," as if to suggest the peculiarity of his works was owing to the fact that he painted sensations that were personal and unique to him. (Cézanne's use of the term may have been influenced by the novelist and art critic, Stendhal, whom he greatly admired.) Almost by way of confirmation, Duret wrote that the Impressionists had set out "to develop their own originality" by abandoning themselves "to their personal sensations." In 1874, Castagnary also defined Impressionism in terms of sensations when he wrote: "They are Impressionists in the sense that they render not the landscape, but the sensation produce by the landscape." Cézanne put the matter most bluntly of all, when he told the young painter Emile Bernard: "To paint after nature is not a matter of copying the objective world, it's giving shape to your sensations."

Trying to paint their own impressions and sensations − or their subjective responses to nature − the different Impressionists

produced sometimes radically different interpretations of the same scene, even when they painted side by side. Thus, Renoir's and Monet's versions of the same scene at La Grenouillère (1869, FIGS. 9 and 55, see opposite and page 88) are quite different, even though they are both recognisably Impressionist in handling. For one thing, Renoir's painting has an eighteenth-century feel in that it glamorises the mixing of the sexes in the manner of Watteau's *Pilgrimage to Cythera* (1717, FIG. 10), which had deeply impressed the young artist. The works Monet painted at La Grenouillère on the other hand, do not do this. In much the same way, Pissarro and Cézanne painted side by side in the 1870s, but Pissarro told his son Lucien in 1895: "each of us kept to the only thing that counts, the unique sensation!" Renoir's interest in Watteau shows that factors like training were also responsible for the differences between the styles of the various Impressionists. Since previous paintings also affect the way an artist sees, their attachment to personal sensations and seeing in a personal way must be central to an explanation of why the Impressionists produced idiosyncratic paintings.

Cézanne's paintings of his native landscape around Aix-en-Provence certainly show a highly personal and individual re-action to the motif: they are marked by his affinity, encouraged

10. ANTOINE WATTEAU
Pilgrimage to Cythera, 1717.
Oil on canvas,
50³/₄" x 6' 4" (129 x 194 cm).
Musée du Louvre, Paris.

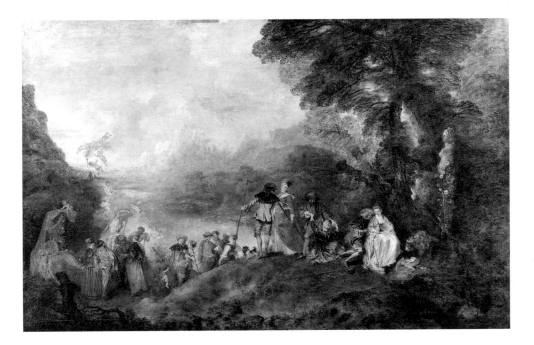

by his classical education, to the classical culture that once existed in Provence. In a version of *Mont Sainte-Victoire* (c. 1887, FIG. 11; also known as *La Montagne Sainte-Victoire* and dated to 1886-8), the echoes between the trees in the foreground and the line of hills in the distance give the painting something of the order and balance to be found in the classical landscapes of the seventeenth-century painter, Nicolas Poussin (FIG. 12), whom Cézanne admired. In his paintings, in other words, Cézanne expresses what he called his "native sensibility," or his belief (almost certainly drawn from Taine) that an artist's racial and geographical origins affected his sensation of nature. At any rate, Cézanne's deeply emotional attitude to the countryside permeated his paintings. Or to use Cézanne's own words of 1899, when he looked at the Aixois landscape he experienced "the vibrating sensations reflected by this good soil of Provence, the old memories of... youth, of these horizons, these landscapes, these unbelievable lines which leave in us so many deep impressions."

Impressionist Vision and Sketchiness

What is broadly similar about many Impressionist paintings is that they exhibit a certain degree of sketchiness or patchiness. But this is not the result of incompetence or hasty working, as critics implied. Nor is it a product of defects in the Impressionists' vision, even if most of them did experience difficulties with distance vision in their later lives. Monet, it is recorded, once rejected a pair of spectacles because they made him see "like Bouguereau," the sharp-focus painter of *Nymphs and Satyr*. Sketchiness is deliberately present in Impressionism from the very beginning, in Monet's *The Garden of the Princess* (1867, FIG. 13), for example. In this case, assuming Monet had an intention which found coherent expression in this work, it seems inevitable that he made the painting sketchy in order that it could convey something of his experience of the rapid movement in the scene depicted. In particular, the technique is well suited to represent the traffic as moving, and it is especially successful with the figures behind the railings of the garden. It has even succeeded in giving a feeling of what it is like to behold a scene whose movement and variety make it hard to take it in at one glance. It would be naive to think that Monet achieved all this simply by working rapidly. Probably some of the initial notations were done quickly, but to achieve such spectacular results would have taken many sessions, and

11. PAUL CÉZANNE *Mont Sainte-Victoire,* c. 1887. Oil on canvas, 26³/₈ x 36¹/₄" (66.8 x 92.3 cm). Courtauld Institute Galleries, London.

One of comparatively few signed paintings by Cézanne, the artist gave this work to his young admirer Joachim Gasquet in 1896. Gasquet recalled seeing it in a small exhibition near Cézanne's home in Aix-en-Provence and that Cézanne, flattered by his enthusiasm, signed it and gave it to him the next day.

12. NICOLAS POUSSIN *Landscape with the Funeral of Phocion,* 1648. Oil on canvas, 44⁷/₈ x 68⁷/₈" (114 x 175 cm). National Museum of Wales, Cardiff.

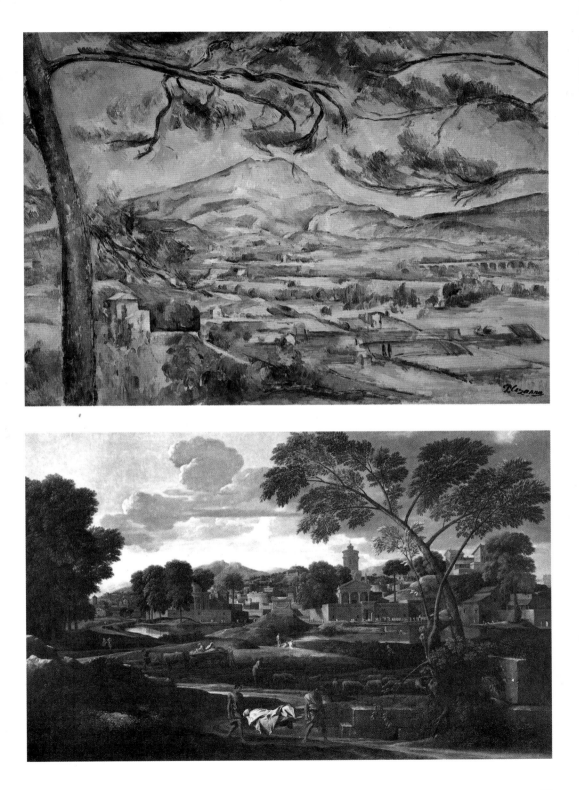

13. CLAUDE MONET
The Garden of the Princess,
1867. Oil on canvas,
35$^1/_2$ x 24" (91 x 62 cm).
Allen Memorial Art Museum,
Oberlin College, Ohio.

patient, careful reworking of the initial layers of paint. The painting might look "spontaneous," but only as the result of careful calculation.

It is none the less true that Monet did sometimes work quickly in his later career. The novelist Guy de Maupassant said that at Etretat in 1885 Monet worked on a canvas only for a few minutes before moving to another to accommodate the changes in light that took place even in this short time. Without doubt, Monet must have worked very quickly in these sessions, but he did so with a lifetime's experience that allowed him to produce something adequate to his intention, and not just a poor sketch. At any event, Monet reworked many of his

canvases in the studio – even in the 1860s – despite publicly subscribing to the myth that he worked only in the open air. One reason for reworking indoors was that he had to adjust the appearance of a painting made outside to the kind of indoor light in which it would eventually be seen.

Monet worked quickly on the early stage of a painting because he was keen to set down the first impression that a scene made on him. In 1901, he implicitly defined the "sketch" as the only adequate record of an impression, when he told his wife about his work in London: "This is not a country where one can finish anything on the spot; the effect can never be found twice, and I should have done nothing but sketches, real impressions." In a similar vein, Monet told the American painter Lilla Cabot Perry (whom he had met in 1889) "that the first real look at the motif was the truest and most unprejudiced, and... that the first painting should cover as much of the canvas as possible, no matter how roughly, so as to determine at the outset the tonality of the whole." What Monet meant can be seen in *Rouen Cathedral, Sunlight Effect, End of Day* (1892, FIG. 1), in which the canvas seems to have been covered rapidly and to have received comparatively little subsequent reworking. Its many areas of blank canvas make it different in this respect from the other more "finished" Rouen paintings. Pissarro also recommended "the first impression" as the truest and best: like Monet, he seems not to have wanted commonsense conceptions or prejudices about how things ought to look to interfere with his personal impression.

There is a direct link between painting the impression and painting colour patches. The idea that impressions (and sensations) were untouched or unformed by knowledge meant they appeared in precisely this form. According to Perry, Monet told her not to paint objects and events in the world, but patches of colour, advising her: "When you go out to paint, try to forget what objects you have before you – a tree, a house, a field, or whatever. Merely think, here is a little square of blue, here an oblong of pink, here a streak of yellow, and paint it just as it looks to you, the exact colour and shape, until it gives your own naive impression of the scene before you." Perry's account contains an additional indication as to why Monet thought seeing in colour patches corresponded to having impressions. She wrote: "He said that he wished he had been born blind and then had suddenly gained his sight so that he could have begun to paint in this way without knowing what the objects were that he saw before him." Since we know

that Monet had read Ruskin by this time, it seems inescapable that he was reiterating advice that Ruskin gave the painter in *The Elements of Drawing* (1857): "The whole technical power of painting depends on our recovery of what may be called the *innocence of the eye*; that is to say, of a sort of childish perception of [these] flat stains of colour, merely as such, without consciousness of what they signify, – as a blind man would see them if suddenly gifted with sight."

In the same vein, Cézanne said "I see. In stains." And he advised that the painter should "see like a man who has just been born." Statements like these may be evidence of Ruskin's impact, but they may also refer to another theoretical source which shaped the Impressionists' vision – Taine's writing about the sensation in *De l'intelligence*. There Taine suggested that raw sensations, unaffected by knowledge and experiences like touch, took the form of colour patches, rather as the vision of a blind man who had just regained his sight did. Sensations, then, were supposed to be formless in the sense that they were mere visual events with no informational or cultural content – patches of colour in the perceiver's mind, and no more.

Similar ideas had found expression in the literature of art. For example, in 1866, Zola defended Manet against accusations of insincerity with the claim that his "temperament" led him to see a subject in "stains." It seems that, even then, a patchy vision signified fidelity to something very like sensation. The articles containing these ideas were published in May as a series with the title *My Salon* in the newspaper *L'Evénement*, with a dedication to Cézanne. Shortly afterwards Cézanne painted his father reading the newspaper, as if to acknowledge his own sympathy with the ideas of the critic who was once his school friend (FIG. 14). And although somewhat robust in its treatment, Cézanne's portrait does break things down into colour patches, and so enacts the ideas its sitter refers to: that painting sensations meant painting in "stains."

There are many problems with this theory of vision. A normal adult usually sees things as things, and not as colour patches: it is impossible for most of us to shake off the years of experience which have led us to co-ordinate visual stimuli with our knowledge of the world and its ways. And it is implausible to think that it was possible for the Impressionists to see like this every time they painted. It has to be the case that ideas from science and esthetics concerning what they should see actually became bound up with what they did see, for all that their vision was supposed to be free from ideas and rules.

14. PAUL CÉZANNE
Portrait of Louis-Auguste Cézanne, the Artist's Father, Reading L'Evénement (also known as *The Artist's Father*), 1866. Oil on canvas, 78¹/₈ x 47" (199 x 119 cm). National Gallery of Art, Washington, DC.

The novelist Emile Zola dedicated to his old schoolfriend Cézanne a series of articles on art which were published in the newspaper that the artist's father is shown reading. Zola prefaced these with the remark: "It is for you alone that I am writing these pages." However, after the publication of Zola's *roman à clef, The Masterpiece*, in 1886, which featured a thinly disguised Cézanne as the failed painter Claude Lantier, the artist never made contact with him again.

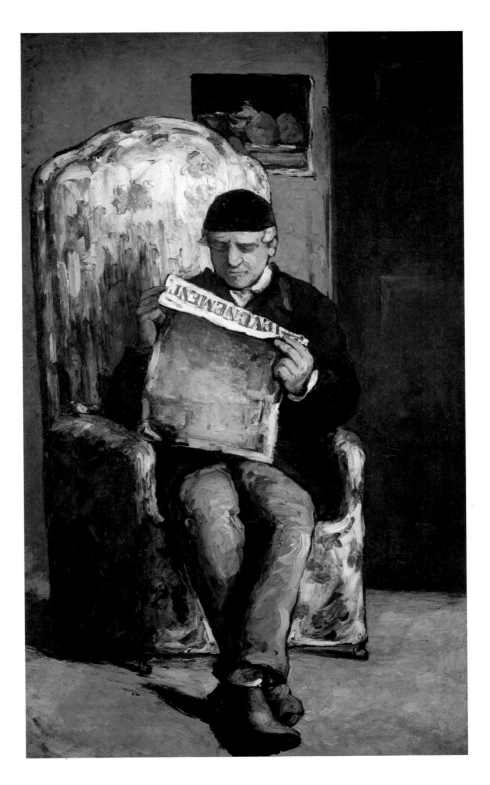

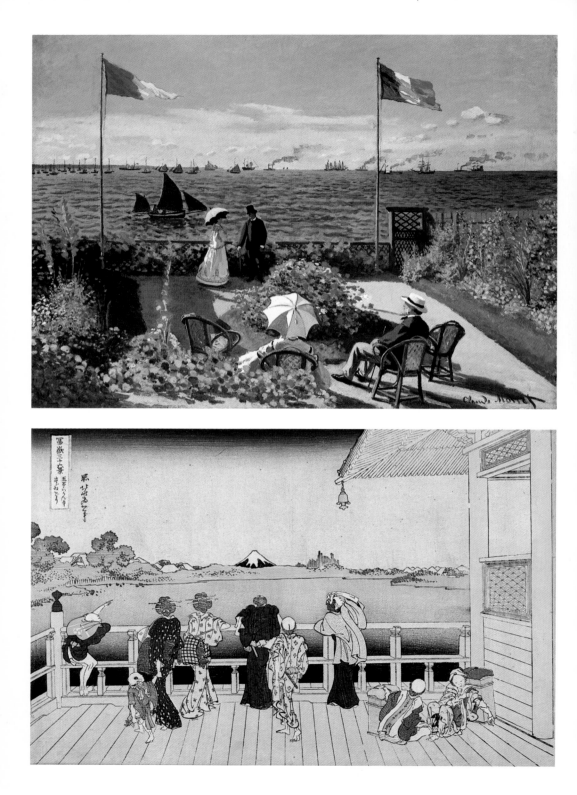

Defining Impressionism

15. CLAUDE MONET
Terrace at Sainte-Adresse,
1867. Oil on canvas, 38¹/₄ x
51¹/₄" (98.1 x 129.9 cm).
Metropolitan Museum of
Art, New York.

Monet exhibited this
painting in 1879, some
twelve years after he had
painted it, but it could still
look radical. One critic
complained he did not
"see nature" as Monet did,
"never having seen these
skies fluffy with pink cotton,
these opaque and moiré
waters, this multi-coloured
foliage. Maybe they do
exist," he added, only to
conclude: "I have never
seen them."

16. KATSUSHIKA HOKUSAI
*The Sazai Pavilion of the
Temple of Five Hundred
Rakan* from the series *Thirty-
Six Views of Mount Fuji,*
1829-33. Woodblock print,
9¹/₂ x 13¹/₂" (23.9 x 34.3 cm).
British Museum, London.

In 1878 the critic and friend
of the Impressionists,
Théodore Duret, described
the impact of Japanese
art on the Impressionists: "As
soon as people looked at
Japanese pictures in which
the most vivid, piercing
colours were set side by
side, they finally understood
that there were new methods
for reproducing certain
effects of nature which till
then were considered
impossible to render."

Moreover, the Impressionists also used existing conventions to help them achieve a painted equivalent to the sensation, notably those of the Japanese print. An early example is Monet's *Terrace at Sainte-Adresse* (1867, FIG. 15), which he called his "Chinese painting with flags in it." (The Impressionists often referred to things Japanese as "Chinese".) In the painting, Monet's debt to Japanese art shows in the work's high viewpoint, its horizontal banding, and its peculiar spatial ambiguity at the extreme right where the line of the garden fence runs parallel to the horizon. It plainly borrows from prints such as Katsushika Hokusai's *The Sazai Pavilion of the Temple of Five Hundred Rakan (The Sazaido of the Gohyaku Rakan-Ji Temple)* from the series *Thirty-Six Views of Mount Fuji* (1829–33, FIG. 16). The reason Monet thought such devices appropriate for conveying *impressions* and *sensations* was that the French of the mid-nineteenth century saw Japanese culture as "primitive," and Japanese prints as masterpieces of naive vision. Such borrowings from Japanese sources show that the Impressionists had to learn their techniques of rendering the sensation, rather as they had to learn their ideas about seeing innocently. Even Cézanne, who advised Bernard to "give the image of what we see, forgetting everything that has appeared before," had to refer to the example of Poussin to express his sensation.

Thus we can see that the Impressionists, despite claiming to paint spontaneously and innocently what they saw and felt (that is, their impressions and sensations), paradoxically had to learn how to achieve the desired effect by studying artistic precedent, Japanese sources, and scientific and esthetic theories. Nevertheless, there was a kind of coherence to their practice as they saw it. They were seeking to record impressions and sensations as the basis of an original means of expression. To understand Impressionism, therefore, we need first to acknowledge this aim.

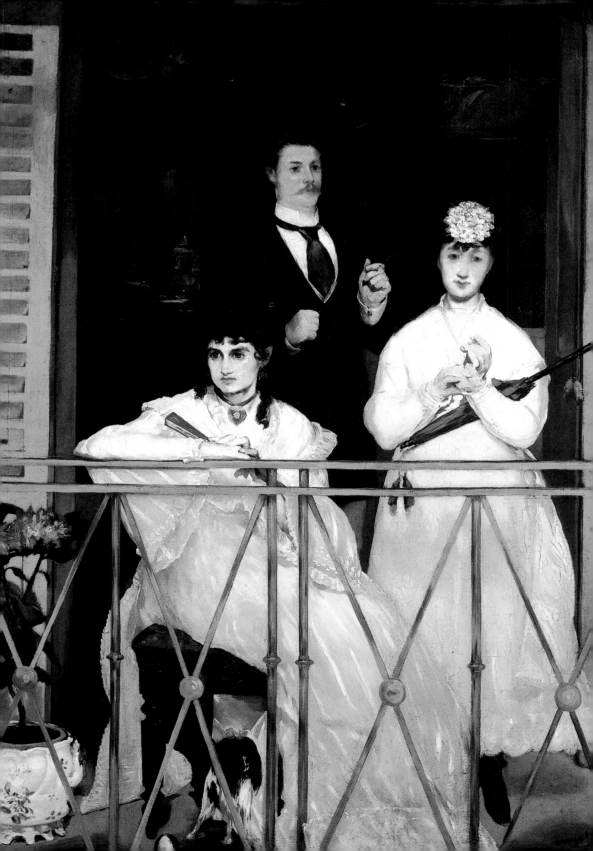

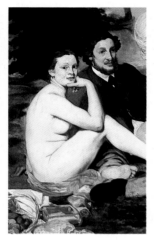

Manet, Baudelaire, and the Artist as Flâneur

"The observer is a prince who rejoices everywhere in being incognito." BAUDELAIRE

L ike many paintings of their type, Degas's *Place de la Concorde* (1875, FIG. 18) and Renoir's *Place Clichy* (c. 1880, FIG. 19) position the spectator in a particular physical and psychological relationship to the scene they depict. They present the scene through the eyes of a *flâneur* (or casual man of leisure) and ask the spectator to see it through the same eyes. They contain what has been called a "spectator in the picture," and cohere only when the real spectator imaginatively "becomes" this other character. Often paintings of this type identify the character and position of the spectator in the picture by very carefully specifying where they are painted from; and sometimes, as with Manet, they have figures within the painting which look back out of it and further identify the spectator in the picture in this way. Such paintings plainly ask women spectators of the picture to identify, imaginatively, with a male spectator in the picture – a problem that is taken up in the next chapter.

The enthusiasm among painters for adopting the perspective of the *flâneur* was encouraged by the poet, Charles Baudelaire, particularly his influential essay *The Painter of Modern Life* (1863). In this complex and curious piece, Baudelaire used the work of the illustrator Constantin Guys (FIG. 20) as a pretext

17. EDOUARD MANET
The Balcony, 1868-9.
Oil on canvas, 66½ x 49¼"
(170 x 125 cm). Musée
d'Orsay, Paris.

18. EDGAR DEGAS
Place de la Concorde,
1875. Oil on canvas,
31 x 46½" (79 x 118 cm).

Degas took pains to make
his work look informal and
spontaneous. According to
the critic George Moore,
Degas said: "No art was
ever less spontaneous than
mine. What I do is the
result of reflection and
study of the great masters;
of inspiration, spontaneity,
temperament I know
nothing."

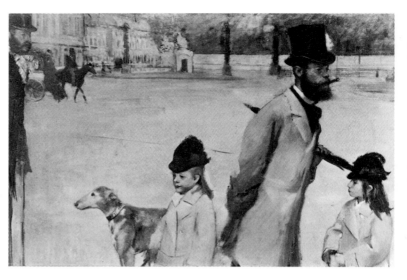

19. AUGUSTE RENOIR
Place Clichy, c. 1880. Oil
on canvas, 25½ x 21" (65
x 54 cm). Fitzwilliam
Museum, Cambridge.

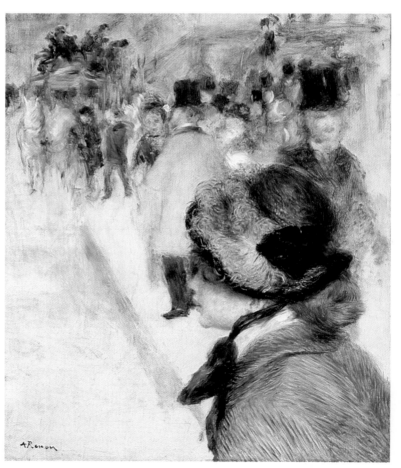

for expressing his own views on painting, the experience of modernity, and the character of the *flâneur*. Like many other critics, Baudelaire argued that art could no longer justifiably concern itself with the antique costume dramas churned out by the pupils of the Ecole des Beaux-Arts and exhibited at the official state Salon every year. Such works were normally scenes from ancient history with didactic narratives, or allegorical works like Ingres's *Apotheosis of Homer* (1827), and they were considered the highest genre of painting by Academics. Instead, Baudelaire argued that if art were to be relevant, it had to concern itself with modernity or "the ephemeral, the fugitive, the contingent."

Baudelaire not only made modernity an imperative for the would-be modern painter, he also singled out in Guys's work the quality he regarded as essential to the observation and recording of modernity, namely that it showed that the artist was a *flâneur*. For Baudelaire, what made Guys a *flâneur* was the quality of detachment in his work, and, superficially at least his dexterity at mastering the shock of modern experience – the speed, flux, and incomprehensibility that gave modernity its characteristic form.

On face value, it looks as though *The Painter of Modern Life* celebrates a duel between the *flâneur* and the transitory impressions of modernity. For instance, Baudelaire describes how the painter of modern life is possessed of the "fixed and animally ecstatic eye of children in front of something new," but also how, as a dandy, he "aspires to insensibility." Baudelaire also sees in Guys's work evidence of a "speed of execution" that matches the "rapid movement" of modern life itself. Baudelaire's apparent enthusiasm for the frisson of pitting oneself against the transitory character of experience was

20. CONSTANTIN GUYS *Promenade in the Bois de Boulogne,* n.d. Pen, brown ink and watercolour, 6³/₈ x 11³/₈" (16.2 x 29 cm). Sutton Place Foundation, Guildford.

In his essay of 1863, the poet Charles Baudelaire used Guys as a pretext for his description of *The Painter of Modern Life.* In Guys's work, Baudelaire saw "a speed of execution" equal to the "rapid movement" of modern life. He also called attention to the improvised quality of Guys's work, but maintained each drawing was "a perfect sketch."

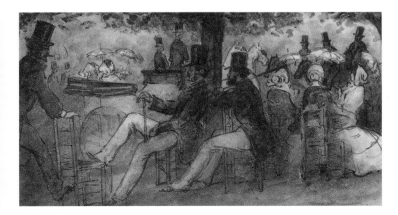

transmitted through café gossip and criticism to the younger generation of artists including Monet and his colleagues.

Much of *The Painter of Modern Life* also seems to be about the excitement of struggling to master a set of appearances which threaten not to make sense. Baudelaire describes his painter of modern life as one who takes "haughty satisfaction in never being astonished." Again, these and similar ideas and experiences find expression in paintings. Degas, in particular, seemed intent on expressing the sudden, unexpected, and opaque quality of the *flâneur's* experiences and encounters. In works such as *Place de la Concorde*, the "spectator in the picture" is a *flâneur* who has come upon a situation with no easy explanation: he finds himself confronted with an elegantly dressed man and what appear to be his children; but his wife is missing, and there are no clues as to why. Degas also emphasises the unexpected and bewildering quality of the experience by using an oblique viewpoint to express how the spectator has stumbled across the scene. In much the same way, the sharply cut-off left edge of the painting (which slices through the back of a passerby) gives the spectator a feeling that is as uncomfortable as it is unexpected.

The Flâneur as Detective

One of the *flâneur's* responses to the illegibility of modern life, as we know from writers like A. Bazin, was to play at being a kind of amateur detective. To help him in this enterprise, the *feuilleton* (pamphlet series) literature of the time contained an armoury of *physiologies* – or taxonomies of social types – which purported to sort out who was what. *Flâneurs* even took *physiologies* with them on their walks, and so became obsessive observers of body types and dress. Paris had been reconstructed over the previous decade by the Prefect of the Seine, Baron Haussmann, into the city of long vistas and wide boulevards familiar today. There was an esthetic dimension to this aspect of the city, and it encouraged tourism, but the reorganisation of Paris meant that the city could easily be surveyed and policed by the forces of law and order. Certain other improvements, like street-lighting and numbered houses, also facilitated official surveillance.

One of the consequences of this regime was that many illegal activities had to be carried out in disguise. For example, prostitutes had to find some way of soliciting in public that would allow them at once to attract customers and yet also

remain undetected by the police. They became adepts at disguise, and their customers became expert at seeing through such disguises. Or as one investigator into the battle between the police and the prostitutes put it: "It does not take much acuteness to recognise that a girl who at eight o'clock may be seen sumptuously dressed in an elegant costume is the same who appears as a shop-girl at nine o'clock and as a peasant girl at ten." Real criminals acted in much the same way, and therefore the *flâneur* leant on aids like *physiologies* in his quest to discriminate between genuine and fake respectability or to search out the criminal type, in the manner of a detective. The *flâneur's* paranoia was increased further by the realisation that if he were a detective, so might everyone else be. Any stroll through the streets involved encountering a vast swathe of nameless city dwellers who might be anyone – potential friends, lovers, or murderers.

Baudelaire too made a variety of allusions in *The Painter of Modern Life* to his *flâneur* painter as a detective. A clue is that Baudelaire calls him "the man of the crowds." This is a reference to Edgar Allan Poe's detective story "The Man of the Crowd," of which Baudelaire had published a translation in 1855. Appropriately enough, this story begins with a man sitting

21. EDGAR DEGAS
Women on a Café Terrace, Evening, 1877. Pastel over monotype, 16¼ x 25¾" (41 x 60 cm).
Musée d'Orsay, Paris.

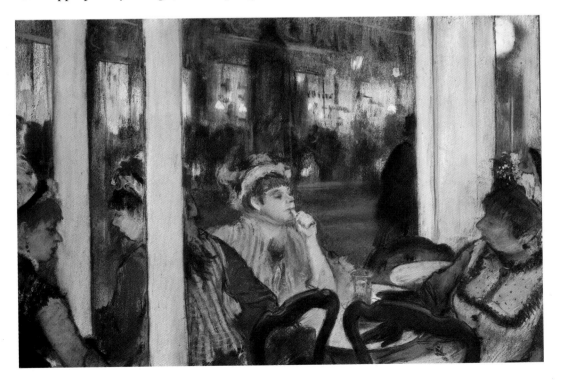

Manet, Baudelaire, and the Artist as Flâneur

in the window of a coffee-house in London analysing the passing crowd into its constituent physiological types.

One work that very clearly positions the spectator as a *flâneur*-detective is Degas's monotype *Women on a Café Terrace, Evening* (1877, FIG. 21; also known as *Women in front of a Café Terrace, Evening*). We observe how the man at the right of the picture has just passed the group of prostitutes assembled on the café terrace for the purpose of soliciting. One commentator has suggested that he might have given a discreet signal to a woman who has vacated a chair. At any event, the woman second from the left appears to be rising from her seat perhaps to fill the space which gives her a better position nearer the street. Although nothing is certain about the scenario, it does draw the spectator into it as a *flâneur*-detective, and invites him to scrutinise the scene for any clues that its characters might let slip. Moreover, Degas treats the women in the picture in a way which is consistent with the fact that he sometimes referred to himself as "Lavater." Johann-Kaspar Lavater was the eighteenth-century physiognomist whose analyses of the features of different character types laid the foundations for later *phsyiologies* of Baudelaire's generation. Degas gives the women almost caricatural physiognomies which reveal their supposedly degenerate nature. In particular, their receding brows and prominent chins give them a simian quality which implies that they are low on the evolutionary ladder. What is more, Degas positions the spectator in this picture so that he remains hidden from the people he observes, or at least they give no indication of responding to his presence. He therefore succeeds in carrying out his observations unseen – like Baudelaire's *flâneur*.

Another *flâneur*-detective picture, Renoir's *The Umbrellas* (c. 1881 and c. 1885, FIG. 20) deals in even greater detail with the frisson of avoiding detection. In this, the spectator is positioned as man in a fashionable park, or at least the way the spectator's attention is engaged by the attractive young woman at the left of the painting suggests this. This woman is carrying a basket covered with an oilskin, perhaps because it contains perishable goods or flowers to sell, and her dress shows she is of a lower social class than the well-dressed people who populate the rest of the picture. Since working-class women were often the objects of the *flâneur*'s "chivalrous" attentions, the picture is designed to prompt the spectator into imagining himself making an advance to the girl – he might offer her his umbrella, for instance, since it has started to rain and she has no protection. However, we can assume there is something illicit

22. AUGUSTE RENOIR
The Umbrellas, c. 1881 and c. 1885. Oil on canvas, 71 x 45¼" (180 x 115 cm). National Gallery, London.

Most of this painting was completed around 1881 in a softer Impressionist style. Some areas, particularly the figure of the young woman at the left, were repainted around 1885 in the harder, more linear style that Renoir developed through his renewed interest in Italian Renaissance art.

in the spectator's intentions because he is being watched by the little girl in the foreground with a hoop. What is more, she is being watched by her mother; who in turn appears to be under observation by the man at the left of the painting – perhaps the father of the family, or a potential rival for the younger woman. Accordingly, if the spectator is to make an illicit advance to the woman with the basket he must do this without attracting attention; crucially, he must do it before the little girl's mother follows the direction of her child's gaze and alerts the man at the left of the painting as to the spectator's intentions. In other words, the picture trades on contemporary anxieties about the necessity of weighing up a situation and acting quickly in order to evade detection by one's peers.

Paintings of this sort suggest that the *flâneur's* vision was marked by a sense of loss. Not only do situations and events threaten to happen too quickly to hold on to, but, as Baudelaire describes in his poem "To a Woman Passing By," even love at first sight threatens to be no more than love at last sight as well. It is no surprise, therefore, that a desire to give the transitory moment some fixity and accessibility is one of the recurrent features of Impressionism. It certainly seems to motivate a painting like Renoir's *Place Clichy*, where the spectator's gaze fixes on the face of a woman passing by as if to hold on to what is all too ephemeral an experience and perhaps even spin a narrative future around it.

The Flâneur and the Crisis of Modernity

In distinction from Renoir, Baudelaire's imagery of erotic loss is metaphorical. That is, he uses the image of the unattainability of love in the modern city in order to point to something else – the disappearance of meaningful communication and even sense itself from social life. Put simply, Baudelaire's reaction to modernity is a reaction to crisis. It is not just that things move too fast, or resist analysis, it is that they do not make sense any more because the city is no longer a community of inhabitants who share values and histories. The city's illegibility is symptomatic of something deeper – in other words, the disappearance of the organic unity between individuals that defines and constitutes a community as such. In place of this, individuals are forced to compete with one another or act as enemies.

Another symptom of the crisis in experience is the way that life was imagined in terms of fantasy, as if this were all

observers could do in a world that did not make sense. And so, while the writer of a popular account of *flâneurie*, Victor Fournel, claims to be involved in physiognomic analysis, he also speaks of the street as an "improvised theatre" where "Each individual furnishes me, if I wish, with the material of some complicated novel... I make move, think, act at my will this theatre of automatons whose strings I hold."

In much the same way, the main character in Gustave Caillebotte's *Young Man at his Window* (1876, FIG. 23) is observing a scene, but is doing it as if he were in a theatre where the street is the stage: the window in the painting even frames the scene with its own proscenium arch. It is possibly one intention of the painting that the spectator should place

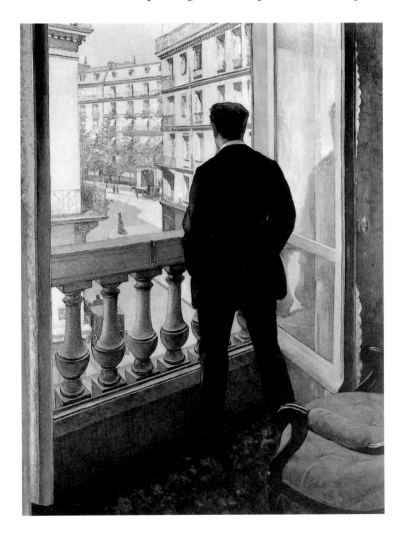

23. GUSTAVE CAILLEBOTTE *Young Man at His Window*, 1876. Oil on canvas, 45³/₄ x 31³/₄" (116.2 x 81 cm). Private collection.

Caillebotte exhibited at five of the eight Impressionist exhibitions, from 1876 to 1882, but his style set him apart from many of his colleagues. Zola greatly disliked the works (including this painting) that Caillebotte exhibited at the second Impressionist exhibition of 1876: "because of their precision, the paintings are entirely anti-artistic, clear as glass, bourgeois. The mere photography of reality is paltry when not enriched by the original stamp of artistic talent."

himself in the shoes of its protagonist; once we do this we might be tempted to make up a (detective) story about the comings and goings of the woman he is watching. In doing this the painting seems to insist that there is no possibility of interaction between its characters, because there is no possibility of their having meaningful communication.

The Painter of Modern Life registers the crisis of meaning in several ways, not least by ironically describing the *flâneur*-detective as someone who tries to "set up home" in the "swell, the movement, the fugitivity, and the infinity" of the crowd, as if such a thing were possible. Baudelaire even undermines the credibility of the *flâneur* as detective by suggesting that his whole enterprise is futile since there is no longer any sense for him to find. For one thing, by making his *flâneur*-detective painter an "incognito prince" in the manner of the writer Eugène Sue's Rodolph in *The Mysteries of Paris* (1844), the poet implies his own hero is a creature of fantasy. Calling him "the man of the crowds" after Poe is also ironic. The point is that while Poe's story begins with his detective succeeding in analysing the crowd, it ends with him having spent the whole night following a mysterious old man ("the man of the crowd" of the title) only to learn absolutely nothing about him. Thus the story concludes with the admission that this character's existence "does not permit itself to be read." Given the reader's expectation that the story will eventually reach a denouement, this strange admission amounts to saying that nothing can be understood.

The Philosophical Flâneur

The artist whose work most clearly responds to Baudelaire's critique of the *flâneur*-detective is Edouard Manet, who had close contacts with the poet from about 1858. Manet specifically acknowledges his friendship with Baudelaire in his *Music in the Tuileries* (1862), where a blurred profile image of the poet appears behind the young woman at the left wearing a blue hat.

However, it is in the way that the painting works (or does not), that it acknowledges Baudelaire most directly. At first sight, Manet appears to position the spectator in the picture as an unselfconscious *flâneur* watching the crowd that he passes by. Manet even facilitates the spectator's imaginative entry into the painting in this role by using three remarkably daring devices. First, he distributes the focus of the faces in the picture more or less randomly – they appear either sharp or blurred

EDOUARD MANET
Profile portrait of Charles Baudelaire, 1862. Etching, 5 x 3" (13 x 7.4 cm).

The artist used this work as the basis for the portrait of Baudelaire in *Music in the Tuileries.*

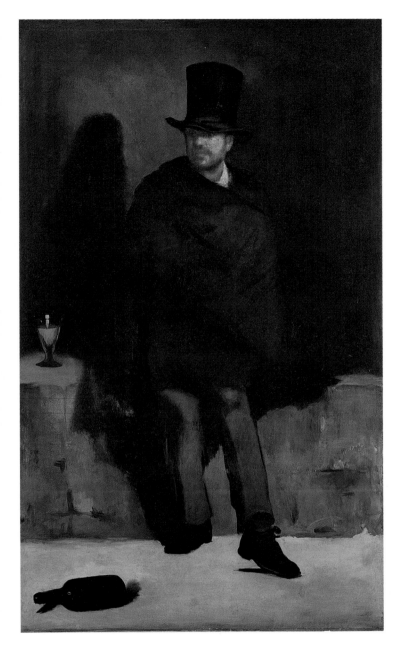

24. EDOUARD MANET
The Absinthe Drinker,
1858-9. Oil on canvas,
70^1/$_2$ x 37" (180.5 x 106 cm).
Ny Carlsberg Glyptotek,
Copenhagen (detail page
164).

Manet's painting was rejected from the Salon of 1859. He said it was simply "a Parisian character whom I had studied in Paris and executed with the technical simplicity I discovered in Velasquez." But Thomas Couture, Manet's teacher from the Ecole des Beaux-Arts, was so scandalised by its low-life subject matter and treatment that he told Manet: "An absinthe drinker! My poor friend, you are the absinthe drinker. It is you who have lost your moral faculty."

irrespective of their distance from the spectator so that one may find a sharply focused woman's face *behind* Baudelaire, for instance. This device gives the spectator something of the experience of scanning the crowd. Secondly, Manet extended the tree towards the centre of the painting at a late stage of its execution so that it continues into the foreground. This

prevents the spectator seeing any great depth in the picture (block it out and the painting recedes), and forces him instead to scatter his attention backwards and forwards across the whole painting. And lastly, Manet reinforces this effect by leaving the centre of the painting very thinly painted, and indistinctly drawn, which again prevents the spectator from settling on it as a fixed centre of attention. These devices do not just simulate the experience of being in a crowd, however. Because they make the painting into one that will not cohere or meld, they present that experience to us spectators as something that happens too fast and which must remain impenetrable and incoherent.

Music in the Tuileries also frustrates our efforts to penetrate it by inviting but also repelling our attention. For example, the attractive young woman in the foreground might arouse the spectator's interest, but he would be pushed back from her by the fierce gaze of her chaperone, and perhaps by the ambiguous disposition of her fan, half-open and half-closed. Manet even has a joke at the expense of the uninformed spectator, since he includes many of his own friends and acquaintances in the painting, whom we can only recognise if we are "in the know." What is more, Manet has the last laugh, in that he stares out of the picture at us from its left edge, as if to watch us playing detective and to accuse us of the futility of our efforts. All in all, the painting is the stylistic equivalent of a Poe detective story or Baudelairean prose poem: it plays with us, throws us into confusion, and frustrates our attempts to read it coherently.

25. EDOUARD MANET
The Old Musician, 1862.
Oil on canvas, 6'1³/₄" x 8'1³/₄"
(187.4 x 248.3 cm). National Gallery of Art, Washington, DC.

For this allegorical painting, Manet drew some of his characters from real life. The old musician was based upon Jean Lagrène, a gypsy from the Batignolles district of Paris and an artist's model, and the ragpicker figure was modelled on a real ragpicker called Colardet.

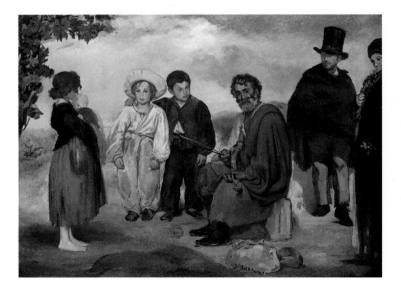

The spectator in this picture is situated by Manet as anything but a simple *flâneur*. He is, rather, forced to reflect on his own situation, to be selfconscious and critical of what he sees, like the "philosopher" or the "solitary individual... ceaselessly journeying across the great human desert," as Baudelaire characterises his ideal *flâneur* in *The Painter of Modern Life*. There is certainly a good deal of evidence to link Manet's intentions to Baudelaire's in this respect, since both poet and painter were interested in portraying the philosopher, often as a mendicant and a drunk. For example, in his poem, "Ragpickers' Wine" from *The Flowers of Evil* (1857), Baudelaire uses the image of the drunken ragpicker shouting defiance to the world (in the belief that he has become invisible to police spies) as a metaphor of how the poet waxes lyrical. Ragpickers were a subclass of Parisian society, largely nocturnal and earning the most meagre of livings by recycling rubbish. But this alienated existence meant they were often seen in contemporary literature as street philosophers, or modern-day versions of the poverty-stricken peripatetics of ancient times: Baudelaire made a variety of connections among the poet, the drunk, and the philosopher in his prose poems. Thus, it is reasonable to think that this poem was about a "philosopher."

26. DIEGO VELÀSQUEZ *Mennipus*, 1639-40. Oil on canvas, 70$\frac{1}{2}$ x 37" (179 x 94 cm). Museo del Prado, Madrid.

Manet was probably aware of this poem when he painted his own heroic portrait of a ragpicker, *The Absinthe Drinker* (1858-9, FIG. 24). It makes no sense as a genre painting, or even as a Realist picture of a social type. By comparison with conventional works of the time it has no story and no narrative, but instead ennobles its sitter by making him isolated and large in scale. Later, in 1870, Manet referred to it as one of four pictures of "philosophers," and it bears close comparison to paintings of the drunken, beggar philosophers of antiquity like *Mennipus* (1639-40, FIG. 26), by Diego Velásquez, whom Manet greatly admired.

It seems, then, that both Baudelaire and Manet identified themselves imaginatively with philosophers through association with the ragpicker. Accordingly, it is possible to see Manet's *The Old Musician* (1862, FIG. 25) as an allegory about the dispossession of the "philosophical" artist, since the absinthe drinker reappears in it, alongside some wandering artists and performers who have been forced out of the city by the new and stringent licencing arrangements Haussmann imposed on these types. More specifically, the likelihood is that the ragpicker represents the poet as philosopher (almost as in "Ragpickers' Wine"), just as the character of the Jew at the

extreme right of the painting almost certainly represents the painter as a dispossessed philosopher. Gustave Courbet (whom Manet knew) had painted himself in *Bonjour M. Courbet* (1854) in the same pose as that of the Wandering Jew in a popular print, one of the *images d'Epinal*. As a selfstyled bohemian, Courbet identified with the popular image of the Wandering Jew as a kind of peripatetic philosopher, based on the legend of how he was condemned to wander the earth for all time, telling the story of Christ's sacrifice.

Manet and the Representation of Woman

Manet's paintings of women reveal his "philosophical" dimension more than any others. In many he uses much the same strategy, which is to invite the male viewer of the painting to adopt the imaginary standpoint of the spectator in the picture, only to make him feel uncomfortable in this role and make him reflect "philosophically" about the attitudes it involves.

The spectator is made selfconscious by having the women at whom he is looking stare back at him. The power of this simple device can be appreciated by contrasting the original version of Manet's *Nymph Taken by Surprise* (1861, FIG. 27) with the final version. In the former, there is a satyr in the top right-hand corner, so the spectator can avoid becoming selfconscious about looking intrusively at the woman in the picture by projecting his attitude onto this creature. However, the satyr is absent from the final version of Manet's painting, which forces the spectator to confront what he is doing – all the more so as the woman's way of looking back now quite unequivocally casts him as the unique intruder on her privacy.

Much the same effect is produced in *Le Déjeuner sur l'herbe* (*Luncheon on the Grass*, FIG. 28) which was refused by the Salon of 1863 and exhibited at the so-called Salon des Refusés that Napoleon III established that year in an attempt to make himself look liberal. One reason for the painting's rejection was probably its way of making the spectator in the picture feel foolish, as if he has stumbled on a scene where he does not belong. The naked woman shows no shame or surprise, even though she is sitting in equally close contact with her two male companions. This bohemian behaviour, and the bohemian dress of the man at the right of the picture, suggests the party may be artists and models. But the whole force of the painting depends on a curious twist. Once the real male spectator takes up the psychology of the spectator in the picture, he is looking

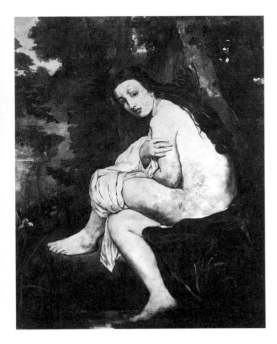

27. EDOUARD MANET
Nymph Taken by Surprise, 1861 (photograph taken by Godet in 1872). 12⅝ x 10¼" (32 x 26 cm). Bibliothèque Nationale, Paris.

This photograph of Manet's *Nymph Taken by Surprise* shows that it originally included a satyr in the top right corner looking at the nymph. Another photograph of the same painting, probably taken in 1883 – the year Manet died – shows the satyr still in the picture. It may well be the case, therefore, that it was someone other than Manet who took it out.

28. EDOUARD MANET
Le Déjeuner sur l'herbe, 1863. Oil on canvas, 6'9⅞" x 8'8" (208 x 264 cm). Musée d'Orsay, Paris.

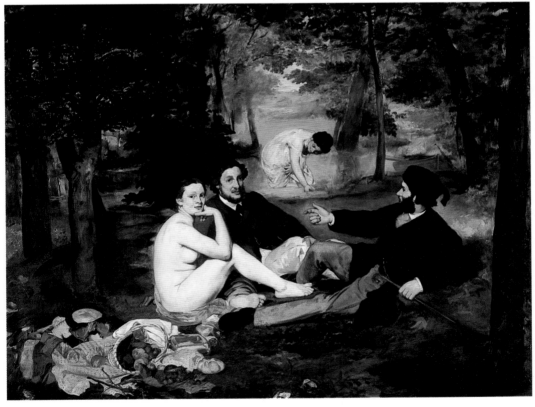

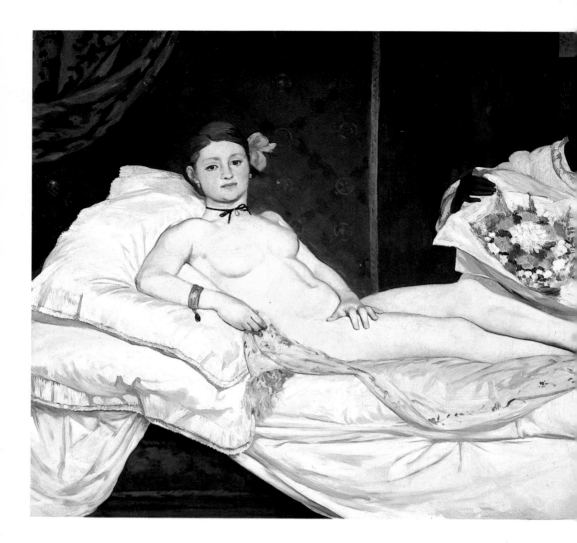

29. EDOUARD MANET
Olympia, 1863. Oil on canvas, 51³/₈" x 6'2³/₄"
(130.5 x 190 cm). Musée d'Orsay, Paris.

Manet's painting depicting a prostitute caused
such a scandal in the days following the opening
of the Salon of 1865 that one critic suggested it
should "have been hung at a height out of range
of the eye." A few weeks later, another critic
wrote: "You had seen Manet's *Venus with a Cat*
flaunting her wan nudity on the stairs. Public
censure chased her from that place of honour.
One found the wretched woman again, when
one did find her, at a height where even the
worst daubs had never been hung."

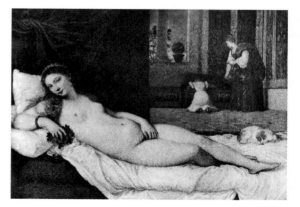

Left
30. TITIAN
Venus of Urbino, 1538.
Oil on canvas, 47 x 65"
(119.5 x 165 cm). Uffizi,
Florence.

at a model who is present and "real." This means he is no longer able to peruse the female body within the artwork from a comfortable distance, or to look at art from the safety of reality. In doing this, the painting seems to want to confront the spectator with the idea that looking at paintings of the nude did not just involve the pure and disinterested attitude it was commonly believed to. Instead, the painting's strange way of making the model "real" seems to suggest that looking at nudes involved many of the attitudes that men actually employed towards real women, but that this is disguised by the fact that women in paintings cannot normally look back. *Le Déjeuner sur l'herbe* certainly prevents the unreflexive, proprietorial and consuming male gaze encouraged by paintings like Cabanel's *The Birth of Venus.*

The attitudes of the *flâneur* towards real women can perhaps be gauged from the fact that in the Paris of the 1860s there were about 35,000 registered prostitutes, and an unknown number of unregistered prostitutes, for a population of about one million – which means that men must have generated a considerable demand. And Manet directly indicts the *flâneur*'s attitudes towards women in his *Olympia* (1863, FIG. 29), which is not so much a nude as a painting of a prostitute that situates the spectator in the picture as her client. Manet contrives this attack on the spectator first of all by making it plain that he cannot distance himself from the scene depicted, or see it from outside, as he can so easily with the Old Master that *Olympia* debunks – Titian's *Venus of Urbino* (1538, FIG. 30). For all their broad similarities, what is significant are their differences, and especially the difficulties with which Manet presents the spectator that Titian does not. Titian's woman is ostentatiously nude or artificially posed as naked, she is acquiescent and her facial expression implies that she is coyly available, even if her genitalia are politely masked by her hand. Most importantly, her response to the spectator is something he can control: she does not necessarily implicate him as present in the scenario. In contrast, Manet's woman is naked, she challenges the spectator with her bold expression, and insistently covers her genitalia with "a hand flexed in a sort of shameless contraction," as one horrified critic wrote.

The most forceful effects of the painting result from its implication that the spectator in the picture is there as a client for Olympia's sexual favours, or at least, if the real spectator assumes the psychology that the painting suggests for the spectator in the picture, that we are actively involved in the

31. EDOUARD MANET
Corner in a Café-Concert,
1877-9. Oil on canvas,
38¼ x 30½" (97.1 x 77.5 cm).
National Gallery, London.

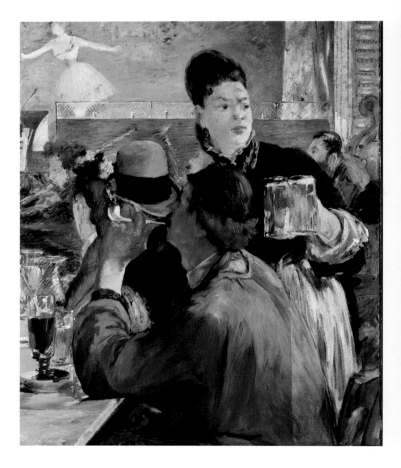

scene and its action. Manet makes this almost inescapable: Olympia has displayed her body *to us* by removing her drape, and *we* have offered an outlandish bouquet of flowers to her servant to smooth our way into her favours. What is more, she is not shown as being sexually aroused in conventional terms (her nipples are scarcely visible), and the bracelet she wears carries a locket, showing she loves someone who is not us, and that any sex she might have with us is purely and simply for the money. As the spectator in the picture, therefore, we are presented with a clear-cut situation in which our progress is apparently straightforward: pay up and Olympia will suffer our caresses. But two things make this progress difficult. First, Manet's most untypically brutal revelation of how sex and money make each other dirty: unlike most paintings about prostitution, this one does not try to dignify it by pretending it is glamorous. And secondly, Manet makes the spectator uncomfortable by emphasising the artificiality of his own technique.

32. EDOUARD MANET
Café-Concert, c. 1878–80. Oil
on canvas, 18³/₄ x 15³/₈" (47.5
x 39.2 cm). The Walters Art
Gallery, Baltimore.

The emphasis on artifice is present in nearly all Manet's paintings, but the effect of this emphasis is strongest in his paintings of women. Essentially, the effect on us is a function of the emphatic factitiousness (artificial quality) of the paint, which makes the spectator conscious of the painting as an artefact that has been made by the painter. Once he has acknowledged this, it is a small step to the realisation that the artist "watches" the spectator in the picture in the process of painting him into it. The business of painting the picture involves as part of its progress toward conclusion the monitoring of how the spectator in the picture is getting on. Having got this far, it is hard to step back into the shoes of the *flâneur* situated as the spectator in the picture, since we know we are being watched – by the artist. To put it another way: the inescapable presence of the artist as someone watching him playing detective serves to make the spectator extremely wary of taking up this role.

Much the same sort of effect is produced by two closely similar paintings, *Corner in a Café-Concert* (1877–9, FIG. 31) and *Café-Concert* (c. 1878–80, FIG. 32), although the two paintings are somewhat different in the identity that they ascribe the spectator in the picture. Indeed, it seems that in making these two versions (and one other) of the same theme, Manet was struggling towards casting the spectator and making him appropriately selfconscious. In the first picture, we are presented with a view of a café-concert (a kind of music-hall) in the early evening. Witnesses' accounts inform us that workers in their blue blouses normally visited such places on their way home from work. Sitting with the worker at the table is a better-off man in a bowler hat, perhaps an artisan or office-worker, and, seen from behind, the streetwalker who appears full-face in the later picture. It is likely that what Manet was trying to do here was show the way that men of different classes might have women of different classes in view as potential sexual partners. The only man who might be interested in the streetwalker would be the worker, while the artisan or office-worker might have the beer waitress in his sights: such women were commonly thought of as available, and did provide sexual services on premises known as *brasseries à femmes*. In fact, the man in the blouse was the husband of the beer waitress – undoubtedly because of the risqué reputation attributed to artists and artists' models, he insisted on chaperoning his wife during her sittings for the painting. Since the custom was that the better-off entered cafés-concerts later in the evening than workers or clerks (who frequented them on their way home from work), it would seem that the spectator in the picture is of a different class from both of the men depicted in the painting: he is probably the elegant *flâneur* of the later version who has just come in after having spent the early evening doing something else, and it makes sense to imagine that he has the woman on the stage in his sights.

What the earlier painting does not do is make its spectator's identity clear, and consequently, it is not all that successful at inducing a feeling of selfconsciousness. In the later picture, though, things are much clearer. The elegant *flâneur* is looking at the singer on the stage (whom we, the spectator, see in a mirror). Our attention is attracted by the beer waitress striking a pose. And nobody appears interested in the streetwalker at all. However, it quickly becomes apparent that as the spectator we are made to participate in a hierarchy of ways of looking: like the *flâneur* represented in the picture, we look at women

33. EDOUARD MANET
A Bar at the Folies-Bergère, 1882. Oil on canvas, 37³/₄ x 51¹/₈" (96 x 130 cm). Courtauld Institute Galleries, London.

according to the way that our class, and theirs, dictates. The painting even arranges its women in a literal hierarchy from high to low, to make the point inescapable.

The culmination of this series of paintings comes in *A Bar at the Folies-Bergère* (1882, FIG. 33). In this painting, the spectator has no difficulty knowing who he is since his reflection in the mirror (at the right of the painting) tells him he is the *flâneur* approaching the woman at the bar. In contemporary parlance these women were known as "vendors of consolation," not only because they dispensed alcohol but also because they often

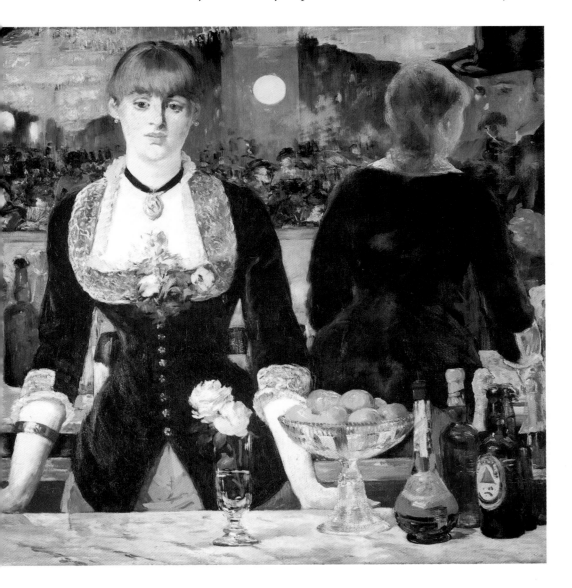

acquiesced in clients' sexual propositions: being a barmaid at the Folies-Bergère was badly paid, and the job only paid well if a woman took advantage of the "opportunities" it offered. There is some ambiguity, then, over what we, as the spectator in the picture, may perhaps be saying to the barmaid.

The painting, however, gives our approach an explicitly critical inflection. While the barmaid is pert and attentive in the mirror, seen face-on she is withdrawn and melancholic – the two views do not match, as if to suggest her public face belies her real feelings. Indeed, everything in the mirror is glamorous but also false. It teems with elegantly dressed men on the lookout for available women, and women eyeing up possible clients. (In Maupassant's *Bel Ami,* one visitor was "hardly bothered with the spectacle on the stage, and kept his eyes fixed on the great gallery behind him, full of men and prostitutes.") And in Manet's painting, the insignificance of the show beside the spectacle of prostitution is indicated by the ironic placement of two tiny feet belonging to a trapeze artist in the top left corner. Therefore, the world in the mirror is no reflection of how things really are, but shows instead the superficial glamour that clothes prostitution, or gives it a respectable face. In effect, then, the mirror serves as a metaphor of the falsehood of appearance, and to provide a contrast with the subjective and more "real" experience of the barmaid. Manet quite deliberately underlined the discrepancy between her inner

feelings and her public face by placing her reflection much too far to the right of the picture, implying that her two aspects do not belong together.

The cumulative effect of these devices is to present the spectator with a choice that he must make physically by choosing his position in front of the picture: either he stands at the right, in which case he assumes the psychology of the predatory *flâneur*, or he stands in the centre, to empathise with the barmaid. Crucially, he cannot take up a position which resolves the dilemma. In fact, neither position gives him a stable relationship to the space of the painting, because wherever he stands, the painting makes no coherent sense: from any position, the relationships among people, objects, and their reflections remain wrong.

One caricaturist felt the need to impose a comfortable solution on the picture (FIG. 34). The caption to the illustration reads: "A vendor of consolation at the Folies-Bergère. (Her back is reflected in a mirror; but, undoubtedly as a result of the painter being distracted, a gentleman with whom she is talking and whose image we see in the mirror, does not exist in the painting. We believe we ought to make up for this omission)." Notwithstanding such sentiments, Manet's painting simply does not allow the spectator to know where to stand.

Memory and Experience

Behind the resolute lack of resolution maintained by the painting may lie a number of motives, most importantly that Manet wanted to diagnose a crisis without offering any simplistic solution. He wanted, in other words, to show that there is an unbridgable gap between an empty, public exper- ience and the more human, private experience that introspection can offer. Indeed, it is a feature of many of Manet's paintings of public scenes that they contain poor and dispossessed women, turned away from the world, and looking into themselves in the state that the French call *absence* (something like the state of daydreaming). The "philosophical" point is that what passes for experience in modern life is, in fact, anything but. Manet made the same point even more emphatically in *The Balcony* (1868–9, FIG. 17), where any efforts on the part of the spectator to penetrate the scene are frustrated by the railing, behind which an introspective Berthe Morisot shelters from the public world and the prying eyes of the *flâneur* – and by the paint that itself forms a barrier to our curiosity if we get too close.

Manet, Baudelaire, and the Artist as Flâneur

But Manet does not present this inward experience as a solution to the emptiness of social life under modernity. The retreat into the self is finally only a way of preserving human values in the modern world. It may seem that this is where Manet parts company from Baudelaire, as the poet had spoken in *The Painter of Modern Life* of the power of introspection and memory to restore something of its lost aura to lived experience. He even claimed that Guys's fevered technique was the product of a "resurrectionist, evocatory memory, a memory that says to everything: 'Lazarus, get up!',", and that in his work "things are reborn on paper, lifelike and more than lifelike." But Baudelaire also said that the reason Guys worked feverishly was that he was motivated by the fear of "letting the phantom [of memory] escape." In other words, although Manet and Baudelaire both treat the inward life of the mind (*absence* and memory) as a superior realm to the lived experience of modernity, it still does not have the power to restore to experience what is lost from it.

Similar ideas and attitudes run throughout Baudelaire's poems, and even his love poems, where the loved object is often present only as something lost, or remembered. Since, for Baudelaire, the impossibility of finding love stood metaphorically for the impossibility of finding meaningful experience in a world of isolated individuals, it would seem that both poet and painter shared a fatalistic attitude towards the ability of modern life to provide fulfilment. Something of this poignant fatalism is present in much of Manet's work, but is most palpable of all in the painting of *Berthe Morisot With a Fan* (1872, FIG. 35).

35. EDOUARD MANET
Berthe Morisot With a Fan,
1872. Oil on canvas, 26⅝ x
17¾" (60 x 45 cm). Musée
d'Orsay, Paris.

TWO

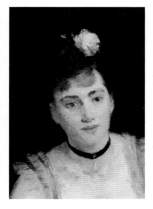

Impressionist Women and Women Impressionists

"I have perhaps too often treated woman as an animal."

<div align="right">

DEGAS

</div>

36. BERTHE MORISOT
The Cradle, 1872. Oil on canvas, 22 x 18" (56 x 46 cm). Musée d'Orsay, Paris.

Morisot was the only woman to show at the first Impressionist exhibition of 1874, and her work attracted at least one commentary which saw it as having distinctly feminine qualities: "nothing is more tender than the young mother ... who leans over the cradle where a rosy child falls asleep."

Manet's paintings of women are untypical in that they offer critiques of, or sometimes alternatives to, the ways of looking at women that paintings by men usually invite. In the majority of these, when women are the main subject of the painting, they are represented as objects of a specifically masculine way of looking. Most often, they appear as objects of the attention of men, and in doing so they answer to men's interests and masculine desires, fantasies, and anxieties.

Of course, there are paintings of women by men that do not conform to this type – Pissarro's paintings of female peasants relaxing, for example. But in many paintings by male artists, including the Impressionists, women plainly provide the male spectator with an object onto which he can project his sexual desire. Renoir's *The Umbrellas,* as we have seen, encourages the male spectator positively to revel in the illicit eroticism of the casual sexual encounter the young woman makes available to him as a *flâneur.* In other paintings, more complex attitudes are in play, where women provide occasion

for more subtle forms of masculine pleasure. In Renoir's *Place Clichy*, for example, the male spectator fixes his attention on the face of the woman passing by as if to hold on to her, or prevent her slipping away. It is possible, on this level, to see in the painting an invitation to the spectator to indulge in a fantasy that subjugates the woman to his desire.

Sometimes a whole range of attitudes comes together in the same painting. Renoir's *La Loge (The Theatre Box,* 1874, FIG. 37) appears to invite simple erotic fantasy from the male spectator, but when interrogated more closely, it becomes clear that it does so only by allaying his anxieties about his right to do so. First of all, it invites the spectator in the picture to enjoy looking at the woman from the physical and psychological point of view of a *flâneur* who is stationed in a box opposite. Her beautiful face, elaborate make-up, and sumptuous *décolletage* all appear to provide a relatively simple, mildly erotic gratification. But a little further attention reveals how the painting goes to some lengths to encourage the spectator to look in this way, almost as if it betrays how he needs assurance about what he is asked to do. Essentially, the painting legitimises the spectator's mode of attention to the woman in the box by contrasting this with the attention that her companion is paying to the women in the upper galleries of the theatre. Since, in effect, this character is scanning the women on view, and very possibly the prostitutes who typically assembled in theatres, his actions seem lewd and deceitful – especially as they are carried on behind the back of his companion. Setting things up this way endorses the attention that the spectator in the picture pays the woman in the box: it is as if we are paying the woman the attention she deserves and which she does not get from her crude and callous companion.

This elaborate staging poses many questions, not the least of which is why Renoir bothers to legitimise the spectator's look. An answer can be had from a little further scrutiny: it must be the case that while the spectator can see the woman in the picture, she cannot see him, hence her slightly glazed expression. (Even if she possesses opera glasses, she seems unable to turn them on the spectator.) The spectator's way of looking (ours) is therefore one that involves a relationship of power over the women depicted. In other words, however respectable our male behaviour may be, it still involves taking advantage of our social prerogative as men who are permitted to look at women and remain in control while we do so, as recent feminist criticism has pointed out. Our attitude belongs to a

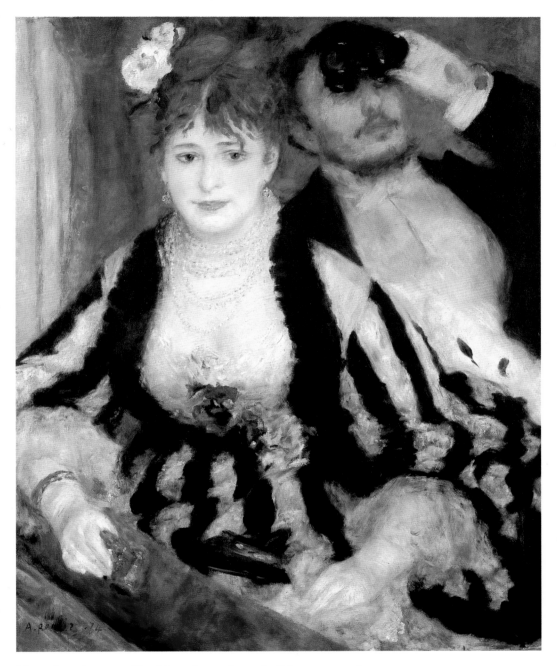

hierarchy of ways of looking that only male *flâneurs* can adopt and which all imply their power over women. Thus, while Renoir may try to arrange things so as to distinguish what we do from what the man in the picture does, we are both tarred by the same brush. Renoir may go to some lengths to excuse

37. AUGUSTE RENOIR
La Loge, 1874. Oil on canvas, 31^1/$_2$ x 25" (80 x 63.5 cm). Courtauld Institute Galleries, London.

the spectator from facing up to this uncomfortable realisation, but his strategy backfires because it tends to make the male spectator criticise the position Renoir asks him to adopt. It does so all the more powerfully if we ask ourselves whether the fact that we are looking at the woman in the box opposite means that we are also ignoring the companion sharing our own box.

Gender and Sexual Difference

Allowing for the oversimplification and single-mindedness of this interpretation of *La Loge,* it still seems fair to say that this type of work suggests that men look and women are to be looked at. (And, if we take the genesis of these paintings into account, they suggest that men paint, while women are subjects for paintings.)

On this analysis, what is in play in *La Loge* and other similar works, especially in their ways of structuring looking, is a kind of ideology. More specifically, they reveal the ideologies of gender – or beliefs about sexual difference – common at the time which constructed this difference on the basis of hard-and-fast oppositions. The rigidly defined categories of "masculinity" and "femininity" were presented as absolute, polar opposites, each with a set of recognisable characteristics. Although gender ideology claimed to map biological maleness and femaleness, we can now see that it did not accurately do so, even though there are problems in defining just what the conditions are. However, because they provided the only or most readily available concepts of what sexual difference was, such ideologies could be taken as true and even seem to represent the natural order of things. Put crudely, these beliefs provided such a rigid framework that to envisage or act upon sexual difference other than in the ways they stipulated was to fall into deviancy or to be "unnatural."

On the kind of view I have elaborated, the point about pictures like those considered so far is that they were complicit with ideology in two ways. First, like the great majority of representations, they were produced by men whose beliefs about sexual difference were already formed by ideologies of gender, in consequence of which they encoded very similar beliefs. Secondly, in the paintings they created, these male artists were themselves contributing further to the stock of ideological images and texts and thus reproduced the same ideologies that existed for the artist for the people who looked at their works.

This is not to say that paintings merely reproduce the ideologies of sexual difference which are bound up in their making. Ideologies of gender (like all ideologies) are never complete or fixed; their relationship to reality is always dynamic and subject to alteration by the groups that generate them and resistance from the groups they subjugate. Any dominant ideology will always be weakened by the power of alternative systems of belief. It seems fair, therefore, to suggest that the ideologies of gender which turn up in paintings are not to be analysed into simple oppositions. Such a mode of analysis tends to force history to remain static, as if ideology were fixed and hence able to fix the social world of belief and action. Since new ideas and ideologies are constantly being generated, this cannot be true. Factors outside ideology must to some extent alter it, in other words. Men and women are not merely victims of ideology; they may both escape the limitations imposed on their conceptions of themselves.

Language, similarly, does not produce a simple ideology of gender in which femininity is defined as the negative of masculinity. This is not to deny that language is often structured in terms of binary "differences" which are hierarchical, or give privilege to one term over another. Rather, it is just too simple

38. MARY CASSATT *Little Girl in a Blue Armchair*, 1878. Oil on canvas, 35 x 51" (89 x 130 cm). National Gallery of Art, Washington, DC.

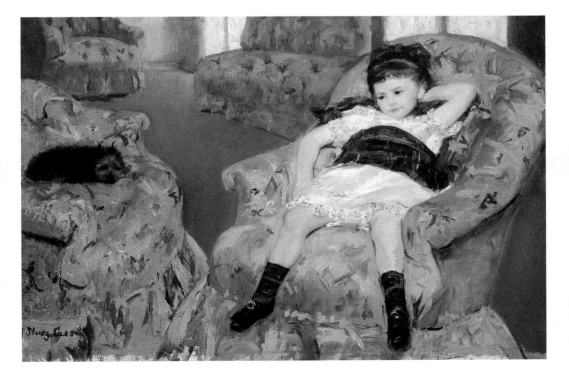

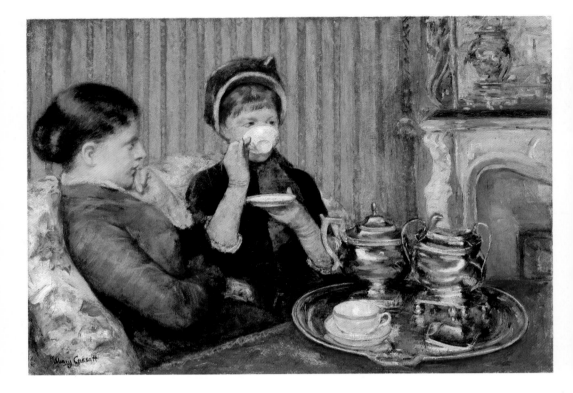

39. MARY CASSATT
Five O'Clock Tea, 1880.
Oil on canvas, 25½ x 36½"
(64.8 x 92.7 cm). Museum of
Fine Arts, Boston.

to say that this one feature of language accounts for the very complex and specific behaviours of men and women, in spite of their superficial conformity to patterns of "difference." It is true, for instance, that by and large nineteenth-century French ideologies held that the domestic environment was the natural habitat for respectable women, while they placed no such restrictions on men. Compare most *flâneur* paintings with works like Berthe Morisot's *The Cradle* (1872, FIG. 36), Mary Cassatt's *Little Girl in a Blue Armchair* (1878, FIG. 38) or *Five O'Clock Tea* (1880, FIG. 39) and this is clear enough. However, on its own, such a statement could not cover other influential ideas – scientific and religious, for instance – about how women's biological destiny as mothers or their place in God's design also affected social life.

It is also important to understand how ideologies were produced by real people so that existing social and economic relations could continue with some degree of efficiency or success. Ideologies that envisaged women's place as the domestic environment were inseparable from facts like the increase in wealth among the capitalist bourgeoisie, and the fact that the family (including the faithful wife) was increasingly being

defined as an ideal mechanism for men to pass on their wealth to legitimate offspring. To a large extent, ideologies of gender were class-specific in the sense that they were produced by and for a male bourgeoisie in response to its own particular situation. Nineteenth-century ideologies of gender had one view of what a respectable middle-class woman is, but a contradictory view of the "nature" of the working-class woman, often as someone lascivious and available for sex. Such views worked in favour of the men who generated them, and so the contradictions they involved often went unnoticed. When contradictions were noticed, they could be "explained" away by other ideologies, for example religious beliefs about the "evil" nature of women.

The Male Gaze

Another powerful tool for analysing what is at work in paintings like Renoir's *La Loge* and, more generally, in paintings featuring men looking at women has been provided by psychoanalytical theory. Many people find psychoanalysis difficult to accept because it challenges our sense of our own rationality. This may also be one reason why some scholars find its theoretical and factual premises shaky, and even fanciful. The majority of psychoanalytical accounts of how and why men look at women as they do – what is commonly referred to as the "male gaze" – are premised on Sigmund Freud's theory of castration anxiety and on the theories developed out of Freud's work by Jacques Lacan. Although these theories are complex, and perhaps contentious, they none the less possess considerable explanatory power.

The argument begins with the idea that the infant male experiences an uninhibited pleasure in his relationship with his mother's body until the stage when he realises that he is in competition with his father for it. In particular, the male infant fears that his father will deprive him of the penis that gives him so much pleasure – a thought confirmed in the infant imagination by the appearance of his mother's genitalia, which look to him like a castrated version of his own. What is more, since the father is much more powerful than the infant, and is possessed of a more developed penis, the infant defers to him by sacrificing the penis that has been his source of pleasure so far and founding his identity on a substitute or "phallus." Asserting identity through the phallus can take a number of forms, but its importance lies in its ability to have a symbolic

value as something that stands for "presence" or "power" – all that the male's physical otherness from the female first signified. This is why it is often argued that perhaps the most important form of identification with the phallus occurs when the male infant learns to signify his social and psychic "presence" through language. Hence some theorists consider language gives privilege to masculinity inherently, or is "phallo-centric."

This view has several important consequences for understanding the forces at work in the male gaze. One relatively simple development of the argument is that the residual fear of castration inclines the man to find ways of deferring recognition of the real nature of the female body, since the association between the female genitalia and castration makes the woman a constant reminder of the possible "trauma" he may suffer. On one level, this association can lead the male to fetishise the woman's body – endow its parts with compensatory phallic attributes in the effort to allay the anxiety it entails. In a related manner, men look at women fetishistically – as if they had a kind of presence and power – as a defence against castration. By this account, the male gaze yields an essentially substitute kind of sexual satisfaction which is bound up with anxiety. Also, the male's identification between the phallus and power can mean that the male gaze involves a symbolic playing out of the power relationship between male "presence" and female "absence." However, this leaves two problems. The first concerns paintings by women Impressionists: how are we to understand the ways of looking that inform them? Do they reproduce the ways of looking that masculine ideology accords as natural to men and women, or do they resist or even subvert these? The second centres on whether or not paintings by men ever escape the conditions of masculine ideologies.

Women's Spaces

Much feminist art history has provided compelling evidence that women painters, including the Impressionists, were restricted by the ideologies discussed here. Middle-class women painters like Morisot and Cassatt did not have as great a range of sites available to them as did their male colleagues because of dominant beliefs about the spheres appropriate and inappropriate to femininity. While it was considered normal for men to roam freely about the city and frequent its cafés, bars,

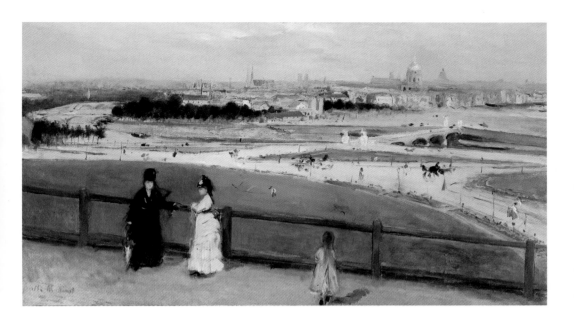

and brothels, decorum made such places out of bounds for respectable women and thus made it impossible for women artists to paint them at first hand. Instead, women Impressionists almost exclusively painted the spaces that ideology deemed were theirs: that is, the home, its extension in the domestic suburbs, and the few urban sites women were able to share with men – the theatre and the opera, for instance.

Paintings dealing with the public urban spaces of the sort encountered in Chapter One are almost entirely lacking from the production of the women Impressionists; indeed their works do deal very largely with intimate domestic scenes. Moreover, when paintings by the women Impressionists represent outdoor subjects, these are normally not pictures of the city, but of the cloistered, middle-class suburbs that served as a kind of extended domestic interior; they were largely the preserve of women, particularly of women raising children. Thus, while Morisot represents Paris in *View of Paris from the Trocadero* (1872, FIG. 40), this is a view of the city from outside, or from within the suburb. Similarly, her *Summer's Day* (1879, FIG. 41), shows a scene not far from her home. The poet Stéphane Mallarmé even teased Morisot about such subjects, calling them "meagre" in comparison to the grandeur of his beloved forest of Fontainebleau.

In the paintings there is also evidence of the women Impressionists' frustration with their confinement. For instance,

40. BERTHE MORISOT
View of Paris from the Trocadero, 1872. Oil on canvas, 18^1/$_8$ x 32^1/$_4$" (45.8 x 81.4 cm). Santa Barbara Museum of Art.

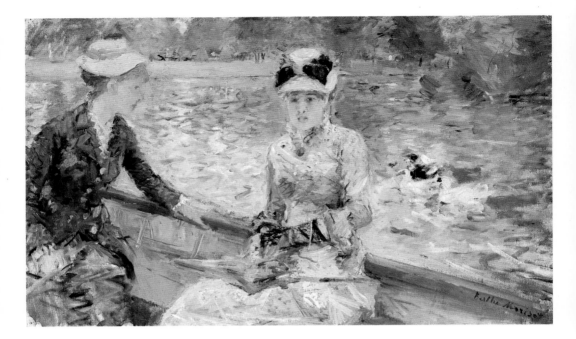

41. BERTHE MORISOT
Summer's Day, 1879. Oil on
canvas, 18 x 29³/₄" (45.7 x
75.2 cm). National Gallery,
London.

View of Paris from the Trocadero can be read as suggesting that
the women in it feel held in by the barrier that separates their
space clearly and abruptly from that of the metropolis. And in
works like *Summer's Day* and Cassatt's *Five O'Clock Tea*, the
same sense of confinement and frustration can be seen in the
way the background pushes forward and "cramps" the space of
the scene the women occupy. There is also much written
evidence of women painters' frustration. For instance, the
successful genre painter Marie Bashkirtseff was to complain
poignantly in her diary in 1882: "Ah! how women are to be
pitied; men at least are free. Absolute independence in
everyday life, liberty to come and go, to go out, to dine at an
inn or at home, to walk in the Bois [de Boulogne] or the café;
this liberty is half the battle in acquiring talent, and three parts
of everyday happiness."

In the case of the last two paintings however, whether they
express such feelings is open to dispute. Paintings of particular
sites do not necessarily express the emotions experienced by the
painter in those sites. Moreover, existing conventions also
determine the look of a painting, and make the issue less clear-
cut. Cassatt and Morisot used spatial conventions that other,
male members of their group had already developed in order to
reflect the cut-off but close-up encounters of modern life in
their paintings. In particular, they deployed the shallow

background that Manet and Degas pioneered from Japanese examples. These conventions can be seen in works like Manet's *Boating* (1874, FIG. 42) and Degas's *After the Bath, Woman Drying Herself* (c. 1885–90, FIG. 48). (Although both are mature or late works, similar effects can be found in Manet's and Degas's paintings of the 1860s). Given that both Morisot and Cassatt were directly influenced by Manet and Degas, it seems that the meaning of their own use of these spatial devices is to be connected with their desire to produce pictures that were as modern as those being produced by their male colleagues. However, this does not rule out the possibility that the shallow background convention had meanings for these women artists that it did not have for their male counterparts. It is just that, on its own, the existence of the shallow background among other spatial devices in paintings by women Impressionists is not enough to secure its interpretation as evidence of claustro-phobia, or as an expression of the resistance among women artists to the restrictive effects that masculine ideology had on their lives.

42. EDOUARD MANET *Boating*, 1874. Oil on canvas, 38¼ x 51¼" (97.2 x 130.2 cm). Metropolitan Museum of Art, New York.

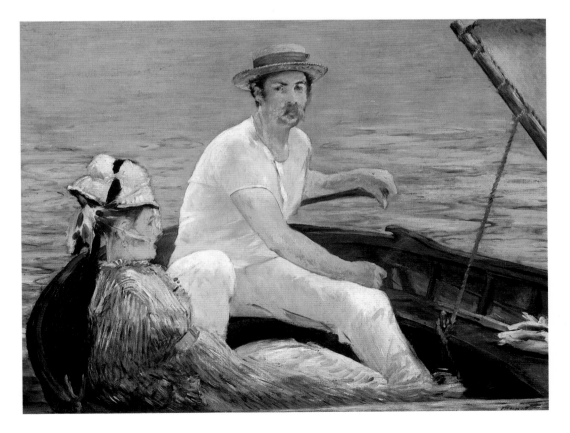

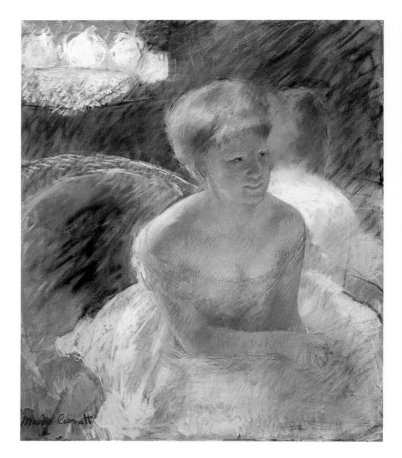

43. MARY CASSATT
At the Theatre, c. 1879.
Pastel on paper, 21³/₈ x
18¹/₈" (55.4 x 46.1 cm).
The Nelson-Atkins Museum
of Art, Kansas.

Several critics commented
on a version of this work,
particularly its unusual
composition, when it was
shown at the fourth
Impressionist exhibition
of 1879. Ernest d'Hervilly
explained how it showed
"a young redheaded
woman in a theatre box,
the back wall of which is a
mirror reflecting the
brilliantly lit theatre."

Women's Femininity

Conventions in use among male artists are also in use among
the women Impressionists in works that address women being
looked at by men. In paintings of this kind, the issue of their
equivalence to paintings by men is complex, as they tend to
exhibit marked signs of resistance to masculine ideologies as
well as similarities with paintings by men. The fact that these
paintings used masculine conventions for representing the male
gaze means that they are sometimes like and different from the
work of male artists, at the same time. Indeed, in many in-
stances, paintings by the women Impressionists modify or alter
masculine conventions, and are sometimes unresolved, unset-
tling and transgressive as a result – and all the more interesting.

One genre of painting where masculine conventions provide
the initial model is the painting of women on display. Works
like Mary Cassatt's *At the Theatre* (c. 1879, FIG. 43; also known

as *At the Theatre (Woman in a Loge)*) and *Woman in Black at the Opera* (1879, FIG. 44; also known as *At the Opera*) and Eva Gonzales's *A Box at the Théâtre des Italiens* (c. 1874, FIG. 45) all fall into this category, but each bears a different relationship to masculine prototypes.

44. MARY CASSATT
Woman in Black at the Opera, 1879. Oil on canvas, 31¹/₂ x 25¹/₂" (80 x 64.8 cm). Museum of Fine Arts, Boston.

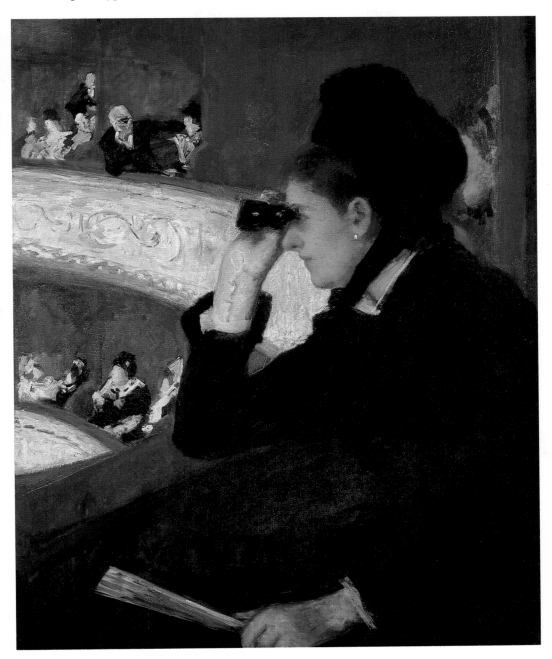

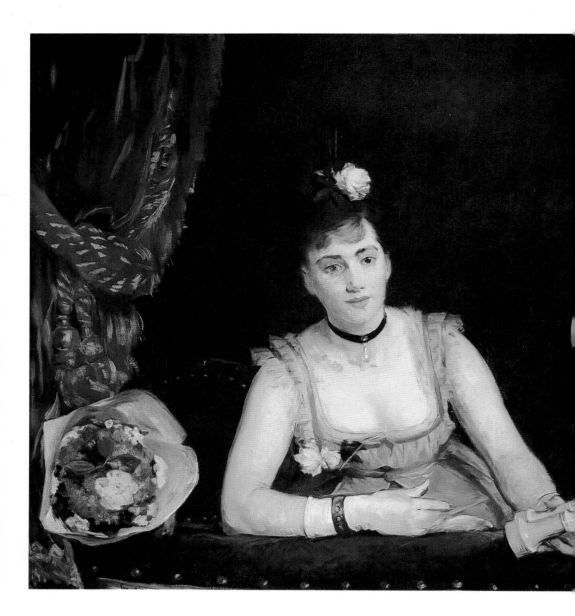

45. EVA GONZALES
*A Box at the Théâtre des
Italiens,* c. 1874. Oil on
canvas, 38¼ x 51½" (98 x
130 cm). Musée d'Orsay,
Paris.

On the face of it, Gonzales's painting exhibits little or no signs of being significantly different from a painting like Renoir's *La Loge*. It displays the woman in the box in such a way that it encourages her to be seen as an object of erotic curiosity by men, or of admiration and rivalry by women. The woman is also compared with the flowers next to her, arguably inviting a traditional enough, and therefore polite, form of sexualised gaze (memories of Manet's *Olympia* might easily have infused this). However, as has been suggested recently, the

fact that this painting was executed by a woman in such a competent and vigorous manner was enough to cause some critics anxiety. The painting's refusal to play down the power of the woman to compel male attention, and thus potentially manipulate it, may have triggered a common contemporary anxiety about the power of some women, and especially courtesans, to exploit men through their sexuality. All in all, therefore, the painting may well rely on masculine conventions, but since it was known to have been made by a woman, it could be seen to usurp masculine prerogatives, and became threatening as a consequence.

Cassatt's paintings are related in diverse ways to masculine conventions. For example, *At the Theatre* is unusual for endowing its sitter – the artist's sister Lydia – with dignity and animation. She holds herself confidently in a relaxed but upright pose and appears to be interested in something outside the frame. Here, then, Cassatt represents a woman who is not just a passive and unspecific object of the male gaze. She is certainly attractive enough, and sufficiently *decolletée*, for this sort of attention; but she also displays character and individuality. She is represented, in other words, rather as she might be seen by a woman who knows her on equal terms. The significance of this, in the context of contemporary conventions, is that the painting does not invite a typically male gaze, but in fact confounds this way of looking. In other words, it does not permit the spectator to look at the sitter as a *flâneur* might, or to take the anonymous pleasure in the woman that is characteristic of male voyeurism. On the contrary, it coheres only if the spectator in the picture assumes the psychology of a woman. Thus it inverts the usual operation whereby paintings by men ignore female spectators or force women to look at them as if they were men.

The conventional relationship between the spectator and the woman depicted in the painting is even more radically disrupted in Cassatt's *Woman in Black at the Opera*. If we take the usual approach and model our psychology on that of the man in the background of the painting looking through binoculars at the woman depicted, then we fail to encounter what we expect. Instead of a passive recipient of our gaze, as in Renoir's *La Loge,* we encounter a woman actively scanning the crowd who shows no signs of being flattered by our attention, or even of noticing it at all. Indeed, it is very difficult to say just who we (as the spectator in the picture) are in this work. It may even be unanswerable, since the painting cuts across the

convention that the spectator in the painting is male, or that if a woman, must spectate as one asked to take on a masculine psychology. One thing seems sure, though: that this woman is transgressive.

Part of the painting's singularity may perhaps be explained by the fact that the sitter is dressed in black, without extravagance, which implies she is a widow. She would then be a woman of a type who was not subject to the same chaperoning arrangements and restrictions as were married and unmarried women, but who enjoyed almost as much freedom as men. However, even if this is the case, it seems fair to say that what interests the artist is the way that the woman's special situation allows her to enjoy what are normally the privileges of masculinity.

The Private Self

Masculine attitudes not only affected how women felt and acted in public, they also conditioned women's more private experience, and that private experience was in many ways affected by what was expected of them in public. For instance, the idea that a woman's appearance should give men pleasure was inculcated into girls from an early age and affected how they saw themselves when alone. Such attitudes normally became internalised so that mature women came to think of themselves as "natural" objects for the male gaze. Paintings by the women Impressionists that address this kind of social training also offer ambiguous and suggestive critiques of conventional looking.

A painting that shows the process at work is Cassatt's *Study* or *Girl Arranging Her Hair* (1886, FIG. 46). We see an adolescent girl looking at herself with a view to the impression she will create in public. Implicitly she is imagining how she will appear to the men and women who will judge her fitness as an object for the gaze. On one level, then, it seems a conventional work: merely a picture of a girl undergoing the initiation rites of puberty in a male-dominated world. But there is also a certain awkwardness to the painting in the blend of self-consciousness and ingenuousness that animates the sitter, which betrays Cassatt's sympathy for the discomfort the girl feels on first learning this strange and unsettling rite. It shows a poignant moment in the sitter's development, when ideologies of womanhood are only just beginning to define and constrain her experience of her own body.

46. MARY CASSATT
Study or *Girl Arranging Her Hair,* 1886. Oil on canvas, 29¹/₂ x 24¹/₂" (75 x 62 cm).
National Gallery of Art, Washington, DC.

Reviewing the eighth Impressionist exhibition, the critic Octave Maus saw an
assurance in Cassatt's work which led him to comment: "No juggling of effects in this
robust painting betrays a feminine hesitation, no difficulties in the draftsmanship, nor
of eluded colour." This particular work, he said, showed "a definite personality."

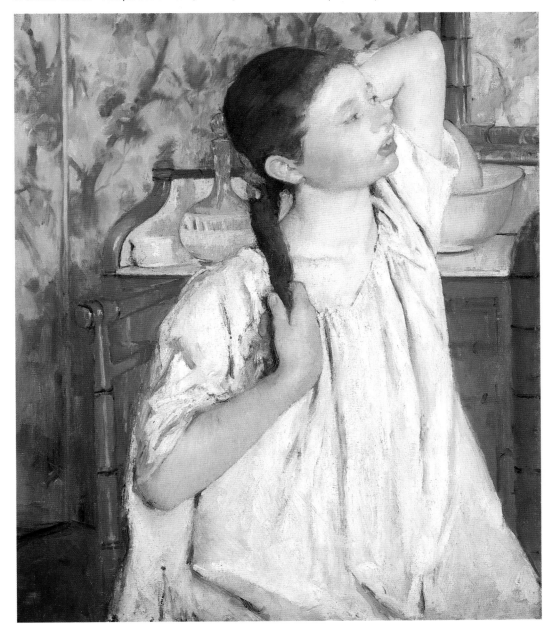

47. BERTHE MORISOT
*Young Woman Drying
Herself,* 1886-7. Pastel on
paper, 16¹/₂ x 16¹/₈" (42 x 41
cm). Galerie Hopkins
Thomas, Paris.

In contrast, Morisot's pastel of a similar theme *Young Woman Drying Herself* (1886–7, FIG. 47; also dated 1887) shows far less ambivalence. Perhaps the greater maturity of the model accounts for this: being used to looking at herself in a way that men demand means she no longer experiences any conflict between her experience of herself as a socialised and sexualised being and as a private self. Still, it is significant that Cassatt chose a moment that Morisot did not, and that must have had a particular poignancy for a woman of her demonstrably critical cast of mind. Being American, it is likely that she could view French conceptions of gender with a more detached eye than Morisot.

There is yet another dimension to Cassatt's work, which is her rivalry with Degas. Cassatt's painting generically resembles the many pictures of women grooming, or otherwise attending

to themselves that Degas produced in the late 1870s and early 1880s – in its subject, and in the abrupt viewpoint which captures the sitter in an unconventionally and seemingly "natural" pose. Thus, *Girl Arranging Her Hair* can be seen as an attempt to prove Degas wrong in his assertion that women were not able to appreciate style and thus be true artists (even though he was the most assiduous supporter of Cassatt's right to exhibit with the Impressionists). Although Cassatt's variant of Degas's painting on the theme might seem an uncomfortable imitation of masculine stereotypes, the atmosphere in her work does not sit easily with the attitudes displayed in most similar paintings by men, and by Degas (which is perhaps one reason why Degas found the painting intriguing enough to buy it). Moreover, the issue of whether or not Degas's works are misogynist, and simply exhibit masculine stereotypes needs considerable un-ravelling.

Degas and Women

Faced with Degas's own statements about women, particularly those that he painted, many art historians have concluded that he was a misogynist whose works do little more than embody that outlook. But such a judgement denies not only that Degas could be reflexive about his attitudes towards women, it also disallows him precisely a capacity that feminism has accorded women artists such as Cassatt.

Degas's works like *After the Bath, Woman Drying Herself* (FIG. 48) may seem to express the patronising and sexist attitude recalled by the English novelist and critic George Moore of Degas when he said that his nudes represented "a human creature preoccupied with herself – a cat who licks herself," adding: "these women of mine are honest, simple folk, un-concerned by any other interests than those involved in their physical condition." The woman in the pastel does no more than experience her own body, since Degas has eliminated any psychology from the figure, or any indication that she thinks: the woman does appear almost as an animal. To this extent, then, it replicates the oppositions to be found in contemporary ideology where masculinity was for the most part identified with culture and femininity with nature. What is more, Degas's pastels of women engaged in such activities have precedents in the work of Japanese artists depicting animals. In 1886, for example, at the last Impressionist exhibition, Degas exhibited *Suite of Female Nudes Bathing, Washing, Drying, Wiping*

Edgar Degas as a young man.

48. EDGAR DEGAS
After the Bath, Woman Drying Herself, c.1885-90. Pastel on several pieces of paper mounted on cardboard, 40⁷/₈ x 38³/₄" (104 x 98.5 cm). National Gallery, London.

Themselves, Combing Their Hair or Having it Combed, whose obvious precedent is to be found among Hokusai's studies of cats washing and grooming themselves.

Another feature of works like *Woman Drying Herself* is their "keyhole" viewpoint, or what a contemporary critic described as a kind of perspective which looked as if Degas "wanted to represent the woman who doesn't know she is being looked at, as one would see her hidden behind a curtain or through a keyhole." Degas himself endorsed this interpretation to Moore, so it looks as though commentators may be justified in arguing

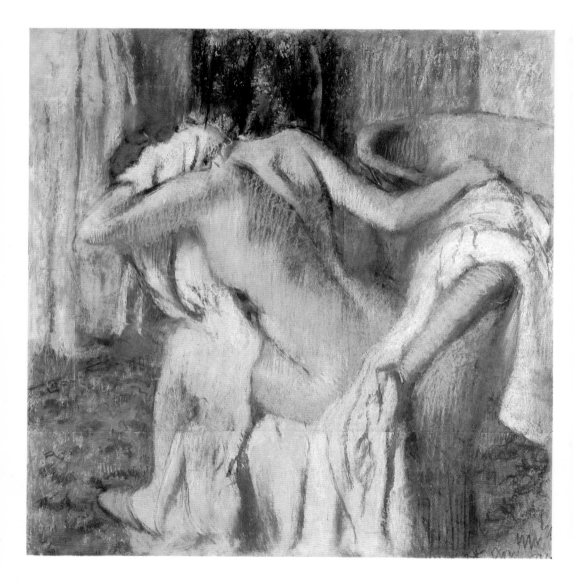

that such works attempt to impose an empowered masculine viewpoint on a disempowered female subject. Men control the situation, in other words, because only men exercise the gaze. Works of this kind would thus answer to a kind of castration anxiety wherein the gaze becomes an extreme form of symbolic (phallic) self-assertion. That Degas was a social marginal, a dispossessed aristocrat, and by some accounts not a normal 'practising' heterosexual (possibly a hair fetishist, on one view), can all be invoked to confirm this sort of reading of his work, and to support such *ad hominem* innuendo.

However, to see Degas's work in these terms is to exclude other explanations which have validity also. Degas's "keyhole" viewpoint can also be explained historically, as the result of his ambition to make a modern nude and as his response to the critic Joris-Karl Huysmans's call in *Modern Art* (1883) for a nude that would be credible, unlike the nymphs and Venuses of the Salon. Degas is doing what Huysmans suggested: he represents the nude "in those moments when the nude is possible."

The idea that Degas was a misogynist was partly invented by critics, notoriously by the self-professed misogynist Huysmans, who described Degas as "a cruel and subtle analyst" of women, discerning the qualities of "attentive cruelty" and "patient hatred" in the work Degas exhibited at the last Impressionist exhibition. But such misogynist interpretations of Degas's work collapse his work into his words, as if the artist were merely replicating in his paintings and pastels the attitudes he expressed verbally. A case can be made that drawing and painting involved a kind of learning for Degas, in that his works sometimes came to satisfy him only when they elicited from him and expressed attitudes different from those his words expressed. So Degas could eventually state (in one of his aphorisms: "I have perhaps too often treated woman as an animal." (Quoted in Bernard Champignuelle, *Degas, Dessin*, Paris, 1952.)

During his close, continual and varied observation of women, Degas learnt much about their experience of themselves. Alongside what must be seen as the voyeuristic and patriarchal attitudes in his works, they also reveal that he saw women in more complex and interesting ways. What is remarkable about the pastel *Woman Drying Herself* is that, while it does regard and represent the woman as an object of the gaze, it also suggests that the artist is interested in imagining and conveying the woman's experience of her own body, particularly the sensations of her skin being surrounded

by a variety of textures such as air, towel, the velvet of her chair, and the satin of her slippers. But what is most intriguing about this work is that it does more than represent these feelings: it expresses them as well. For the surface of a painting can function metaphorically. While the artist is working the surface will develop some particularly salient quality, which the artist can then make fully visible to express the salient property of what is being represented. In Degas's *Woman Drying Herself* the surface of the painting, the skein of marks which contains the image of the body, can be seen as a metaphor for the skin of the woman represented. Its action of containing the image can therefore be seen as metaphorically enacting the way the woman's skin contains her body, and its feelings – a metaphorical use of the surface not new to the Impressionists, of course.

Viewed this way, the picture contains the means for allowing Degas to learn, in imagination at least, something of what it might be like to occupy the body of a woman. Put simply, the artist responds unconsciously to the kinds of coherence and authority the picture assumes as it is painted. Degas was affected by the picture, in other words, as much as it was affected by him. And he was a great experimenter, trying out new procedures and gauging the effects they produced: he was the most radical innovator among the Impressionists in his use of mixed media and print. Most notably, his late sculptures almost ignore existing conventions and stereotypes. In a work like *Dancer Looking at the Sole of Her Right Foot* (c. 1890, FIG. 49), Degas did not use the ready-made armatures (or "skeletons") that usually determined the pose of a figure; instead, he used collapsible wire to build his figures, and sometimes paintbrush handles tied together. Nor did he use conventional methods of modelling: for example, he sometimes used cork as an infill, and worked in Plasticine instead of clay. It is easy to forget how empirical Degas's search for effects in his sculptures was, as they have nearly all come down to us in bronze. But Degas himself never cast his sculptures in bronze – all the casts were made posthumously. Indeed, he explicitly envisaged these works as experiments: "My sculptures will never convey that feeling of completeness that is the *nec plus ultra* for statue-makers; because after all, nobody will see these experiments.... Before I die, all of it will disintegrate of its own accord." Thus, to see these works as anything but experiments is to miss their improvisatory and expressive character. To put it more strongly: Degas set up his procedures in such a way that they

49. EDGAR DEGAS
Dancer Looking at the Sole of Her Right Foot, c.1890. Bronze, height 19¹/₈" (48.6 cm). Metropolitan Museum of Art, New York.

Degas made a wax model which was the original for this bronze. One of Degas's models, known as Pauline, remembers that the artist would run his hand along the model's body in the effort to transfer its "feel" to the wax as he worked on it.

demanded that he respond unconsciously to the possibilities they provided.

It would seem therefore that Degas produced works whose meaning and effects were to some extent *sui generis*, and which ran counter to dominant ideological conceptions of femininity in virtue of this. In this regard, his work is not that unlike Cassatt's *Woman in Black at the Opera* for instance. Or, insofar as both artists allowed their work to determine its own progress, this enabled it to cut across the ideological boundaries that standard conventions for representing women normally imposed.

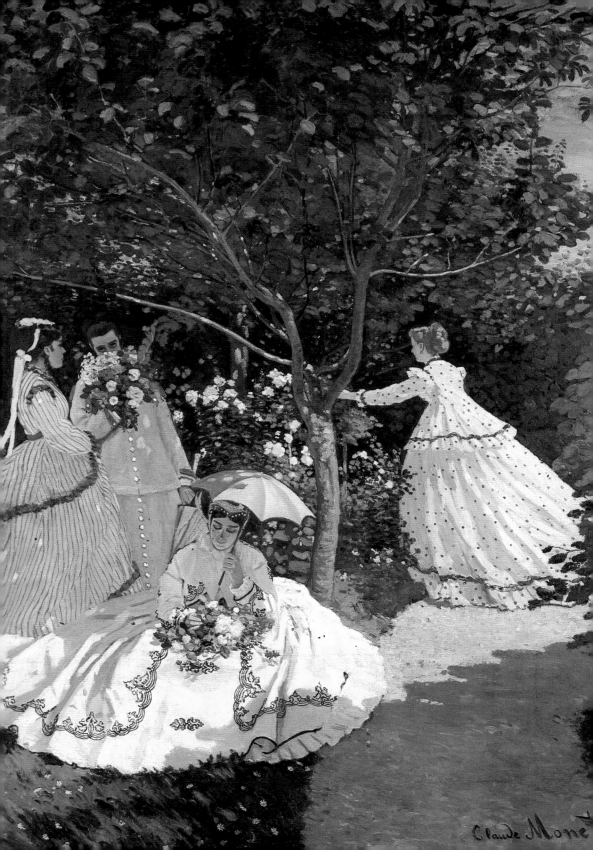

THREE

Monet and the Moment of Art

"I'm more than ever disgusted at things that come easily, at first attempt." MONET

50. CLAUDE MONET
Women in the Garden,
1866-7. Oil on canvas,
7'6¾" x 6' 9⅞" (255 x 205
cm). Musée d'Orsay, Paris.

This painting reflects
Monet's rejection of the
training he, Renoir, Bazille,
and Sisley had in the studio
of the Academic painter
Charles Gleyre. One
evening, around 1863,
Monet told them: "Let's get
out of here. The place is
unhealthy. There is an
absolute lack of sincerity."

On the face of it, Monet's art developed simply, moving away from traditional subject matter and narrative to become increasingly and exclusively concerned with recording the artist's impressions and sensations. Monet used the word impressions in the 1860s to describe what he wanted to paint; and as late as June 1912, he told a critic that his art was about its ability to "fix my sensations." Indeed, his career is remarkable for the single-mindedness with which he pursued his central aim – the rendering of what by 1890 he called "instantaneity". However, this is too simple a view. It hides the fact that Monet was a careful and devoted picture-maker who often reworked his paintings in the studio to give them internal unity, or to bring unity to the groups of paintings, or series, which he made in later life. It also fails to bring out how Monet's paintings were embedded in a whole set of beliefs and practices being formulated and fought for by the new middle class or bourgeoisie which emerged as a major force in France in the mid-nineteenth century. For all the rhetoric of the latterday bohemian circles in which he moved in the 1860s and 1870s, Monet was a bourgeois through and through. Many of his paintings not only expressed but also helped consolidate the identity of that class and its ideologies of leisure, conspicuous consumption, spontaneity, and individualism. It may even be that the same origins account in part for Monet's increasing abandonment of subject matter in favour of his own individual sensation.

To highlight or explain the reasons behind the peculiar single-mindedness of Monet's art, and to learn the significance of its avoidance of subjects and values with which many artists of the time were concerned, we need to explore further than Monet's stated intentions. One way to start understanding why it was significant for Monet and others of his generation to paint the moments of their experience – as opposed to narratives or allegories – is to compare Monet's *Women in the Garden* (1866–7, FIG. 50) with a painting by an Academic, Gleyre's *Minerva and the Graces* (1866, FIG. 51). For Monet – and Pissarro, Renoir, and Sisley – worked in Gleyre's studio between 1862 and 1864, so this comparison gives some idea of what these young artists were reacting against, and why.

In many respects, Gleyre's painting is typical of the classicism which the Académie still regarded as the most elevated style in art, even though the Salon accepted a broad range of subjects and styles in the 1860s as part of Napoleon III's "liberal" arts policy. A painting like this meant a number of things, but essentially it was a contrived, and largely unconvincing, attempt to show how the ideas which served as the prototypes for humankind were the fount of virtue. These ideas are shown embodied in the goddess Minerva (representing wisdom) and her attendants the Graces (representing loveliness). The work's emphasis on the smooth, idealised forms of the female body was meant to show something of the divinely ordained forms of beauty that mortal bodies only imperfectly possess. It was also meant to lead the mind to the contemplation of goodness, since in Neoplatonic thought, beauty was considered to be the "radiance of goodness," both having been invented by God. Gleyre's technique was meant to be equally "perfect," or at least it was meant to be sufficiently transparent not to distract the spectator's attention away from what it depicted.

Monet's painting is in almost complete contrast to Gleyre's. It represents ordinary, modern people, not ideal types – Monet often used family and friends as his models. It represents them in a everyday and up-to-date setting, not in a mythological and remote past. It makes no attempt to hide its technique, but exhibits openly the means with which it is made. Most interestingly of all, it seems that Monet made every attempt he could to eliminate narrative content from the painting. In particular, the artist has masked the incident in the centre of the painting where the young woman is plucking a rose. In another kind of painting, such an action could be loaded with

narrative or symbolic significance, but here it is hidden by the branch of a tree. In much the same way, Monet has half hidden the face of his wife-to-be, Camille, behind the bunch of flowers she carries. The cumulative force of these peculiarities is considerable: the painting prevents us as spectators "reading" the picture as an incident in a story with a past and a future, and instead makes us experience the painting as an isolated moment of time. Monet's painting was also providing an alternative to the emphasis in Gleyre on eternal esthetic and

51. CHARLES GLEYRE
Minerva and the Graces,
1866. Oil on canvas, 7'5" x
55" (226 x 139 cm). Musée
des Beaux-Arts, Lausanne.

Monet and the Moment of Art

52. CLAUDE MONET
Camille or *Camille in a
Green Dress,* 1866. Oil on
canvas, 7'7" x 59½" (231 x
151 cm). Kunsthalle,
Bremen.

53. CAROLUS-DURAN
The Woman with the Glove,
1869. Oil on canvas, 7'5" x
64½" (228 x 164 cm).
Musée d'Orsay, Paris.

moral values. In their place, Monet put the ephemeral, impromptu, spontaneous sociability that the bourgeoisie of the 1860s held as its ideal.

The contrast between these two paintings in effect represents the contrast between the ideologies of the conservative and the *laissez-faire* bourgeoisie. It is not that Monet's painting is politically radical; rather, it expresses beliefs characteristic of a new middle class rising to power and prominence, and keen to establish and celebrate its own identity and worth. None the less, to esthetic and moral conservatives, paintings like this could look dangerous in their disregard for the canon of classicism and the values it enshrined. In other words, Monet's insistence upon the momentary and ephemeral could be taken as a powerful and aggressive denial of their own values to people used to an art dealing in the "eternal." It could even look "revolutionary" in a sense that was not simply to be applied to the challenge his work presented to art and its institutions.

The technical radicalism of Monet's work, therefore, had meanings for some that it did not have for the artist, which helps explain the hostility and insensitivity that critics showed towards his work. Monet's way of seeing, and his way of representing this, must have struck many of his contemporaries as bizarre. For instance, in *Women in the Garden* there are few if any of the concessions to convention that mark the painting *Camille* or *Camille in a Green Dress* (1866, FIG. 52), exhibited with great success at the Salon of 1866. Duret recalls that this work caused a "sensation" and, to his great indignation, Manet was mistakenly congratulated on his triumph with the painting, people having mistaken the signature as his. Duret's further remark that *Camille* suggested Monet would enjoy "something like the career pursued by M. Carolus Duran" helps isolate just why this painting was so successful. Comparison with Carolus-Duran's *The Woman with the Glove* (1869, FIG. 53), for example, shows that Monet did indeed employ much of the vocabulary of Salon Realism. For instance, he used a contrived pose (based on fashion plates) that showed off his sitter's dress to best advantage. He also employed a contrived light source that gave a dramatic highlight to the face and a smooth modelling to the figure. And he even used a contrasting background to give his sitter salience.

In *Women in the Garden*, however, Monet does none of this. For instance, in place of the directional and relatively gentle light of the studio, Monet represents the harsh sunlight of

summer in the Île-de-France. With no gentle gradations of light and shade, he represents the sharp contrasts between light and dark that bright sunlight creates. He even captures the way that very bright sunlight imparts a uniform tone to the objects it lights directly: the skirt of the central figure is a *tour de force* in this technique. Monet also renders certain effects which painters had known about for centuries but which they rarely painted. For example, he shows how green reflections from the trees modify the flesh colour of the face of the woman seated beneath them. Most notoriously, perhaps, Monet also renders shadows blue – as they sometimes appear when daylight colours them.

Monet's interest in these effects grew out of his habit of painting in the open air. For *Women in the Garden* he even dug a trench in his lawn so that he could paint the upper parts of this tall canvas outside. We are told that Gustave Courbet visited Monet while he was at work on the painting and remarked on the silliness of his practice. In other words, even though it was to some extent contrived, by comparison with

54. CLAUDE MONET
The Bathing Place at La Grenouillère, 1869. Oil on canvas, 28¼ x 36¼" (73 x 92 cm). National Gallery, London.

most contemporary works the painting was an uncompromising record of a lived experience.

By Monet's own account to Bazille in a letter of July 1864, his aim was to base his art on "observation and reflection" and work that he did "quite alone." He expanded a little in December 1868 when he wrote to his friend from Etretat:

> Don't you feel that one does best alone with nature? I'm sure of this. Moreover I've always thought thus, and what I've finished in such conditions has always been the best. One is too concerned with what one sees and hears in Paris... and what I do here will at least have the merit of not resembling anyone... because it will simply be the expression of what I will have personally felt [*ressentir*].... The more I continue the more I see that one never dares to express frankly what one experiences. It's strange.

Monet seems to have wanted to say in these letters that his overriding ambition was to shape his own art so that it would express his originality, his sensations, and not the personalities of other artists. What seems to underlie such statements is the same ethos Monet represents in his paintings: that people should be free to determine themselves as much as possible, without outside interference or influence. To this extent, Monet's work of the 1860s and 70s represents and expresses the belief in individualism and self-determination that was fundamental to the ideology of the new bourgeoisie to which he belonged. But on a deeper level, Monet's art is more than a trivial celebration of the individual and spontaneity: his attachment to the ephemeral moment as the source of value in life implicitly involves a rejection of the idea that value is to be sought in some higher or metaphysical dimension – not just the Ideal, but also the afterlife. Monet's insistence on the present and the contingent as the site of human fulfilment is not without its courage.

Such a belief in bourgeois values does seem to have blinded Monet to the economic and social conditions of leisure. Nowhere is this more apparent than in the paintings he made alongside Renoir in 1869 of La Grenouillère, the bathing place on the Seine near Chatou. Altogether, Monet made four paintings of the site, including *The Bathing Place at La Grenouillère* (1869, FIG. 54) and *La Grenouillère* (1869, FIG. 55). In these, there is little or no indication that the mixture of classes at such places was largely superficial and that the divisions of

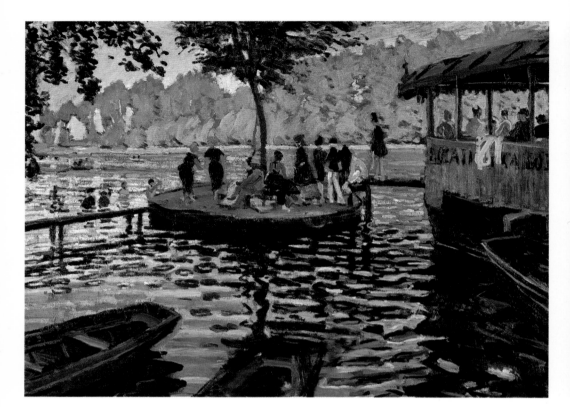

55. CLAUDE MONET
La Grenouillère, 1869.
Oil on canvas, 29¹/₂ x 39¹/₄"
(74.6 x 99.7 cm).
Metropolitan Museum of Art,
New York.

the city were at best only temporarily suspended during leisure hours. Nor is there any explicit reference to how the mixing of the sexes at La Grenouillère was often venal or to the fact that bathing provided a plausible way for prostitutes to ply their trade. Monet thus offers no indication at all of the causes in urban life underlying such social divisions and repressive practices, despite the fact that these would have been present in the subject of the painting.

In fact, Monet's Grenouillère works are remarkable for the way they make its somewhat seedy environment appear as a glamorous playground. The effectiveness of these paintings may lie partly in their match between what is represented and the viewpoint the spectator is given. Within the scenes depicted, people seem to associate freely, and casual encounters and spontaneous behaviour are the order of the day. Correspondingly, they are framed in such a way as to imply that the spectator has just stumbled across the scene, as if roaming freely. In other words, the lack in either painting, especially the first, of any firm compositional focus or hierarchical structure encourages the spectator to situate himself as someone like the

people in the scene, a *flâneur* ready to participate in the random pleasures it offers.

It may also be that the virtuoso technique Monet developed for such scenes was itself designed to express the artist's belief in the virtue of spontaneous experience, and even his pride in his ability to master an all-too-fleeting moment. Arguably, Monet's seemingly rapid brushwork – which looks like the artist struggling to note down the passing moment – displays his enjoyment of his ability to take it in, organise it, and control it despite its ephemerality. Monet does not freeze a scene; rather, he presents it in a state of flux – but one of which he is in control.

Making a Sensation

In a letter Monet wrote Bazille in September 1869, towards the end of his campaign at La Grenouillère, he told his friend of his hopes and frustrations. Having run out of money, Monet wrote:

> Here I've come to a stop, for lack of paints.... It's only I who have done nothing this year. This makes me angry with everyone... if I could work everything would go all right.... Now the winter is coming; a bad season for the unfortunate. Then the Salon will come. Alas! I won't figure there again, since I will have done nothing. I do indeed have a dream, a painting, the bathing place at La Grenouillère, for which I've done some bad sketches, but it remains a dream.

Monet had hoped to turn his small paintings into a large picture that might go down well at the Salon. But no such painting ever emerged. Nevertheless, Monet's letter does imply that his working methods were a good deal more synthetic than legend has it, and that he was happy to make paintings out of studies. Indeed, even *The Bathing Place at La Grenouillère* looks as though it might have been made up from sketches that Monet made separately, or at least that it was made with their aid. The painting splits easily into two: one section above and one section below the walkway, the lower section corresponding closely to an earlier study of boats. The peculiar perspective of the painting, wherein things are seen from above in the foreground but frontally in the background, can be explained as the result of Monet "stitching" together separate

views and sketches. That he did this can be deduced from that fact that the different areas of a scene – land, water, and sky – do not change uniformly with the weather. For instance, on different days at the same time, the sky might be the same, while the water might be calm instead of choppy. Indeed, several of Monet's early marines exhibit signs of being combined from separate observations, for the areas of water, land, and sky in them are sometimes separated by very thin but definite gaps.

One commentator has argued that the reason Monet never made the large painting he planned was because any such work would have had to combine the views that survive, and this would have involved making a painting with deep space, something like a panorama. It is most unlikely that Monet would have chosen this solution as his paintings of this date reveal his determination to find a way of representing his sensations as patches of colour; to have produced a work that receded sharply into deep space would have made it impossible for the spectator to see the world in Monet's painting in this way. Whatever did prevent Monet from making his large

56. CLAUDE MONET
Autumn Effect at Argenteuil,
1873. Oil on canvas, 22 x
29¹/₂" (55 x 74.5 cm).
Courtauld Institute Galleries,
London.

picture it is inescapable that he preferred to work up the paintings he made on the spot at some stage after their original completion as "bad sketches." Close examination of the paintings themselves shows that Monet added many touches to the La Grenouillère paintings, almost certainly some time after they were initially completed. The two paintings unite when seen side by side – which suggests that Monet did indeed view them as studies for a single larger work.

Monet employed the same principle of colour organisation in his *La Grenouillère* canvases as he did in later life. In 1887, for instance, Geffroy recalled: "Rapidly he [Monet] covers his canvas with the dominant values, studies their gradations, contrasts them, harmonises them." This suggests it was already his ambition to create patchy surfaces in which colours none the less cohered well, and which could therefore succeed in conveying his sensations of colour and light without falling into simple illusionism. As Monet told Bazille in 1864: "It's decidedly frightfully difficult to make a thing complete in all its relationships"; but in *The Bathing Place at La Grenouillère* he achieved this and thus established the technical basis of his later work.

The Series

In 1871 Monet moved to the prosperous suburb of Argenteuil, some eleven kilometres by rail outside Paris. Many of the paintings he produced there during the following decade or more are concerned with the same kind of leisure subjects that he produced in the 1860s. The difference is that his work shifted away from an anecdotal and narrative treatment and placed more emphasis on the atmospheric effects of a scene. As the decade progressed, Monet moved away from subject paintings towards treating the landscape, and the impression it made on him, as the unique subject matter of the painting.

A notable work in this evolution is *Autumn Effect at Argenteuil* (1873, FIG. 56). This shows not only the problems Monet faced with painting his adopted landscape, but also the radical solutions he imposed on it. Monet's new home range was not a traditional site for painting. Crucially, Argenteuil was a very Parisian suburb, half densely populated town, half "nature" for the Sunday tripper. It had been substantially industrialised by the time Monet painted it, so he had to find a way of dealing with the intrusion of factories and the like into the landscape when there were few fine art conventions to

57. CLAUDE MONET
The Railway Bridge, Argenteuil, 1874. Oil on canvas, 21⁵/₈ x 28³/₈" (55 x 72 cm). Musée d'Orsay, Paris.

guide him. Monet could not but imply some judgment in the compositional choices he made – in deciding where he set the framing edge of a landscape, or what he included in the painting and excluded from it. Any decisions of this kind could be interpreted as value judgments about the beauty, ugliness, and social desirability of what the painting represented. In other words, a painting of the sort Monet wanted to make would read as if the artist's point of view were part of its content – not just in the sense of his physical position within the landscape, but in the broad sense implying his beliefs, values, and doubts.

In *Autumn Effect at Argenteuil,* Monet chose to underplay the existence of industrialisation (paintings of his that deal with the negative effects of industrialisation are very rare). He painted the scene from a quiet side arm of the Seine known as the *petit bras.* Framed by trees, it gives the impression of seclusion and tranquillity; and in the distance, the sight of traditional secular and religious buildings in coexistence implies a landscape where history is settled and its legacy is benign. To achieve this, Monet had to chose his viewpoint carefully, to exclude from the painting the many factory chimneys that populated the distant bank. It has been argued, however, that the strip of blue in the distant water betrays the encroachment of industry into Argenteuil, in that it represents a slick of indigo dye which has leaked out of a factory upstream. It may, however, simply represent an area where the water is in shadow as a result of the bank behind it blocking out the sun.

58. CLAUDE MONET. *The Railway Bridge, Argenteuil.* 1874. Oil on canvas, 21½ x 29" (54.5 x 73.5 cm). Philadelphia Museum of Art.

The cumulative effect of Monet's choices in the painting is to underplay topographical and social details in order to emphasise that the painting is a record of the artist's impression of a particular moment. Here Monet pays quite specific attention to the atmospherics, not just of the season, but of the moment. In particular, he conjures a sense of how the wind stirs the tree on the right by scoring through the paint with the handle of his brush. The feeling of the moment is highlighted through doubling up the effect of sunlight on the trees and giving equal emphasis to the reflections they cast on the agitated water. As a result, the play of contrasts between the warm autumnal tones of the reflections and the cool water mirrors the play between the warm and cool of the trees against the sky, and even vies with it for the spectator's attention. This is already a world where experience is as important as the things that give rise to it, where the materiality of the scene is its least important feature.

As the 1870s progressed, Monet started to emphasise his perceived impression of a scene at the expense of description of the scene *per se,* in that he began painting pairs of pictures of an identical or similar motif which recorded the different impressions it produced on him at different times. He knew of Jongkind's efforts in this direction; but it would seem that even his closely matched pairs of paintings, like the two versions of the railway bridge at Argenteuil (1874, FIGS. 57 and 58), were not yet conceived of as part of any systematic attempt to render the different impressions produced by a series of moments.

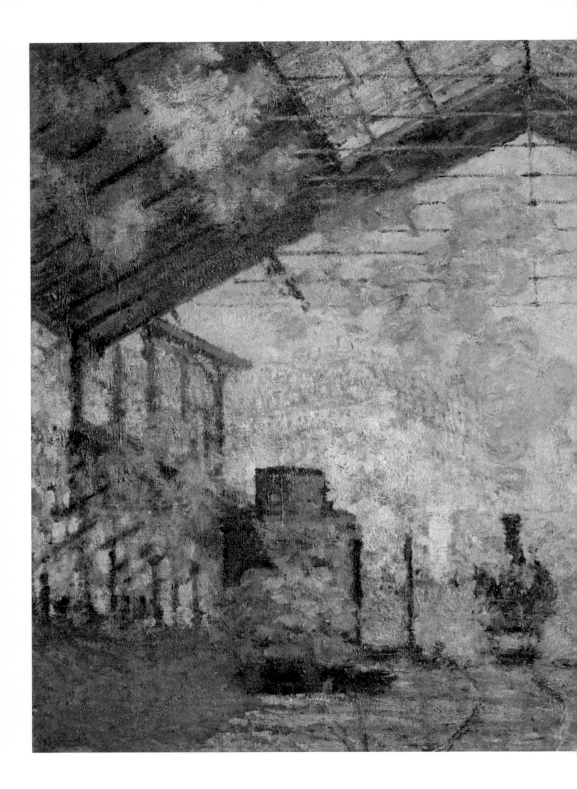

Monet and the Moment of Art

59. CLAUDE MONET
*Interior of Saint-Lazare
Station,* 1877. Oil on
canvas, 29³/₄ x 42"
(75.5 x 104 cm). Musée
d'Orsay, Paris.

Monet was able to paint the
rich effects of smoke and
steam at Saint-Lazare only
because he gave the
impression to the station
master that he was an
important Salon painter.
Accordingly, the station
master had the trains get up
steam especially for his
"distinguished" visitor.

Monet and the Moment of Art

60. CLAUDE MONET
Sunset, Etretat, 1883. Oil on canvas, $21^{5}/_{8}$ x $31^{7}/_{8}$" (55 x 81 cm). North Carolina Museum of Art.

61. CLAUDE MONET
Etretat, Choppy Sea, 1883. Oil on canvas, $31^{7}/_{8}$ x $43^{1}/_{4}$" (81 x 110 cm). Musée des Beaux-Arts, Lyon.

Other closely related pairs may have been painted in different years, with the artist returning annually to paint the same subject from a favourite spot.

Monet did make twelve paintings of the Paris Saint-Lazare station in 1877 which show his impressions of it under a variety of atmospheric effects. Again, however, a work such as *Interior of Saint-Lazare Station* (1877, FIG. 59) does not appear to be part of a systematic series of impressions. Only two of the set were painted from the same position, and although eight of them were exhibited at the Impressionist exhibition of 1877 there is nothing in the records to indicate that they were shown as a series of changing effects, or as a set that detailed the way impressions of a motif altered systematically with time and weather. Rather, the idea of detailing the changing impressions of a scene in the series format was something that Monet says he formulated only later: "I felt that it would not be trivial to study a single motif at different hours of the day and to note the effects of light which, from one hour to the next, modified so noticeably the appearance and the colouring of the building. For the moment I did not put the idea into effect, but it germinated in my mind gradually." Opinions vary as to the precise period to which this account refers, but it is likely that it was around the late 1870s and early 1880s that Monet's idea began to "germinate." Certainly, by 1882, when Monet painted at Varengeville, he started to treat the same motif under a variety of conditions. But it is probably at Etretat, on the coast near Le Havre, where Monet worked from 1883 to 1886, that his serial procedure attained its first maturity. From these campaigns there survive as many as six canvases painted from a closely similar viewpoint, although some may have been done in different years. None the less, works such as *Sunset, Etretat* (also known as *Etretat* and *The Cliff, Etretat, Sunset),* and *Etretat, Choppy Sea* that Monet made in 1883 (FIGS. 60 and 61) seem to have been part of a systematic attempt to capture the differing impressions a motif produced as the light and atmospherics changed.

Monet's letters of the period show that he had canvases ready to paint whatever the weather. Maupassant recalled that, in 1885, Monet set off to paint whatever subject he was currently working on "followed by his children and Madame Hoschedé, carrying his canvases, sometimes as many as five or six, representing the same subject at different times of day and with different effects. He took them up and put them aside in turn, according to the changes in the sky."

Similarly a journalist reported in 1889 that while at Etretat Monet had "Between his knees... two or three canvases, which took their turn on his easel for a few minutes each. On the same stormy sea, framed by the same cliffs, they were different effects of light." And Geffroy recalled of Monet at Etretat that he was "so active that he begins during a single afternoon several studies of a single view." So it seems that Monet already had the intention of producing a series, in the sense that we now understand the word, before he left Etretat, and had developed the technique to allow him to carry out his intention.

But patient observation was not the whole story. High tide is later every day, by a period ranging roughly from half an hour to an hour, and it reaches different levels, so a marine painting, however quickly painted, which is faithful to one, single impression is an impossibility. Moreover, Monet systematically reworked his series paintings in the studio to unify them internally and with one another. He was also wary of producing works that were not "varied" and was worried that he was "giving way to repetitions" (as he told Alice Hoschedé in January 1888). He therefore seems to have had quite defined ideas about how his paintings should look in advance of painting them. In later life, around 1915, he even told Geffroy that: "No one is an artist unless he carries his picture in his head before painting it, and is sure of his method and composition."

All Monet's care that the final painting should be coherent does not contradict the fact that his serial procedure was grounded in "observation" and the fact that experience could sometimes come as a revelation. For all Monet's concern that the painting should turn out well according to broad criteria of quality, the foundational logic of the serial procedure was that it allowed the artist the greatest possible opportunity to record aspects of the self which contact with nature revealed by serendipity.

From left to right: Germaine Hoschedé, Lili Butler, Madame Joseph Durand-Ruel, Monsieur Georges Durand-Ruel and the artist Claude Monet, photographed in the garden at Giverny.

"More serious qualities"

Monet made many more series paintings in the 1880s – at Belle-Île in Brittany in 1886, at Antibes on the south coast in 1888, and elsewhere. But perhaps the culmination of the procedure came with the *Grainstacks* series that Monet began in 1890 and completed in 1891 (he had done other paintings of this theme in the preceding years but they do not belong to this series). Although all the paintings which were exhibited as the final

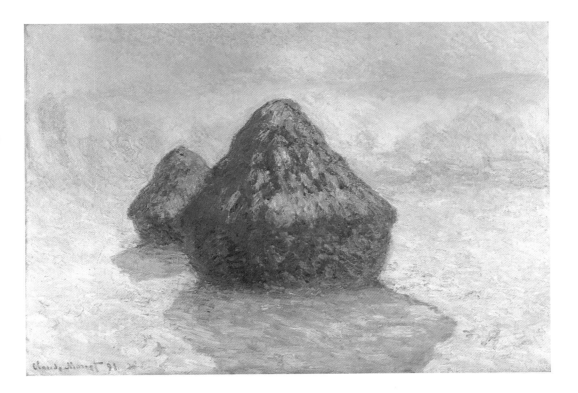

62. CLAUDE MONET
Grainstacks: Snow Effect, Sunlight, 1890–91. Oil on canvas, 25³/₄ x 36¹/₄" (65.1 x 92.1 cm). National Gallery of Scotland, Edinburgh.

Monet's serial procedure was very lucrative. All of the 30 *Grainstacks* paintings exhibited at Durand-Ruel's galleries in May 1891 sold within three days of the opening of the show, for prices ranging from 3000 to 4000 francs.

series were dated 1891, they can be roughly divided into three main compositional kinds, each of which corresponds to a more or less discrete stage in the evolution of the project. First, there came paintings like *Grainstacks: Snow Effect, Sunlight* (FIG. 62). These show two stacks, the larger of which is on the left; most were painted over the late summer of 1890 and the early winter of 1891. Then came works like *Grainstack, (Snow Effect)* (FIG. 63) that represent one stack placed more or less centrally; most were painted over the winter of 1890–91. Finally, Monet painted works like *Grainstack (Sunset)* (FIG. 64) that show a single stack, but crop this with the edge of the picture.

Like other series, the *Grainstacks* included a number of near-identical views of the same motif; but what distinguishes this series is the fact that it was also conceived of as an integral unit. This was the case by December 1890, when a letter of Monet's to the dealers Durand-Ruel shows he was reluctant to sell any of the paintings to the dealers Boussod and Valadon (although he eventually did so). By April 1891, Pissarro reported in a letter that Monet was planning an exhibition which included "nothing but Grainstacks," which, although not eventually the case, does at least indicate that Monet

conceived of them as a group. This was definitely his intention by May 1891, when he exhibited thirty *Grainstacks* at Durand-Ruel's gallery, and told a visitor to the exhibition that the individual works would "only acquire their full value by the comparison and succession of the whole series."

The *Grainstacks* also show evidence of having been re-worked in the period between February and April 1891, which implies Monet was trying to find ways of linking one painting with another, and not just ways of unifying individual pictures. In the same way, the fact that Monet retouched some *Grainstacks* after the exhibition closed strongly suggests that he needed to undo the work he had done in order to unify them as a series if he were to reinstate their character as individual works.

Plainly then, any account of Monet's ambitions in the *Grainstacks* series needs to acknowledge that the painter's engagement with "the fleeting moment" was anything but simple or passive. The series may indeed have originated in Monet's ambition to record his impressions and sensations of small intervals of time. (Monet's friend the politician Georges Clemenceau said that the series was related in intention to paintings of a poppy field that Monet did in the summer of 1890, which the artist made "with four canvases... changing his palette as fast as the sun pursued its course.") But this was not all there was to Monet's enterprise, and his concerns about the unity of the individual work and the whole series were just as important as his concerns about impressions and sensations, perhaps more so.

Around this time Monet was becoming frustrated with the business of recording evanescent effects of light if doing so did not result in a harmonious painting. For instance, he wrote to Geffroy in October 1890 to tell him: "I'm working away at a series of different effects (of stacks), but at this time of year, the sun sets so quickly that I can't keep up with it... I'm becoming so slow in my work that it makes me despair, but the further I go, the better I see that it takes a great deal of work to succeed in rendering what I want to render: 'instantaneity,' above all the *enveloppe*, the same light diffused over everything, and I'm more than ever disgusted at things that come easily, at first attempt." From these remarks, it seems that Monet wanted it both ways – at once to record an effect of light, and to produce a coherent work of art out of this. His best option, therefore, was to record effects of light that had unity themselves and so lent themselves to translation into a unified painting. This interpretation can also make sense of the cryptic

63. CLAUDE MONET *Grainstack (Snow Effect),* 1890–91. Oil on canvas, 25³/₄ x 36³/₈ (65.4 x 92.3 cm). Museum of Fine Arts, Boston.

64. CLAUDE MONET *Grainstack (Sunset),* 1890–91. Oil on canvas, 28⁷/₈ x 36¹/₂" (73.3 x 92. cm). Museum of Fine Arts, Boston.

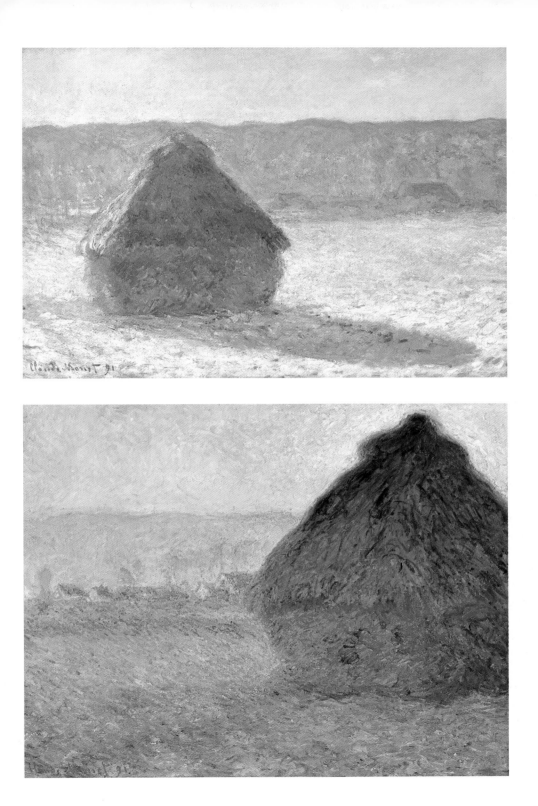

remark Monet made in 1892 that he could "no longer paint anything that pleased him, no matter how transitory" and that he was looking instead for "more serious qualities" in his work.

It might be said that up till the 1890s, Monet envisaged the painting as adequate if it could render his impressions and sensations with accuracy. This meant that the work needed to be harmonised and unified according to the laws which determine the operation and appearance of colour on the depicting surface. What appears to be novel about his thinking in the 1890s is that Monet started to accept, and even exploit, how the unified painting had expressive possibilities which could exceed the possibilities of the impressions and sensations in which it originated. This can be appreciated by comparing his early works, which generally celebrate the flux of an experience, with later paintings, which arguably betray the artist's efforts to "fix" the moment, to hold on to it, precisely because it threatens to become lost. It might be said, therefore, that Monet's attempts to give his paintings "more serious qualities" than flux or transience are born of a desire to hold onto the unique moment, and give it a permanent artistic form.

None the less, Monet never "freezes" time, as does Seurat, for example, in his *Un Dimanche d'été sur l'Île de la Grande*

65. GEORGES SEURAT
Un Dimanche d'été sur l'Île de la Grande Jatte, 1884, 1884–6. Oil on canvas, 6'5¾" x 9'8¼ " (200 x 300 cm, according to Seurat, actual measurement 2.07 m x 3.08 m). Art Institute of Chicago.

By his own account, Seurat's ambition here was to paint "the moderns in their essential aspect." In this, he was following the advice of the academician Charles Blanc, who suggested he should paint people in their "eternal" aspect, or as they might exist independently of the dimension of time.

Jatte, 1884 (Summer Sunday on the Island of the Grande Jatte, 1884, or *A Sunday on La Grande Jatte, 1884–6*, FIG. 65). Things are never represented as static in his paintings, or as fixed in what Seurat called "their essential [meaning eternal] aspect." Indeed, Monet's work is characterised by a singular absence of metaphysical implications. He seems to want to convey that transient, lived experience is all we have, and that if art has value, then it lies in art's ability to celebrate such experience. On one level, this attitude is consonant with a more general enthusiasm among the nineteenth-century bourgeoisie for life – the *joie de vivre* that involved making the most of the present, taking risks, and being open to new experiences. Some of Monet's remarks about his way of choosing a motif express these attitudes. For example, a critic recalls that Monet "felt that his cycle of grain stacks was due to a chance circumstance. He tells how one day, beguiled by the opulence of a beautiful stack in the plain of Giverny... he had come with his step-daughter... to make a study of it, with no intentions of multiplying this theme." Thus, painting a series of *Grainstacks* was not something Monet had planned; it was the revelatory character of his experience of a particular stack that decided him to do so. Attitudes like being open to new experience and being ready to make things up as he went along also inform some of Monet's comments on the unexpected turns his pictures took. For example, in a letter of March 1884 to Alice Hoschedé, Monet explained how in his recent paintings he really had put down the colours he saw in nature, however surprising that might seem. Monet went further, suggesting that painting nature involved constant revelations, and that his main problem was his lack of courage in pursuing these. In the letter, he tells Alice about his recent work: "Obviously people will exclaim at their untruthfulness, at madness.... All that I do has the shimmering colours of a brandy flame or of a pigeon's breast, yet even now I do it only timidly. I begin to get it."

There is something genuinely daring about Monet's dedication to his sensations, namely that it implied there is nothing but lived experience, and hence nothing else that gives life value apart from the living of it. The development of Monet's practice over the remainder of his life supports such an interpretation. For he increasingly refined his serial procedure, concentrating on smaller and smaller spans of time when dealing with a particular motif, as if attempting to home in on those specific features of actual, lived experience that made it worthwhile. Monet told Lilla Cabot Perry that he worked on

66. CLAUDE MONET *Poplars (Bank of the Epte),* 1891. Oil on canvas, 36³/₈ x 29" (92 x 74 cm). Tate Gallery, London.

When Monet found this motif on the bank of the river Epte, the poplar trees had already been marked for felling and he had to pay their owner to leave them standing for several months while he painted them. In most cases, he did this from the boat he used as a floating studio, although this work is probably painted from the bank opposite.

the individual canvases of the *Poplars* series of 1892, such as *Poplars (Bank of the Epte)* (1891, FIG. 66; also known as *Les Peupliers au Bord de l'Epte* and *Poplars on the Epte*), for only seven minutes at a time otherwise changes in light would destroy the impression he was attempting to capture. He also worked on a series of the river Seine in 1898 that was so time-specific that it involved using up to fourteen canvases during a session. And he spent less time travelling to find spectacular motifs, concentrating instead on how the familiar and close-at-hand appeared to him, as if the subject of his work was, and must be, experience *tout court*.

A comparison between Monet's treatment of the landscape in his *Grainstacks* and Jean-François Millet's treatment of a closely similar motif in *Autumn, the Haystacks* (c. 1868–75, FIG. 67) can serve to bring out the religious in Millet's work. For him, the landscape was charged with the presence of God: the use of light and the agitated sky even imply as much by convention. As far as Millet was concerned, the relationship of humankind to the landscape was divinely ordained and thus fixed within a permanent order of things. Albert Sensier's 1883 biography had made plain (to the dismay of the anarchist in Pissarro) that Millet was no socialist for whom the peasantry was heroic. For Millet, the peasant was bound to the land by his dependency on it and glorified God in labouring to extract his daily bread from the earth. There are no such implications

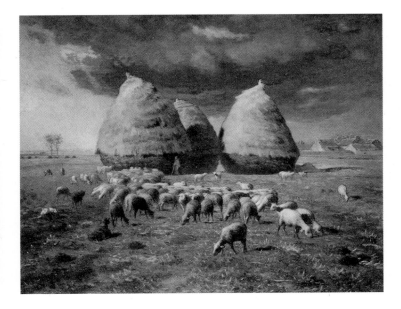

67. JEAN-FRANÇOIS MILLET
Autumn, the Haystacks,
c. 1868–75. Oil on canvas,
33¹/₂ x 44¹/₄" (85 x 110 cm).
Metropolitan Museum of Art,
New York.

68. CLAUDE MONET
*Rouen Cathedral, the West
Portal and the Tour
d'Albane, Harmony in Blue,*
1894. Oil on canvas, 35½ x
24½" (91 x 63 cm). Musée
d'Orsay, Paris.

69. PAUL CÉZANNE
*Mont Sainte-Victoire seen
from Les Lauves,* 1902–4.
Oil on canvas, 28¾ x 36¼"
(72.4 x 92 cm). Philadelphia
Museum of Art.

in Monet's works. The landscape is about sensation, not God or the dignity of labour.

Indeed, the majority of Monet's other works contain no metaphysical implications. Even the paintings of Rouen cathedral, like *Rouen Cathedral, the West Portal and the Tour d'Albane, Harmony in Blue* (1894, FIG. 68) focus on the minute and subtle differences of light effects, without at all seeming to suggest the building was the house of God. The paintings have little symmetry that might suggest a divine presence organising the scene; they accord the cathedral no special place in the landscape; and they concentrate on effects of light at the expense of those details which indicate the cathedral is a house of God. In pursuing this course, Monet went against a tradition of treating the landscape which still had validity even for such modern painters as Cézanne. His *Mont Sainte-Victoire seen from Les Lauves* (1902–4, FIG. 69; also dated 1904–6) strongly implies the hand of God at work in it. Its hierarchical arrangement (with the mountain dominating the scene) and its sheer richness of coloration all suggest a power at work in nature,

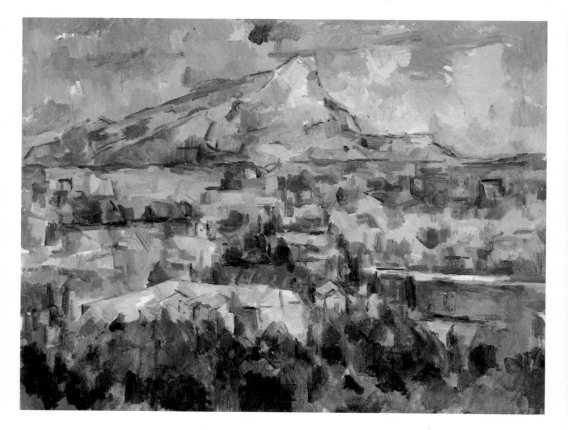

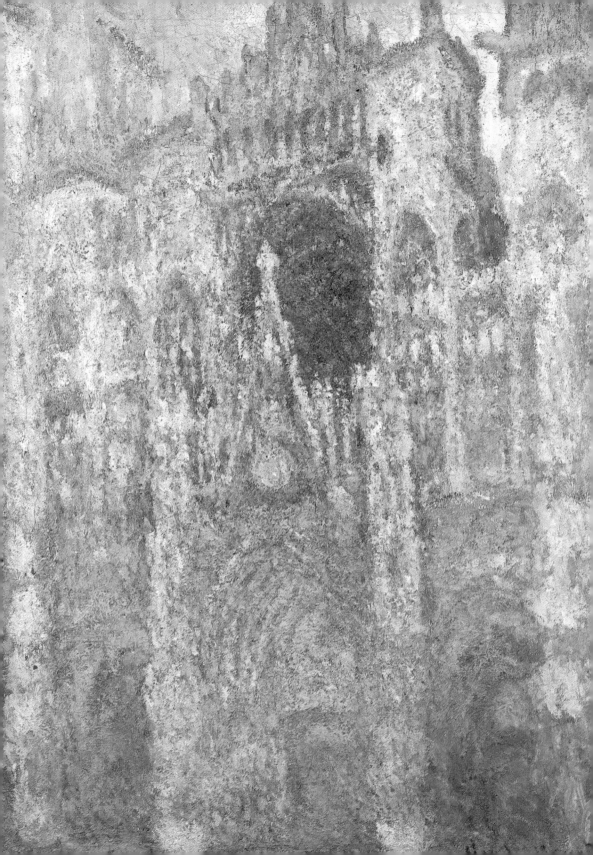

70. CLAUDE MONET
Green Reflections, 1914–22
(detail). Oil on canvas, right-
hand canvas, 6'6" x 13'10"
(1.97 x 4.25 m). Musée
d'Orsay, Paris.

organising it vigorously and according to a purpose. Cézanne expressed precisely this idea in a letter to Bernard of April 1904, when he described the landscape as "the sight which the eternal, omnipotent Father spreads out before our eyes." In contrast, therefore, and if only by omission, Monet's paintings of Rouen seem to imply his faith in God had been superseded by a trust in his own sensation.

Monet's enterprise was not trivial: it was centred on the belief that art could extract from experience qualities that gave it value, despite, but also because of the fact that experience and life were transient. It would seem, then, that for Monet the value of art resided in its power to endure, while human life did not. Classicism insisted that art could represent an eternal order persisting behind experience, but Monet's art sought only to distil the beauty of a moment as such, without pretence.

These very modern ways of treating experience and the virtue of art come through in Monet's late *Waterlilies* paintings –

in works like *Green Reflections,* painted over the period 1914–22 (FIG. 70). The overt subject of these paintings was the private world of the rich garden that Monet cultivated from 1890 when he moved to Giverny, about 30 kilometres from Rouen. During the First World War, however, Monet could hear the munitions trains passing nearby on their way to the front. Putting these two facts together, the *Waterlilies* can seem to be the product of a practice that was more self-obsessed than self-contained as they record the enclosed world of the established "genius" of Impressionism. But they can also look like an effort in concentration; Monet's attempt to hold on to a kind of experience that barbarism threatened to wipe out. Indeed, Monet donated a series of these works to the French nation on Armistice Day 1918, offering them as "a bouquet of flowers" to the nation that war had exhausted.

FOUR

Pissarro's Political Vision

"Our ideas impregnated with anarchist philosophy seep into our works."

PISSARRO

71. CAMILLE PISSARRO
Peasant Women Planting Pea-Sticks, 1891. Oil on canvas, 21⅝ x 18⅛" (55 x 46 cm). Private collection (on loan to Sheffield City Art Galleries).

P issarro made many remarks that he was no less committed to an art based on impressions and sensations than was Monet. In a letter to his cousin Esther of September 1903, Pissarro told her his whole career had been marked by the effort to "understand my sensations," even if he had been able to do this "only vaguely," "around the age of forty" (in about 1870). Although their art shared much, Pissarro's pursuit of sensations and impressions stemmed in part from concerns alien to Monet's and was therefore inflected by different meanings. Primarily he desired to express the anarchist beliefs that he began to acquire in the mid-1870s, an ambition that affected almost all aspects of his technique, imagery, and practice.

Little of Pissarro's radicalism is visible in his earliest paintings, which nowadays can even look derivative because of their reliance on conventions borrowed from previous painters, particularly Corot (from whom Pissarro received lessons in the late 1850s). For example, *View From Louveciennes* (c. 1870, FIG. 72) bears significant similarities to Corot's *Sèvres-Brimborion, View Towards Paris* of (c. 1855–65, FIG. 73; also known as *Le Chemin de Sèvres, Vue Sur Paris*): its use of a sharp perspective, with a tree framing the landscape on one side; its inclusion of a peasant; and its somewhat "feathery" brush-stroke. Pissarro's picture is further indebted to Corot in that it is organised into

72. Camille Pissarro
View From Louveciennes,
c. 1870. Oil on canvas,
20³/₄ x 32¹/₄" (52.7 x 82 cm).
National Gallery, London.

73. Camille Corot
*Sèvres-Brimborion, View
Towards Paris,* 1855–65.
Oil on canvas, 13³/₈ x 19¹/₄"
(34 x 49 cm). Musée du
Louvre, Paris.

Late in life Pissarro
acknowledged his debt to
Corot: "Old Corot, didn't he
make beautiful little
paintings Happy are
those who see beauty in the
modest little spots where
others see nothing. Every-
thing is beautiful, the secret
lies in knowing how to
interpret."

more or less discrete areas of tone, themselves articulated
around a culminating point (here, the peasant's white hat).

It is therefore surprising that some contemporary commen-
tators saw Pissarro's work of this period as more radically
"modern." Zola in 1868 said of Pissarro's *Banks of the Marne in
Winter* (1866) that it showed the painter's ability to "bring out
the vulgarities of the contemporary world." And with the same
painting in mind, he spoke of how: "It's there, the modern
countryside."

Quite what Zola meant is difficult to pin down. However,
Pissarro's engagement with modernity is more obvious in some
of the other paintings he did of the environs of Paris in the
1860s and early 70s, which deal with the encroachment of

modern forms of industry on the countryside, albeit in a highly ambiguous manner. *The Seine at La Grenouillère* (c. 1869, FIG. 74) is a poignant painting. It shows the same stretch of river that Monet and Renoir depicted as an unproblematic bourgeois pleasure ground; but unlike his colleagues, Pissarro includes in the painting the industrial buildings and factory chimney that existed on the site. The meaning of doing so is not entirely clear: it can be seen as Pissarro's way of stating the facts of the landscape straightforwardly as would a Realist; as his enthusiastic, modern response to the coexistence of industry and nature on equal terms; as an ironic joke about the corruption of the "nature" that Parisians enjoyed; or, which is most likely, as an unresolved attempt to find some way of painting industry and nature side by side. There just did not exist a set of conventions in Corot, or elsewhere, that could provide Pissarro with a ready-made way of rendering such a subject, or his attitude towards it, any more than there had been for Monet at Argenteuil.

74. CAMILLE PISSARRO
The Seine at La Grenouillère, c. 1869. Oil on canvas, 13³/₄ x 18¹/₈" (35 x 46 cm). From the Collection of the Earl of Jersey.

75. CAMILLE PISSARRO
Factory Near Pontoise,
1873. Oil on canvas, 18 x
21¹/₂" (45.7 x 54.6 cm).
Museum of Fine Arts,
Springfield, MA.

Pissarro's difficulties with finding a formula that would satisfactorily express his attitudes to the industry in the countryside emerge most pointedly in his treatment of the same factory in two paintings of 1873, *Factory Near Pontoise* and *The Oise in Spate* (FIGS. 75 and 76). In the first, the painter has integrated the large chimneys of a new factory into a hierarchy that incorporates the poplar trees growing behind the factory. The meaning of this arrangement is unclear, but the attempt to integrate the two sets of forms suggests that Pissarro intended to avoid any implication of conflict or tension between the forces they represented. It seems that Pissarro wanted to suggest that industry could exist in nature, and even sometimes dominate it, but without destroying its host. Two other pictures of the same building suggest much the same but the fourth, *The Oise in Spate*, is different. Here, the sparse remnants of nature left behind by the flood are used to mask

the factory, but only ineffectually. It is as if Pissarro were lamenting the obtrusiveness of industry in the landscape: when the trees are bare the factory sticks out; its refusal to march in time with the seasons makes it an eyesore, rather than one harmonious feature of the landscape among others.

After the early 1870s Pissarro's attitude to industry was never very positive. In later life, he seemed happier about the "pure" countryside, although his paintings of the countryside were never simple or unequivocal. They also manifest some of the social tensions that lie behind the peaceful appearance of the landscape. An unusually explicit case is *The Donkey Ride at La Roche-Guyon* (c. 1865, FIG. 77), where Pissarro shows without equivocation that the poor children in the painting can only look on while the better-off enjoy a ride. But the painting is remarkable not because it shows how class divides the community, but because it shows class exists at all. In most

76. CAMILLE PISSARRO
The Oise in Spate, 1873.
Oil on canvas, 15³/₈ x 18¹/₂"
(39 x 47 cm). From the
Collection of the Earl of
Jersey.

representations, the social differences between the classes are not shown and thus the way that class affects and structures human life remains absent from such works.

It may seem as though Pissarro was expressing sentiments he had learned from anarchism, but this is anachronistic. Pissarro only developed his commitment to the philosophy about 1876, when he took up a subscription to the broad-left journal *La Lanterne*, which included articles by the anarchist philosophers, particularly P.-J. Proudhon, whose work Pissarro came to admire. In 1871, however, he referred to the anarchist *communards* who took over Paris in 1871–2 as "murderous socialists," which would indicate relatively conservative sympathies at this date.

Nevertheless, the works of the late 1860s and early 70s do show a certain critical detachment on the artist's part. He portrays Pontoise as an outsider might, with a sense of not belonging in his paintings that shows up in the physical and psychological distance that interposes itself between the painter

78. CAMILLE PISSARRO
Red Roofs or *The Orchard, Côtes Saint-Denis at Pontoise*, 1877. Oil on canvas, 21¹/₂ x 25⁷/₈" (54.5 x 65.5 cm). Musée d'Orsay, Paris.

and the landscape, especially the figures in it. In 1876, the theorist of landscape painting F. Henriet had defined the artist as "an essentially intermittent being." And as a Jew, a Danish citizen, and painter by profession, Pissarro would have had little in common either with the largely Catholic French bourgeoisie who lived in the town or with the peasants he painted. As he told his son Lucien in a letter of June 1887, he was neither one thing nor the other, "a bourgeois – without a penny."

Something of Pissarro's detachment emerges in his habitual choice of a certain kind of motif – an isolated section of the landscape instead of the more usual overview. Works like *Red Roofs* or *The Orchard, Côtes Saint-Denis at Pontoise* (also known as *Les Toits Rouges. Coin de Village, effet d'hiver*) and *The Côtes Saint-Denis* or *The Côtes des Boeufs* (also known as *The Côtes des Boeufs at L'Hermitage, near Pointoise*), both 1877 (FIGS. 78 and 79) are typical of this kind of composition. The painter

80. CAMILLE PISSARRO
Young Peasant Girl with a Stick or *The Shepherdess*, 1881. Oil on canvas, 31⁷/₈ x 25¹/₂" (81 x 64.5 cm). Musée d'Orsay, Paris.

Regarding paintings like this, Pissarro said: "I have the temperament of a peasant, I am melancholy, harsh, and savage in my works, it is only in the long run that I can hope to please."

seems to be looking at an isolated part of the landscape from without, not at a section of a wider whole within which he belongs. Pissarro heightens the detachment of such works by presenting the motif as something partially obscured by trees that intervene between it and the painter. Such "screens" almost make us peer through the picture as if we were the painter seeking to penetrate the alien landscape. However, it could equally be a deliberately modern way of treating the landscape. Corot had used the device in many paintings in trying to find an alternative to the traditional way of representing the landscape as an open space that recedes in front of the painter-spectator. Pissarro's use of the "screen" also seems to present the motif as something that is never completely captured – something that only half reveals itself to the artist, the occasion for sensations that remain unstable and unfixed because that is their nature. Indeed, Pissarro was using the word sensation by the early 1880s as a matter of course to describe what it was he was painting. And he implied that sensations were experiences that just happened when he was faced with a motif. When describing one of his paintings of 1882, Pissarro admitted that the peasant figure in it was "not gay" but added "what do you expect, I follow the inclination of my sensations."

The Painter as Theoretician

In a letter of September 1892, Pissarro advised Lucien that all he needed to be a successful painter were "persistence, will, and free sensations, free from everything but your own sensations." However, there was more than a whiff of rhetorical exaggeration to this advice, since Pissarro knew that his own style had changed considerably under the impact of ideas, and especially scientific ideas, that he had encountered over the years. For example, the marked shift towards more colourful paintings in the late 1870s is one that he said himself could be put down to his increasing understanding of the science of optics, and to the knowledge it gave him of what he should be seeing in the landscape. As he told Lucien in February 1887:

De Bellio... tells me that research in physics on colour and light can be of no more use to the artist than anatomy or the laws of optics... By Jove! if I didn't know how colours behaved from the researches of [Eugène] Chevreul and other scientists, we [the Impressionists] would not have been able to pursue our study

of light with so much confidence. I would not make a distinction between local colour and illumination, if science had not brought it to light. And the same goes for complementaries, contrasts, etc.

81. CAMILLE PISSARRO
*Young Peasant Girl
Drinking Coffee*, 1881.
Oil on canvas, 25⅛ x 21⅜"
(65.3 x 54.8 cm). The Art
Institute of Chicago.

The paintings Pissarro produced in the late 1870s and early 1880s bear this out. They show that he was seeing a rich diversity of colour phenomena in the motif, but of a kind to which only contemporary science might have alerted him. For instance, Pissarro is attentive to the way that the local colour of an object (its normal hue) is modified by the light falling upon

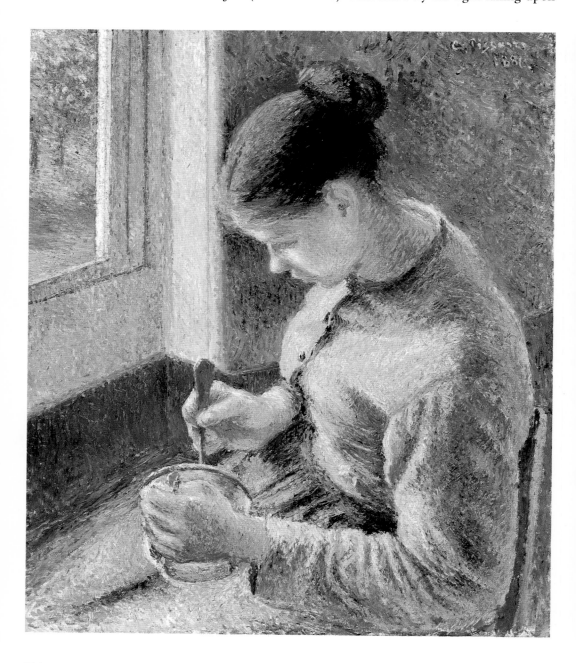

it. Thus, in *Côtes Saint-Denis* everything is suffused by a silvery autumnal light, the product of warm sunlight and the blue top light that comes from the sky. In *Edge of the Woods* (1879) and *Young Peasant Girl with a Stick or The Shepherdess* (1881, FIG. 80; also known as *Jeune Fille à la Baguette* or *Paysanne Assise*) much of the work is coloured blue by the same top light (where the sun fails to penetrate the thick canopy of trees). In *Young Peasant Girl Drinking Coffee* (1881, FIG. 81; also known as *Young Peasant Woman Drinking Her Coffee* or *Café au Lait*) the sitter's face is coloured green by reflections from the grass and trees outside the window. And in many paintings of this period, Pissarro focuses on the way complementary colours – red and green, orange and blue most commonly – intensify one another's hue. In *Red Roofs*, for instance, he makes a feature of red and green. By comparison with the colour circle that Chevreul produced in 1864 to illustrate his book *On Colours and their Applications to the Industrial Arts* (FIG. 82), it seems that Pissarro's way of seeing really was affected by what he read there.

Pissarro's vision was affected by science to the extent that the particular understanding of colour it gave him became bound up in what he saw. In paintings like *View From My Window, Eragny* (1886–8, reworked 1888, FIG. 83; also known as *View from my Window, Overcast Weather*), his treatment of complementaries changes as a result of his acquaintance with

82. EUGENE CHEVREUL
Colour circle from
On Colours and their Applications to the Industrial Arts. Paris, Baillère, 1864.

Based on the theory of colour developed by Isaac Newton in the seventeenth century, this diagram explains the way pigment colours (not coloured lights) mix.

83. CAMILLE PISSARRO
View From My Window, Eragny, 1886–8 (reworked 1888). Oil on canvas, 25⅝ x 31⅞" (65 x 81 cm). Ashmolean Museum, Oxford.

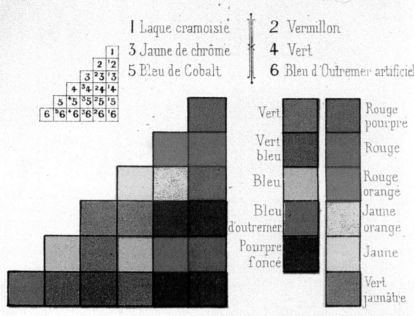

84. Ogden Rood Colour Diagram from *Théorie scientifique des coleurs,* Paris, Baillère, 1881.

This diagram was based on the nineteenth-century theories of Thomas Young and Hermann von Helmholtz and explains how beams of coloured light mix to form new colours. It also explains how colours will fuse in the eye to form new colours – or it would, had the printer not used grey in mistake for the dark blue.

the relatively novel theory of colour vision elaborated by Ogden Rood in his book, *Théorie scientifique des coleurs* (1881) which Pissarro mentions in a letter of November 1886 to his dealer, Durand-Ruel. Instead of using red as the complementary to green, in paintings of this date Pissarro uses a purplish red, as Rood suggests (FIG. 84). In *View From My Window*, the tilled earth next to the green grass is distinctly of this colour. Rood's account of colour vision was based on the theory pioneered by Thomas Young and Hermann von Helmholtz which superseded the Newtonian account upon which Chevreul's theory ultimately rested. The Young-Helmholtz theory not only replaced Newton's taxonomy of complementary colours with a different list, but radically revised Newton's view of what a primary colour was. Instead of red, yellow and blue, the Young-Helmholtz theory instated red, green, and blue-violet as primaries.

The Neo-Impressionist technique adopted by Pissarro in 1886 was also seen by him as "scientific" Impressionism as distinct from the "romantic" Impressionism of Monet. This technique is evident in works like *View From My Window*. Pissarro gives some of his reasons for adopting the new style in five letters he wrote around the time between May 1886 and May 1887 to the critic Félix Fénéon, in order to help him with his analysis of the Neo-Impressionist technique. (Fénéon's analysis appeared in several articles in 1886 which were brought together in the pamphlet *The Impressionists in 1886* and in two more articles in 1887.) It appears that Pissarro was particularly attracted by the possibilities the new technique offered for "optical mixture." Rood's description explains: colours would mix in the eye to form resultant colours if they were applied to the painting in small touches, or touches too small to be discriminated individually.

When Pissarro told Durand-Ruel that he used "optical mixture" to "decompose tones into their constituent elements," he was not denying that he used the technique to paint colours on the canvas which represented the "simple" colours he saw. For example, he used green to represent grass, as in a conventional painting. But he did want to imply that he also used combinations of colours, and the resultant colours they yielded in "optical mixture," in order to analyse, and recompose, the more complex colours in the scene depicted. So, for instance, he might represent an earth tone not with brown, but with a variety of warm and cool colours. In *View From My Window*, both aspects of the technique are in play.

For Pissarro, following Rood, the great advantage of optical mixture was that the result it yielded "give rise to much more intense luminosities than do mixtures of pigments" and hence made a more luminous painting than traditional techniques allowed. When two colours are mixed in the eye they retain their luminosity to a large extent, while if they are mixed physically as pigments, they become duller because their capacity to absorb coloured light is combined. Accordingly, the technique is particularly useful for making luminous mixtures of colours, such as earth colour, that cannot be found among the artist's pigments or used pure from the tube. Significantly, Fénéon made very similar claims to Pissarro about the virtues of optical mixture. What is more, his taxonomy of the colour phenomena it could convey was almost identical to that which Pissarro stated in the letter of February 1887 to his son, and elsewhere.

It is not the case, therefore, that Pissarro followed the lead of the supposed inventor of Neo-Impressionism, Georges Seurat, or that Fénéon voiced Seurat's ideas in his pioneering account of the rationale behind the Neo-Impressionist technique. Pissarro's scientific researches were well advanced before he met Seurat in 1885, and all he took from Seurat's technique was the small, systematic stroke, the *pointille* or "dot." Moreover, the scientific ideas that Fénéon attributes to Seurat are not Seurat's (most of whose ideas about colour came from the writings of the Academic Charles Blanc), but Pissarro's.

The Political Colour of Pissarro's Vision

At first sight, there is little about Pissarro's incorporation of scientific discoveries concerning the behaviour of light and colour into his work to immediately signal his anarchist beliefs. But it would seem that Pissarro's commitment to science was consonant with his political beliefs. For example, it is known that Pissarro had read Proudhon's *On Justice in the Revolution and the Church* (1858) sometime before January 1884 when he first mentions it, and was therefore familiar with Proudhon's belief that the twin engines of human "progress" were "natural justice" and "science." In other words, human affairs could progress if science were allowed to produce enough wealth to allow humankind's natural sentiment of justice to find practical expression. Paramount in this process was the fundamental anarchist principle of free self-determination: anarchy, literally "no rule," means government without imposed laws. Thus

both Proudhon and Pissarro believed that if people were not subjected to the injustices of capitalism and the authority of its laws, but were instead allowed to develop their own economic systems and moral codes in freely associating communities, they would develop a just and equitable way of living.

So the freedom that science gave Pissarro's sensations also gave those sensations a political dimension. It looks as though Pissarro was attracted to optics because it liberated his way of seeing from that of the Académie and the Salon, imposed by the "bourgeois" state. Science helped Pissarro determine his way of seeing for himself – an anarchist and anarchic vision; at the same time, it enabled him to produce an art which was visibly the opposite of the art he was against. In 1905 Cézanne, Pissarro's friend from the 1870s, said that science affected how Pissarro saw and at the same time expressed his political beliefs. Such at least seems to be the meaning of Cézanne's cryptic remark to Bernard: "Study changes our vision, to such an extent that the humble and colossal Pissarro finds justification for his anarchist theories." More succinctly, and more cryptically, Pissarro remarked to Lucien in 1891: "I firmly believe that our ideas impregnated with anarchist philosophy seep into [*se déteignent sur*] our works."

To see how science gave Pissarro a means of fighting and displaying opposition to an imposed, "bourgeois" way of seeing, we need only compare his work with Ingres's tribute to the Academic tradition, the *Apotheosis of Homer* (1827, FIG. 85).

85. JEAN-AUGUSTE-DOMINIQUE INGRES *The Apotheosis of Homer,* 1827. Oil on canvas, 12′8″ x 16′11″ (3.8 x 5.1 m). Musée du Louvre, Paris.

The message of this painting is authoritarian: Homer sits atop the Academy and under him sit his successors, the various princes, philosophers, writers, dramatists and artists who have continued the esthetic and moral values which, in Ingres's view, Homer had initiated. The painting includes Pericles, Alexander the Great, Socrates, Plato, Aristotle, Aesop, La Fontaine, Horace, Virgil, Dante, Fénélon, Aeschylus, Sophocles, Corneille, Racine, Molière, Phidias, Apelles, Michelangelo, Raphael, and Poussin. It states that there is one set of values, the classical, that is eternal or good for all time, in politics, morality, literature, and art. Moreover, it implies that an ambitious practitioner in any of these disciplines must stick to the canon it represents. In contrast, Pissarro's paintings of his free, personal sensations liberated by science amounted to a refutation of all that such conservatism implied, politically, esthetically and ideologically.

Pissarro's choice of the odd verb *se déteigner* to explain how his beliefs infiltrated his paintings was not casual either. Normally this verb is used to describe how the colour from one fabric tinges or runs into another. Science, then, opened Pissarro's eyes to the diversity and complexity of colour effects that existed in the world. He considered that such effects were there to be seen as long as one was not blinded to them by what he considered the "muddy" and "bourgeois" tonal style of the Academics.

Affirming the value of sensations of colour and light over the precise perception and articulation of textures (as in Ingres) had a political edge to it. It particularly went against the grain of works like Ingres's *Madame Moitessier* (1851, FIG. 86), in which (despite its implicit claim to offer a disinterested, timeless beauty revealed by God) what is really being offered the male spectator is a kind of self-congratulation in his wealth and masculine prowess. The painting was commissioned by the sitter's husband, and, one imagines, largely for his delight. While this is not obvious at first sight, the painting contains enough details to make this last conclusion convincing. The painting turns on the fact that the sitter is an aristocrat who has married a *nouveau riche* public official: in the top right corner, Ingres has even recorded the fact in an inscription: "Madame Inès Moitessier, née de Foucault," the "de" being the aristocratic component of her name. In essence, the painting records a trade-off: Monsieur Moitessier provides his wife with the pleasures her birth supposedly entitles her to – the various luxury items and textures that the painting lovingly displays; and he in return enjoys the surrogate dignity of being married

86. JEAN-AUGUSTE-DOMINIQUE INGRES *Madame Moitessier*, 1851. Oil on canvas, 57³/₄ x 39¹/₂" (146.7 x 100.3 cm). National Gallery of Art, Washington, DC.

87. CAMILLE PISSARRO
The Market at Pontoise,
1895. Oil on canvas, 18¹/₄ x
15¹/₈" (46.3 x 38.3 cm). The
Nelson-Atkins Museum of
Art, Kansas.

to an aristocrat. Furthermore, Monsieur Moitessier's wealth ensures he enjoys the benefits of a faithful and sexually desirable wife. Her white skin displays not only her nobility, or the fact that she remains in faithful confinement largely within the domestic interior, but it also declares that he possesses a very valuable erotic commodity. If we compare this painting

with the following passage from Balzac's *Cousine Bette* (1846), describing the appearance of the courtesan Valerie, this "hidden" message becomes clear:

> That evening, by one of those happy chances that occur only to pretty women, Valerie was looking charming. Her bosom gleamed dazzlingly white.... All Parisian women, by what means no one knows, manage to possess lovely contours and yet remain slender. Her dress, of black velvet, seemed about any moment to slip from her shoulders, and she wore a cap trimmed with clusters of flowers. Her arms, at once slender and rounded, emerged from puff sleeves frilled with lace. She was like one of those luscious fruits, arranged enticingly on a fine plate, which make the very metal of the knife-blade ache to bite into them.

Pissarro's paintings, especially of women, substitute for this kind of satisfaction in fantasies of possession a gentler pleasure in light and colour for themselves. To use the earlier terminology of the radical critic Théophile Thoré, Pissarro was effectively placing value on his vision at the expense of the viewpoint of a bourgeois class, whose preoccupation with the "useful" and "money" made them lose any "sentiment of nature" and rendered them "blind in front of the pictures [in nature] that light colours."

The correlation between sensations of colour and radical political beliefs eventually enabled Pissarro to prevent science ruling his work, or inhibiting the spontaneity of his sensations. Thus he could write to Signac in August 1888: "apply the science which belongs to everybody... [but] keep for yourself the gift you have of feeling in the manner of an artist of a free race." If a little science liberated his sensations, too much inhibited them. So Pissarro later abandoned the Neo-Impressionist technique, because its systematic scientific nature made it a poor vehicle for "the freedom, the spontaneity, the freshness of sensation of our Impressionist art" (written to Lucien in September 1888). As he told the Belgian painter Henri van de Velde in March 1896, it made it "an impossibility to follow my sensations."

This is not to say that all the Impressionists agreed with Pissarro that painting sensations of colour had an anarchist significance. Freedom of individual expression was just as much a tenet of *laissez-faire* capitalism as of anarchism. However,

Pissarro must have realised this irony, as he jokingly referred to the conservative Degas in a letter of April 1891 as "Such an anarchist, in art of course, and without knowing it!"

Another reason why Pissarro's paintings could signify anarchist beliefs was that the richness and variety of their colour placed them within an esthetic that the urban worker and the peasant shared. Traditionally, these classes dressed in coloured costumes, while the bourgeoisie restricted themselves to a black and white garb, although *embourgeoisement* led some workers to adopt a more restrained dress in the late 1870s. In the writings of populists like Jean Richepin and Gustave Kahn in the 1880s, the esthetic of colour and variety is given specific and aggressive working-class significance. In paintings like *The Market at Pontoise* (1895, FIG. 87), which show peasants wearing a costume of sumptuous colour and variety, it would seem Pissarro is staking out his sympathy with this esthetic, and implicitly, his sympathy with what he sees as its anarchic tendency, or the refusal of colour to conform to dull "bourgeois" norms.

The Anarchist Subject

For all their complexity, it is clear that there was a consonance in Pissarro's paintings of the 1880s between the colour chosen for them and their subject matter of the worker and the peasant. It is as if Pissarro were trying to find a mode of seeing the peasant which was appropriate to the subject and which expressed what he saw as "peasantness" or rusticity. He told Lucien in 1883 that his *Young Peasant Girl with a Stick* was meant to convey his own "rustic" and "savage" temperament, and thus was designed to express the qualities he believed he shared with the peasantry. Other paintings of peasants express similar properties which the painter saw in the peasant. For instance, Pissarro records how a painting of an old peasant woman of 1876 was "a sombre, terrible painting, not lacking in character" – just like its sitter.

Pissarro also focused on aspects of peasant labour that were to his liking. He made many paintings of peasant markets in the 1880s and early 1890s in which *maraîchers* – smallholders who sold their own produce – figure prominently. *The Poultry Market, Gisors* (1885, FIG. 88) is one such painting that is bathed in the characteristic overall blueness of the period. These paintings suggest more than approval of the activities of these independent producers: they imply Pissarro identified with the ethos of the *maraîcher* because it provided an example of self-

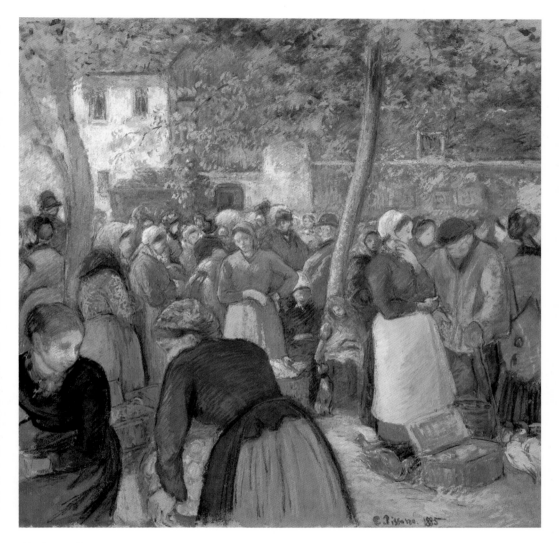

88. CAMILLE PISSARRO
The Poultry Market, Gisors, 1885. Gouache and black chalk on
canvas, 32³/₈ x 32³/₈" (82.2 x 82.2 cm). Museum of Fine Arts, Boston.

determination. In a strange Symbolist book, *The Little Directory of Letters and the Arts* of 1886, Paul Adam actually referred to Pissarro as a *"maraîcher impressionniste,"* which suggests the artist had identified publicly with this way of life.

Plainly, then, Pissarro was not trying to see peasant life as peasants saw it. Indeed, in April 1892, in a letter to Octave Mirbeau, Pissarro attacked the view of the anarchist writer Pierre Kropotkin that the painter must live as a peasant in order to understand them. Instead, Pissarro told his correspondent: "Let's be artists first of all and we will be able to experience [*sentir*] everything, even a landscape, without being a peasant." Relying on his artistic sensation, in other words, was Pissarro's aim. What is more, Pissarro was not too worried about this sensation or impression being a direct record on canvas of something he saw in front of him. If a letter he wrote to Lucien in April 1892 is any guide, Pissarro would trust his "impression in memory" because it revealed things synthetically, without "vulgarity" in their "perspicacious, felt [*sentie*] truth." And around the same time, Pissarro said that it was only in the studio that "our impressions... become co-ordinated," rather as in many letters of this period and even as early as 1873 he had mentioned the necessity of studio practice. Pissarro wanted, in his own words, to paint "the true poem of the countryside," or show it not as it was, but how it might be. Such a project demanded an approach almost antithetical to on-the-spot observation – namely a patient synthetic stitching together of various studies to make a coherent painting that would express a deeper "truth" than that of mere appearances.

Pissarro's imaginative way of treating peasant subjects conforms specifically with the utopian vision of peasant life that Proudhon and Kropotkin expounded in their writings. And although Proudhon sometimes advocated a Realism which would be critical of the injustices of capitalist society, his writings suggested to the artist that he could also show how things might be in a utopian society. In essence, Proudhon's ideal society was small, rural, agrarian, and based on free association. Proudhon's other ideal was that his society (or societies) should not produce surplus value, or goods for sale and hence money. He advocated that they should provide only for their own needs, and devote the time remaining to leisure and contemplation. In paintings like *Young Peasant Girl with a Stick*, it seems that this state of affairs is just what Pissarro renders. Similarly, *Peasant Women Planting Pea-Sticks* (1891, FIG. 71) conjures a vision of harmonious co-operation. Unlike

Proudhon, Pissarro represented the peasant woman as someone who was able to partake fully in this kind of social organisation. In this painting in particular, the rhythmic and circular composition implies that work is done co-operatively within the community, suggesting that Pissarro was abandoning his *maraîcher* ethos in favour of a more radical, anarchist position which held that goods should be produced for the benefit of the community only, without thought of selling them on. These latter paintings therefore not only conform to Proudhon's ideal, but also anticipate the ideas of Kropotkin (who wrote, much later, that goods should be produced "for the use of those very people who grow and produce them").

Pissarro and the City

Although Pissarro continued to paint the countryside for the remainder of his life, his most ambitious paintings of the 1890s and afterwards are his paintings of city scenes, especially Paris.

89. CAMILLE PISSARRO *Capital* from *The Social Turpitudes,* 1889. Pen and brown ink over pencil on glazed paper, 12⅛ x 9½" (31.5 x 24.5 cm).

This was by no means a simple decision for a painter who was committed to an anarchist vision of rural co-operation, and for whom the capital was also capital itself. Indeed, Pissarro had produced a series of drawings in 1889 for his nieces Esther and Alice Isaacson, entitled *The Social Turpitudes* (FIG. 89), which detailed the various ways in which capitalism in the city forced people into degradation and despair. He explicitly equates Paris with capital in the first illustration (called *Capital*), in which a heaving crowd of urban poor entreat a rich man on a dais for something from the bag of money he holds.

The Paris paintings begin with a few studies of the streets around the Gare Saint-Lazare, which Pissarro made in 1893. But in February 1897 he wrote to tell his son Georges that "I have started my series of *Boulevards*," showing that he had made a conscious decision to embark on a systematic series (of the Boulevard Montmartre and the Boulevard des Italiens) after the fashion of Monet. A slightly earlier letter to Georges betrays his reasons for undertaking this campaign: "The small ones I have made [already] have pleased Durand[-Ruel]." Pissarro's idea undoubtedly pleased Durand-Ruel since Monet's series pictures had sold like hot cakes. Moreover, the last-mentioned letter also shows that Durand-Ruel suggested that the Grand Boulevards (or the salubrious boulevards of the right bank) would make a good subject, undoubtedly because they would attract buyers from the classes who frequented such places.

However, Pissarro found it was not easy for him to manipulate the motifs to his own satisfaction. He told Georges: "I have a horrifying motif, which it will be necessary to interpret through as many effects as possible; to my left, I have another motif which is less terribly difficult, it's almost a bird's-eye view, of the cars, the omnibuses, the people between great trees, large houses which I will have to render with aplomb, it's steep! It goes without saying that I have to bring it off all the same." Looking at two paintings from the campaign, *Shrove Tuesday on the Boulevards* (also known as *Mardi Gras on the Boulevard Montmartre*) and *Boulevard des Italiens, Morning, Sunlight Effect* (both 1897, FIGS. 90 and 91), it is not obvious why Pissarro found the motifs outside his window so difficult. One explanation is that he faced technical problems absent from his rural paintings. For instance, the anxieties he had about painting the crowd in another version of *Shrove Tuesday* led him to prepare the architectural setting in advance. And in the later *Avenue de l'Opéra, Sunshine, Winter Morning* (1898, FIG. 92), a pinprick in the centre of the painting betrays how he

90. CAMILLE PISSARRO
Shrove Tuesday on the Boulevards, 1897. Oil on canvas, 25 1/2 x 31 1/2" (64.9 x 80.1 cm). Fogg Art Museum, Harvard University Art Museums.

Pissarro may have painted this to please his dealer, who asked for bright paintings of the boulevards. At any rate, the artist was anxious about the subject, as he told his son Lucien in a letter of February 1897: "I have unpacked and I am stretching some large canvases. I am going to get one or two ready to paint the crowd on Shrove Tuesday. I don't know if I can manage it; I am very much afraid the serpentines will hamper me no end."

91. CAMILLE PISSARRO
Boulevard des Italiens, Morning, Sunlight Effect, 1897. Oil on canvas, 28 7/8 x 36 1/4" (73.2 x 92.1 cm). National Gallery of Art, Washington, DC.

Overleaf
92. CAMILLE PISSARRO
Avenue de l'Opéra, Sunshine, Winter Morning, 1898. Oil on canvas, 28 3/4 x 36 1/8" (73 x 91.8 cm). Musée des Beaux-Arts, Reims.

used threads to work out its perspective. None the less, there were precedents in the work of other Impressionists (notably Monet and Caillebotte), and it would therefore seem unlikely that Pissarro's difficulties were purely technical.

Rather, Pissarro seems to have been interested in making money out of these paintings and was prepared to compromise his artistic integrity if necessary with paintings of whose merit he was doubtful. For one thing, he had to paint these pictures from the windows of expensive hotel rooms, that is, from the physical and psychological point of view of a social type that he did not like. He seems to have been positively embarrassed by working on his series paintings in expensive hotels. In March 1897, for example, while working on the *Boulevard Montmartre* series, he wrote to the editor of the anarchist newspaper *La Révolte* from his room in the Hôtel de Russie: "I am at your service for the drawing you ask me for; I have been here for two months, in harness on a labour for Durand-Ruel. I will have finished this job in a fortnight."

The pressure from Durand-Ruel to produce appealing and saleable paintings out of this series was probably hard to bear for an uncompromising painter like Pissarro, for whom beauty was anything but prettiness. In a letter of September 1896, he also confided to Lucien that: "Durand recommends that I do paintings with sun so that they are light and luminous and of a selling effect!!!" And in subsequent years while he was working on the *Avenue de l'Opéra* series, Pissarro told his younger sons that he was anxious to ensure that he did make some "sunlight effects," even though the weather was not appropriate. It may even be that the small patches of sunlight in *Boulevard des Italiens, Morning, Sunlight Effect* were put in to please Durand-Ruel: they were plainly added at a late stage of the painting, and then populated with some hastily and thinly sketched street staffage to integrate them with the rest of the painting.

Unity and the City

It might be expected that a painter who spent much of his career making large paintings of large-scale figures would have given the city dweller a more monumental treatment than he did. However, the cityscapes unfailingly dwarf the city-dweller in Pissarro's work. Figures tend towards mere patches of tone or colour integrated into the harmony of the whole.

It could be argued that Pissarro's priorities were shifting from an engagement with reality towards purely pictorial

concerns. He was certainly very interested in the "unity" and the "harmony" of the painting as he grew older. In June 1895, for example, he told Lucien that Monet's *Cathedrals* series demonstrated to him the kind of unity he had been seeking. In the letter to Esther of 1903 quoted before, he told her that "at fifty, that was in 1880, I formulated the idea of unity, without being able to render it, at sixty I [began] to see the possibility of doing so." The most complete statement of how he saw and painted in later life comes in an account published the year after his death: "I only see stains. From the moment I begin a painting, the first thing I try to fix is the harmony [*l'accord*].... The great problem to resolve, is to bring everything, even the small details of the painting, into harmony with the whole, that's to say, into *accord*." However, this kind of formalist explanation has little to do with the ambitions Pissarro stated elsewhere. Moreover, Pissarro's work hitherto was such that if he painted with a view to unity in his late works, there must have been some expressive point to it. It is possible that the components of the paintings work in a way that expresses those values that he found so hard to see in the actual scenes he painted – democracy, interaction, give and take. In other words, pictures like *Shrove Tuesday on the Boulevards* may fail to represent democracy because it is only a sham, or a state-sponsored spectacle. But they still express it, or at least express the hope that a state of affairs might come about between human individuals which will be like the way that individual colours react on one another to form a harmonious whole, and yet retain their individuality. Certainly, in works like this, Pissarro is a long way from Corot's hierarchical technique in which one culminating point or bright spot is the keynote around which all the other tones harmonise. In Pissarro's paintings, no one tone rules: instead, colours associate demo-cratically, in a technique of a kind that Baudelaire once described as a kind of pictorial "anarchy."

However, Pissarro's anarchist beliefs are of little use in explaining why he spent the bulk of his last years from 1899 to 1903 painting pretty and saleable pictures of the Louvre and its gardens, when once it was the very symbol of all that was con-servative in art and thought for him – so much so that he once told Cézanne he would like to "burn [it] down." The like-lihood is that, finally, Pissarro succumbed to the exigencies of the very capital that he had spent the greater part of his maturity battling.

A Parisian boulevarde and the Porte St Denis photographed during the Second Empire (1852-70).

FIVE

Cézanne and the Problem of Form

"Art is a harmony parallel to nature." CÉZANNE

93. PAUL CÉZANNE
Still Life with Plaster Cast,
c. 1895. Oil on paper
mounted on panel or board,
27$\frac{1}{2}$ x 22$\frac{1}{2}$" (70.6 x 57.3 cm).
Courtauld Institute Galleries,
London.

Cézanne's work has received a variety of interpretations which are sometimes at odds with the facts and with one another. For one thing, his later work is often considered Post-Impressionist, even though this category was invented after Cézanne died, and meant nothing to him. Moreover formalist and psychoanalytical interpretations do not agree with one another, or with interpretations that seek to explain Cézanne's work in terms of his stated intentions.

The formalist way of looking at Cézanne was already well established by the second decade of this century when the English esthetic theorists Clive Bell and Roger Fry used the artist's work to illustrate their doctrine that good paintings possessed "significant form," or contained "forms arranged according to certain unknown and mysterious laws [which] move us in a particular way." For Bell, these forms were exclusively properties of the painting's surface as such – "combinations of lines and of colours," in his own words. However, this interpretation is consistent with Cézanne's own aims and objectives only if these are understood superficially. For instance, Cézanne did once point out how he saw the landscape at L'Estaque as a flat and decorative scene, but only to remark that this was an unusual effect of the strong sun, at odds with his usual preferences in landscape. Thus he wrote to

94. PAUL CÉZANNE
Landscape: Nature Study,
c. 1876. Oil on canvas, 16 ½
x 23 ¼" (42 x 59 cm). Venturi
Cat. 168.

Pissarro in 1876, in connection with the L'Estaque *Landscape: Nature Study* (c. 1876, FIG. 93):

> It's like a playing card. Red roofs against the blue sea... The sun here is so tremendous that it seems to me that the objects are defined in silhouette, not only in black, but in blue, in red, in brown, in violet. I may be mistaken, but it seems to me to be the antithesis of modelling.

The point Cézanne was trying to make was that nature looked odd at L'Estaque that summer because it did not demand, or even lend itself to, a three-dimensional treatment, as it usually did. The artist was certainly convinced that nature normally should be rendered this way: he told Emile Bernard in 1905 that "nature... is more depth than surface."

Notwithstanding such clear evidence, formalist commentators have used other remarks by Cézanne to make his work fit their way of seeing it. For instance, Cézanne's advice to Bernard to "treat nature by means of the cylinder, the sphere, the cone" in a letter of April 1904 has been interpreted to mean that Cézanne was interested in the pure forms of geometry. But

95. EMILE BERNARD
Breton Women in the Meadow, 1888. Oil on canvas, 29⅛ x 36¼" (74 x 92 cm). Private collection, Paris.

Cézanne regarded Bernard's painting in this style as flat. In a letter of April 1904, he advised the younger artist to "turn your back on the Gauguins and [Van] Goghs!" Ironically, it was not Gauguin or Van Gogh who first developed this style, but Bernard himself. In 1888, the critic Edouard Dujardin christened it "Cloisonnism" because its heavy contours enclosed areas of colour rather in the manner of the metal wires in *cloisonné* enamel.

Cézanne was giving a lesson in drawing to a painter whose work he considered incompetent and flat (see FIG. 95). His advice was probably a paraphrase of a manual on drawing and perspective by a Professor Thénot, *The Rules of Perspective Made Simple.* It is true that such quasi-geometrical forms sometimes find their way into Cézanne's paintings like *The Lake at Annecy (Le Lac d'Annecy,* 1896, FIG. 96) but they are present as volumes and not as decorative surface forms (in Bell's sense). And, if they appear more geometrical than natural forms, this is probably because they are schematically modelled.

96. PAUL CÉZANNE
The Lake at Annecy, 1896. Oil on canvas, 25¼ x 31⅛" (65 x 81 cm). Courtauld Institute Galleries, London.

Cézanne painted this landscape during a stay at Talloires in July 1896. In a letter he commented on his picturesque motif: "To relieve my boredom, I paint; it is not much fun, but the lake is very good with big hills all round, two thousand metres so they say, not as good as our home country, although without exaggeration it really is fine – But when one is born down there... nothing else means a thing."

Cézanne and Psychoanalysis

If the fault of formalism is to make Cézanne's painting all form and no content, psychoanalysis tends to the other extreme in making Cézanne's painting little more than the residue of the urges and anxieties which may or may not have lain behind it. To question its emphasis, however, is not to deny that it does provide compelling insights into Cézanne's work. The artist's letters and the known facts of his life strongly suggest that Cézanne was shy and inhibited when it came to love and sex. He seems to have fallen in love when young and again around the age of fifty, but lacked the courage to approach the women with whom he was infatuated. And many of Cézanne's early works, such as *The Rape* (c. 1867, FIG. 98), contain explicit and violent erotic imagery, suggesting that he sublimated into painting the sexual fantasies and desires that he found difficulty expressing in real life. Cézanne even referred to the style of these early paintings as *peinture couillarde* ("spunky painting") and *peinture au pistolet* ("painting done with a pistol").

Psychoanalytical interpretations have suggested that apples are significant features of Cézanne's early paintings which treat of sexual themes. In *The Amorous Shepherd* (mistitled *The Judgement of Paris*, 1883–5, FIG. 97) they facilitate mixing between the sexes. In such works apples also symbolise the female bodily qualities and the sexual fulfilment that sexual love promised Cézanne in fantasy. Apples are objects whose

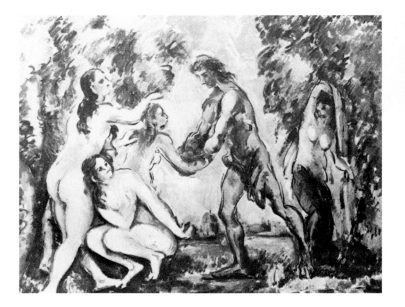

97. PAUL CÉZANNE
The Amorous Shepherd,
1883–5. Oil on canvas,
20½ x 24⅜" (52 x 62 cm).
Present location unknown.

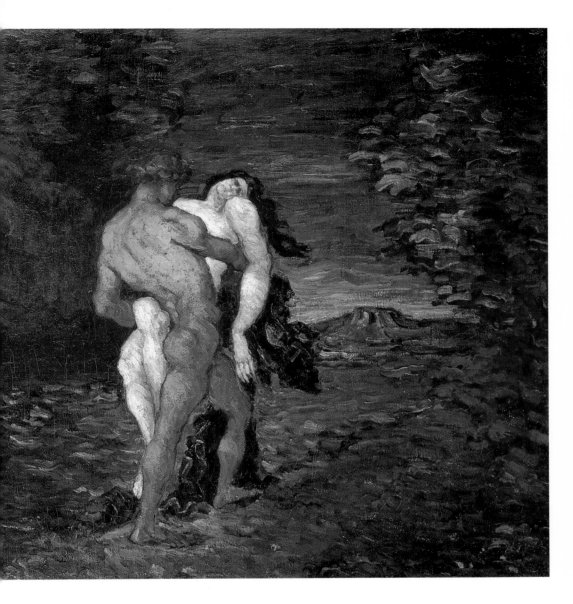

98. PAUL CÉZANNE
The Rape, c. 1867. Oil on canvas, 35¹/₂ x 46"
(90.5 x 117 cm). The Provost and Fellows of
Kings College, Cambridge, on loan to the
Fitzwilliam Museum, Cambridge.

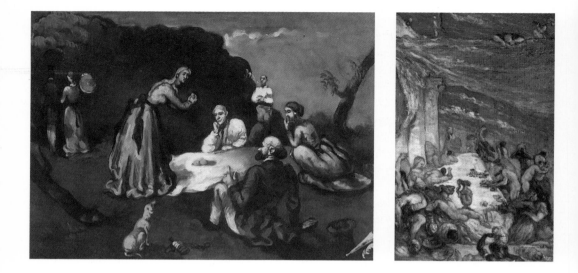

99. PAUL CÉZANNE
Luncheon on the Grass,
1869–70. Oil on canvas,
25³/₄ x 31³/₄" (60 x 81 cm).
Private collection, Paris.

roundness, ripeness, and penetrable skin lend themselves to male erotic fantasies about women's bodies. It comes as no surprise, then, that a woman offers an apple to a man who closely resembles Cézanne in *Luncheon on the Grass* (1869–70, FIG. 99). Given these associations, apples in works like *Still Life with Plaster Cast* (c. 1895, FIG. 93; also dated c. 1894) can be seen as expressing Cézanne's repressed erotic impulses. However, it is a weakness of this sort of account that it maintains Cézanne was unaware of what he was doing. In *Still Life with Plaster Cast*, the artist contrasts Cupid (the plaster cast) with the picture of the flayed man in the distance, rather as he contrasts sweet-tasting apples with bitter onions, as though to say deliberately that love is an ambivalent experience.

Another psychoanalytic view of Cézanne's work insists that it is laden with anxieties and guilt that the artist felt because of intimidation by his father – the Oedipus complex version of his work. Cézanne was indeed dominated by his father. Notably, it was only in 1886 when Cézanne *père* was 88 years old that he consented to his son's marriage. A work like *Luncheon on the Grass* can plausibly be linked to the feelings Cézanne might have had about his father, in that the shy Cézanne figure is being watched by a powerful man smoking a pipe in the background, who watches over and inhibits his timid response to the female figure's offer of an apple. Paintings like *The Orgy* or *The Feast* (c. 1870, FIG. 100) have also been linked to Cézanne's feelings about his father. Working from a long poem called *The Dream of Hannibal* that Cézanne wrote as young man, one

100. PAUL CÉZANNE
The Orgy or *The Feast,*
c. 1870. Oil on canvas, 51 x
31³/₄" (130 x 81 cm). Private
collection, Paris.

commentator has linked the excessive behaviour it depicts with the guilt-laden fantasies about promiscuity, drunkenness, and masturbation that the poem supposedly expresses. The same commentator has also pointed out how Cézanne's mature "Bather" compositions, for instance *The Large Bathers* (c. 1895–1906, FIG. 101), had their origins in his erotic compositions and in works like *The Temptation of Saint Anthony* (c. 1872–5, FIG. 102; also dated c. 1875), which reveals an identification with the saint who fled to the desert to escape temptation, only to be tormented by visions of a naked Queen of Sheba.

Such arguments have their merits. They help explain, for example, how even in the late "Bathers" women are accompanied by fruit, and how the same works betray a very hesitant approach to modelling the female body. But the generic problem that such interpretations raise is whether or not a painting of Cézanne's is merely to be reduced to its possible psychological causes. Analysing a painting into its unconscious sources is without doubt a viable technique, but it is questionable whether a painting is merely the sum of its constituents, any more than a beautiful scent is just a blend of the smells that make it up.

101. PAUL CÉZANNE
The Large Bathers,
c. 1895-1906. Oil on
canvas, 50¹/₈" x 6' 5¹/₈"
(127.2 x 196.1 cm).
National Gallery, London.

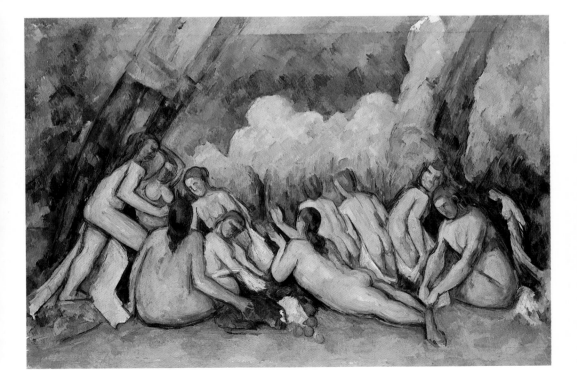

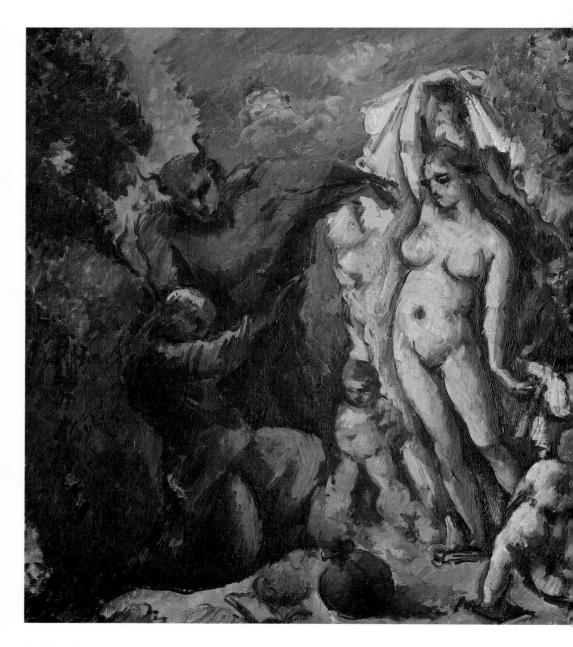

102. PAUL CÉZANNE
The Temptation of Saint Anthony, c. 1872-5.
Oil on canvas, 18¹/₂ x 22" (47 x 56 cm). Musée
d'Orsay, Paris.

Cézanne's "Optic"

Cézanne's own explanation of what he was trying to do naturally contrasts with the psychoanalytic account of his work. But since psychoanalysis of course maintains that unconscious impulses are just that, the two kinds of explanation are not mutually exclusive. Cézanne's own explanation does, however, largely dispense with any need to credit formalist explanations of his work. In particular, it gives the lie to the idea that he deliberately distorted objects in order to make his pictures decorative.

By his own account, there were two sides to Cézanne's practice: his "optic," or his theorised way of seeing, and his "logic," or his theorised way of organising his sensations inside the picture. Cézanne's "optic" is itself complex, but in essence, the artist was committed to the idea of seeing innocently. He said he saw in "stains" or spots of colour, and thus subscribed to the theory of innocence that the Impressionists derived from Ruskin and Taine. Cézanne also believed in seeing things without the preconceptions which determine how we normally see them. He said that he wished to see "like a man who has just been born" and in 1905 remarked to Bernard that it was the duty of painters to "Give the image of what we see, forgetting everything that has appeared before." That meant unlearning conventions of painting, like perspective, which might encourage a painter to impose a ready-made order on what he or she saw, or how it was painted. And that meant forgetting about other paintings when painting oneself. Thus Cézanne said: "Today our vision is a little tired, imposed on by the memory of a thousand images. And these museums, paintings in museums!... And exhibitions!... We don't see nature any more; we see the pictures."

So Cézanne had quite specific ideas about what innocence was, and these were anything but naive or uninformed. Like Pissarro, his innocence was based on familiarity with the work of a number of scientists and psychologists of perception. As he told Bernard in 1905: "Optics, which are developed in us by study, teach us to see."

Cézanne's fidelity to what he saw means that many of his paintings are full of what look like errors to eyes used to conventional perspective. *Still Life with Plaster Cast* is an outstanding example. For one thing, the apple in the background looks as if it is too big in comparison with the apples in the foreground. But if Cézanne were trying to see without

Paul Cézanne painting at Aix-en-Provence in 1904.

preconceptions, it might have looked that big, especially if it were a big apple. In these and other details Cézanne dispenses with the idealisations of perspective in this painting in order to paint what he sees.

The same goes for other features of such paintings, which formalists and Modernists have seen as incontrovertible evidence of Cézanne's formalist and Modernist intentions, his desire to make a feature of "flatness" and "surface." These are the relative flattening of background and foreground, and the tilting of objects such as the table top towards the surface of the painting. So-called flattening is simply a result of how Cézanne tended to work at a distance from his motif and select a small part of his visual field for the painting. From such a position, the space between near and far objects becomes compressed, rather as a telephoto lens produces a photograph which compresses the space between near and distant objects. Cézanne probably adopted such an unusual way of working as a result of reading J. D. Régnier's *On Light* (1869), where the author points out how the eye focuses on only a small section of the visual field. Explaining why objects in Cézanne's paintings appear "tilted" is another matter, although this is in fact another effect of Cézanne's fidelity to what he saw. It results from Cézanne recording how his eyes look at different parts of a scene from different angles, and hence look down on those parts of it which are below eye-level. The effect looks odd to us because the use of perspective has largely eliminated it from most paintings and because in a photograph the "eye" of a camera does not move.

Colour and Drawing in Cézanne

Formalist and Modernist interpretations of Cézanne's manner of composing the painting out of "flat" patches of colour parallel to the picture surface are also redundant. These "stains" are, rather, meant to model the "depth" Cézanne saw in nature. Cézanne did not believe the painter saw lines in nature, only colour patches, and hence he did not consider that lines had a place in the painting, at least ideally. Colour could and should do the job of drawing. Some of Cézanne's comments on these subjects are cryptic, but their cumulative message is clear. For example, he is thought to have said: "Pure drawing is an abstraction. Drawing and colour are not distinct, everything in nature being coloured." And also: "As one paints, one draws. Accuracy of colour [*ton*] gives at the same time light and the

modelling of the object." And on the same subject, Cézanne told Bernard:

> There is no line, there is no modelling, there are only contrasts.... From the exact relationship between colours [*tons*], modelling results. When they are harmoniously juxtaposed and they are all there, the painting models itself on it own.

and:

> Drawing and colour are not distinct; as one paints one draws; the more colour harmonises, the more the drawing becomes precise. When colour is at its richest, form is at its fullest.

Put simply, since Cézanne saw nature as colour patches arranged in "contrasts and relationships of colours," his aim was to organise the colour patches in his paintings in the same way. Or as he told Bernard, in a kind of summary of his ideas on colour vision and colour "drawing": "To read nature is to see it under the veil of its interpretation as coloured patches following one another according to a law of harmony. These colours are thus distinguished by modulations. To paint is to record sensations of colour." A basic explanation of how Cézanne achieved depth with this technique might begin with the fact that he organised colours in a harmonious play of warm and cool. Warm colours advance, cool colours recede: thus, in combination, and within a harmonious overall arrangement, they can be adjusted or "modulated" so as to produce salience and recession. However, Cézanne being the obsessive he was, no such simple explanation does justice to the complexity and subtlety of his actual procedure.

A Harmony Parallel to Nature

In a letter of September 1897 to Joachim Gasquet, a young admirer, Cézanne summed up the relationship between nature and art in the sentence: "Art is a harmony parallel to nature." That is, art can never copy nature in the sense that it can contain the same colours as those which exist in the natural scene; it can only ever produce colours whose relationships with one another are like, not the same as the relationships between the colours to be seen in nature.

Behind Cézanne's statement lies the fact that natural light is more powerful and wider in tonal range than the light a

painting reflects. A painting hung indoors reflects far less light, than, say, the Provençal landscape on a summer's afternoon. Moreover, the most luminous pigment in a picture is normally only about twenty times more reflective than the darkest pigment, while the eye can detect a much wider range of values in nature even if there are limits to its ability to discriminate brightnesses above a certain level. A representation can still look convincing because seeing depends on the fact that the eye registers comparative differences of value (or light and dark) between the various elements in the visual field and not absolute values of light. In fact, the eye and brain greatly simplify and compress the range of values which exist in nature. Accordingly, a painting can look convincing because it can produce a set of value differences which is similar to the set of value differences the eye sees in nature. Thus a moonlit scene and a desert scene can both look relatively persuasive even when hung on the same gallery wall. However, a painting can never reproduce exactly the differences that the eye sees in a brightly illuminated landscape, either as regards their intensity or their variety. The painter, in other words, must accept the limitations of the medium and seek to translate the values seen in nature into the diminished scale of values that is the best the painting can manage.

These facts were popularised by Helmholtz in his *Optics and Painting* (1878): "What the artist must give us is not a simple copy of the object, but a translation of his impression into another scale of sensation." Cézanne's remarks on the subject are so close to Helmholtz's as to suggest he knew this passage: "To paint is to seize a harmony among several relationships, it's to transpose them into a scale proper to them" Along the same lines, he said to the Symbolist painter Maurice Denis in 1906: "It is impossible to reproduce light, it must be represented by something else, by colours."

Cézanne relied on imitating as best he could what he saw as the way nature's colouring worked. He used in his paintings what he saw as the organising principle of colour in nature, "contrasts and relationships of colours". Accordingly, Cézanne often placed many complementary and near-complementary colours side by side, as in *In the Park of the Château Noir* (c. 1900, FIG. 103; also known as *The Grounds of Château Noir*). Apart from imitating colour in nature as Cézanne perceived it, this technique also has the advantage that it makes the painting appear intense. In other words, it simulates something of the brightness of outdoor natural light and colour, and produces a

psychological impact on the spectator that contains something of power or the sensation in which it originated. So, even if Cézanne could not reproduce light in his paintings, he could do the next best thing.

In order to achieve the desired effect, the contrasting touches, and every other colour in the painting, need to be organised so that they all harmonise together. Achieving this kind

103. PAUL CÉZANNE
In the Park of the Château Noir, c. 1900. Oil on canvas, 35³/₄ x 28¹/₄" (90.7 x 71.4 cm). National Gallery, London.

of "global" harmony was no small ambition. Cézanne often referred to his way of harmonising colour as "modulation" and in using this musical term, seems to be strongly implying that he saw the whole painting as if it were a piece of music, and its details as if they were notes which had to fit with the "key" of the whole.

Finishing the Painting

This procedure presents enormous difficulties, not least because of the diversity of effects of the colour relationships Cézanne aimed to control. Colours next to each other, or in a global harmony, affect each other's hue, intensity, and saturation, and thus need to be very carefully "tuned." Each patch of colour affects the apparent size and position in depth of the others which is why details of Impressionist paintings sometimes look flat and badly drawn in isolation, but seem "correct" when seen in the context of the whole painting. Given the inherent difficulties of his technique, Cézanne had to take great pains to get the global balance of colour right.

In a useful account Bernard tells us that Cézanne's progress on a painting was a "patient and attentive march" in which "all the parts are worked on at once, each accompanying the other." What he meant was that Cézanne worked up the whole depicting surface as a single entity, constantly re-working the various parts so that they stayed in harmony after each addition or alteration. Essentially, the problem was that every time Cézanne added a touch to the painting it had to be modulated to harmonise with what was already there; either that, or the existing portions of the painting had to be brought into harmony with the new touch. It is hardly surprising, then, to discover that many of the paintings of Cézanne's maturity are unfinished. Those that are near a state of completion almost certainly took a very long time to work up. (In a letter of 1903 Cézanne told Gasquet that a canvas he was working on needed another six months; and Bernard recalled in 1904 that Cézanne had spent ten years working on one version of *The Large Bathers.*)

Despite all these problems some canvases, like the *Château Noir,* did approach a state of completion. One that got to the very brink was the *Portrait of Ambroise Vollard* (1899, FIG. 104), only for Cézanne to find himself thwarted by being unable to find the right colour to finish off two small areas. Vollard recalls:

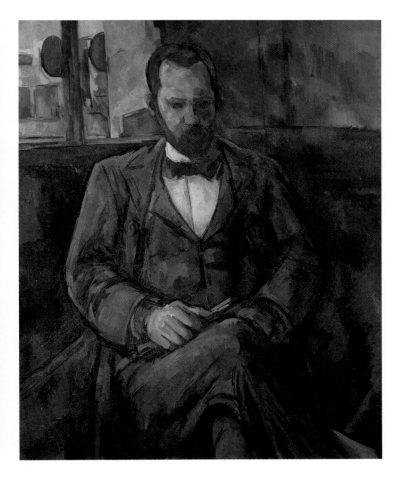

104. PAUL CÉZANNE
Portrait of Ambroise Vollard,
1899. Oil on canvas, 39$^1/_2$ x
32" (100 x 81 cm). Musée
du Petit Palais, Paris.

Once, towards five o'clock in the evening, he [Cézanne]
paused for a moment, and said, his face exuding
happiness: "Monsieur Vollard, I have good news for
you. I am sufficiently satisfied with my study so far, that
if the weather tomorrow is bright and overcast, I think
the session will be good."... Very few people have been
able to see Cézanne with his brush in hand; it was only
with great difficulty that he could bear being watched
while at his easel. For someone who has not seen him
paint, it is difficult to imagine the extent to which, some
days, his progress was slow and painful. In my portrait,
there are two little spots on the hand where the canvas is
not covered. I pointed them out to Cézanne. He replied:
"... I may be able to find the right colour [*ton*] with
which to fill in those blank patches. But understand a

105. PAUL CÉZANNE
Turn in the Road, 1900-6.
Oil on canvas, 29 x 37"
(73 x 92 cm). Courtauld
Institute Galleries, London.

little, Monsieur Vollard, if I put something there at random, I would be forced to begin my painting again, starting from that point."

The global harmony of colours in a painting by Cézanne is so delicate that it can easily be upset by the frame and the wall around it. Cézanne was careful to paint the walls of his last studio a light grey, ensuring that this neutral hue would not

interfere with the colour harmonies in his paintings. Similarly, he did not seem to frame his own paintings very often: in *Still Life with Plaster Cast*, for instance, none of the canvases represented are framed. When a work had to be given a frame, when it was sold or exhibited, for example, Cézanne preferred the frame not to be too bright or obtrusive.

One strategy that Cézanne developed in order to solve the problems of working towards global harmony was to sketch the main colour harmonies of the picture at its inception. These "incipient scales," as Bernard called them, make up paintings like *Turn in the Road* (*Route Tournante*, 1900-6, also dated 1902-6; FIG. 105). Cézanne seems to have abandoned many such works almost at the beginning, perhaps because of technical problems, and perhaps because ill health made it difficult for him to stay out on the motif towards the end of his life. In theory, starting the painting like this had the advantage of giving the artist an idea of the final colour harmony of the painting. And we might imagine that many of Cézanne's more finished paintings began like this before they were worked up to their final state.

Characteristically, the "finished" work is much richer in colour and contrast than the sketch, which makes sense if Cézanne saw colour contrast and harmony as his means of drawing. One such work is *Jug and Fruit* (1893-4, FIG. 106), where it can be seen that Cézanne used contour lines in the lay-in to help him keep the painting under control during its early stages. However, he only considered these as expedients which he inserted in the hope of replacing them with colour relationships later on. *Jug and Fruit* is an extraordinarily richly

106. PAUL CÉZANNE
Jug and Fruit. 1893-4. Oil on canvas, 17 x 24³/₄" (43.2 x 62.8 cm). National Gallery, London.

coloured and resolved painting, with a remarkable feeling of volume to it. Most of its contour lines are sunk beneath thick ridges of paint where Cézanne has "stitched" colour relationships together in a number of careful applications.

Obviously enough, oil paint helped Cézanne considerably, as it would dry relatively opaque and hide the earlier layers. Works in some other media, like *Still Life with Apples, Bottle, Glass, and Chair,* also known as *Still Life with Apples, Bottle, and Chairback,* (1902–6, FIG. 107), on the other hand, show all the changes (or *pentimenti*) that Cézanne made as he went along, notably the many lines he drew during the work's progress. These repeated contours may result in part from the difficulties Cézanne confessed he had with seeing edges; but they also result from the way that the global harmony of the painting affects the "drawing" of objects as it changes. Objects will appear to swell or contract and advance and recede as the colours around them change; and they will do the same sort of thing if their colour is changed without the harmony around them being adjusted. It is hardly a surprise, therefore, that Cézanne often reinstated contour lines at quite advanced stages of a painting's completion, as he did several times in *Still Life with Apples, Bottle, Glass, and Chair.* Similarly the many contour lines around the rocks in the foreground of the *Château Noir* show how Cézanne just could not do without them if he were to keep the "drawing" of even a relatively "finished" picture under control – for all he rejected the use of lines in principle.

Cézanne as Art

Cézanne knew that art could not be what it represented, and that – however paradoxically – it must maintain its distinctness from nature and exploit this if it were to resemble nature. In *Still Life with Plaster Cast*, he even made a visual joke about this simultaneous similarity and difference between art and nature. He confused the boundary between the (real) still life that the picture directly represents with the boundary of a (painted) *Still Life* that he included within the picture. In the lower right corner, it is difficult to see where the blue cloth on the table ends and the same blue cloth within the canvas against the wall begins. It is also hard to be certain whether or not the shoots of the onion on the left of the table are real or not, since the line marking the bottom edge of the painting behind rides over the junction between the onion's stem and its shoots.

These devices can be interpreted as showing that while art and nature were different, art could sometimes remake nature in its own terms well enough to make it difficult to see where one ended and the other began. Cézanne never wanted to be anything but faithful to nature and perhaps something of his humility is at work here. Seen another way, the same devices indicate Cézanne's awareness that, however much he tried to make his art a vehicle for conveying sensations, it was not just that – it was to some extent different from what it represented. He is reported to have said in 1902: "The transposition made by the painter, from a perspective of his own, gives a new interest to that part of nature which he has reproduced; he renders as a painter that which has not yet been painted; he makes it into painting in an absolute sense – that it to say something other than reality. This is no longer straight forward imitation."

Therefore, to work out what, finally, Cézanne did think about the relationship between art and nature is a considerable problem. But remarks like these suggest that the interest of Cézanne's late paintings does not lie in any subservience on their part to sensation, but in the way they express feelings of a particular sort. His works achieve this not because Cézanne was a formalist, even less because they were merely the efflux of his neurotic temperament. Cézanne's paintings produce effects and express feelings of which only they are capable because of the unique way that they represent volumes and spaces and touch, and transform whatever causes lie behind them.

Impressionism as Art

"The sensations which emanate from a work of art."

PISSARRO

It seems that the other Impressionists had at some time the same sort of realisation as Cézanne. Perhaps the very fact that they protested so adamantly that their art was faithful to sensation suggests that were actually uneasy about this. It is difficult, after all, to explain many aspects of Impressionist paintings simply as features which "map" what the artists saw: however assiduously this sort of explanation is pursued, it falls short of explaining why some Impressionist paintings look as they do. Furthermore, the Impressionists' own accounts fail to explain completely the expressive and esthetic effects of their paintings, just as these accounts rarely address their paintings' ideological complicities or effects. To say this does not contradict the fact that Impressionists themselves stated that they wanted to record sensations, and to develop novel and original techniques in order to do this. It is to suggest that they were more interested in making paintings for the effects that these could produce than they said they were.

Sometimes, however, the realisation of the unique affective qualities of the painting actually did inflect the way the Impressionists spoke of the sensation. For example, when writing to his son in September 1888 about the disadvantages of the Neo-Impressionist technique, Pissarro said he had to abandon it because it lacked "the freedom, the spontaneity, the freshness of sensation of our Impressionist art." Whatever else this statement means, it certainly implies strongly that the sensation was an effect that a painting produced. And Pissarro gave sensation much the same inflection when he wrote to Mirbeau in January 1892 that the majority of Symbolist painters had "no appreciation of the sensations which emanate from a work of art."

The Impressionists did occasionally reveal their interest in the effects that the picture produces. For instance, when Degas replied to Vollard's inquiry about how he could achieve such "brilliancy" in his pastels, he simply replied: "With the 'neutral tone,' by Jove!" Degas was really saying that a "neutral tone," or grey, makes its neighbouring colour more saturated and intense; so he was parodying the idea that an artist can achieve rich colour simply by using strong colours. But observation of this first principle brought the realisation that a picture which is organised in the terms it dictates is one which assumes an identity of its own, or a character that it does not share with the world of sensation in which it originates.

Whatever the Impressionists said, or realised, the effects proper to the picture came into play whenever they looked at the painting in the relevant way. To understand this it is important to appreciate that the artist is not just the agent of her or his painting, or the person who makes it; she or he is also the spectator of the painting, or the character for whom it is made. This has at least three important consequences. First, it will greatly facilitate the perception of a painting as art if the spectator can imagine the artist's own way of looking at it. A spectator can try to do this by finding kinds of coherence in the painting, or by retracing the artist's compositional decisions in any changes the painting might exhibit. Secondly, the painting will direct its own progress to the artist in two ways: either the satisfaction it yields will decide when it is right, or the way it is developing will affect the way the artist sees the world. Thirdly, the unconscious or intuitive perception of feedback from the painting partly determines the character of the artist while painting the picture, which may then reveal to her or him kinds of satisfaction that were previously unsuspected.

It was through making and remaking his paintings that Manet arrived at his special kind of composition that estranged or challenged the spectator in the picture. Arguably, painting *Woman in Black at the Opera* induced a kind of self-consciousness in Cassatt and made the spectator in this picture a more complex and uncertain character than the male viewer was wont to be. More obviously, with Degas, the way the surface of the painting could act as a metaphorical skin seems to have elicited from him a degree of imaginative identification with the female body that could surprise those who view him as a misogynist. For Pissarro, the way his technique dematerialised things gave him satisfaction because it prevented objects and women from becoming too tangible or resembling the

commodified contents of Salon art. In all these cases, the paintings presented their authors with surprising and perhaps unintended conclusions which could not have been reached had the artists followed the conventional rules of painting.

For all this, the Impressionists remained committed to basing their paintings in their sensations of reality. They had a variety of reasons for wanting to do this, some political, some esthetic. But not one of the Impressionists ever abandoned the belief that art must be rooted in reality. By the late 1880s, however, many artists sought different foundations for their art. Seurat, in the *Grande Jatte*, based his art on "harmony" and what he believed were the metaphysical essences or ideal prototypes behind appearances. In August 1888, Van Gogh told his brother Theo he was now an "arbitrary colourist" who sought to "exaggerate" what he saw in order to express his feelings "forcibly." Accordingly in September, he told Theo that in *The Night Café* (FIG. 108, c. 1888) he had "tried to express the terrible passions of humanity by means of red and green," adding: "It is not colour locally true from the point of view of the *trompe-l'oeil* realist, but colour to suggest some emotion of an ardent temperament." An equally radical example of the new art was Paul Gaughin's *Vision after the Sermon. Jacob Wrestling with the Angel* (1888, FIG. 109). In this, devout Breton peasants are represented experiencing a vision of Jacob wrestling with the Angel after a sermon on this theme. Not only does the painting show religious belief as a virtue, but it

108. VINCENT VAN GOGH
The Night Café, c. 1888.
Oil on canvas, 28¹/₂ x 36¹/₄"
(71.2 x 90.6 cm). Yale
University Art Gallery, New
Haven, CT.

109. PAUL GAUGUIN
Vision After the Sermon. Jacob Wrestling with the Angel, 1888. Oil on canvas, 28¾ x 36¼"
(73 x 92 cm). National Galleries of Scotland, Edinburgh.

In September 1888, shortly after he completed this work, Gauguin sent an explanation to Van Gogh: "I have just done a very badly made religious painting.... All in all it is very severe.... For me, in this painting, the landscape and wrestling match exist only in the imagination of the people in prayer following the sermon. This is why there is a contrast between the natural people and the wrestling match in its unnatural and disproportionate landscape."

elevates the inner life of the mind over that of outwardly-directed, sensuous experience. The red field in which Jacob wrestles with the angel even shows a completely different view on Gauguin's part of the idea of fidelity to sensation, which challenges head-on the esthetic on which Impressionism rested.

Hardly surprisingly, Pissarro disliked this kind of painting intensely. For a committed anarchist, an art that diverted attention from the real world was tantamount to escapism, and could be seen to collude with the forces of political reaction insofar as it diverted attention away from the struggle to achieve "justice." In 1891, Pissarro wrote a long critique of the new art and singled out the work of Gauguin as a prime example of its reactionary tendency towards mysticism. In indignation, he wrote with respect to the opinion of an erstwhile patron of his:

> De Bellio confessed to me that he had changed his view of Gauguin's work, that he now considered him a great talent. Why? It's a sign of the times, my dear. The bourgeoisie, astonished by the immense clamour of the disinherited masses feels it necessary to restore to the people their superstitious beliefs. Hence the bustlings of religious symbolists, religious socialists, idealist art, occultism, Buddhism, etc. etc. Gauguin has sensed this tendency. The Impressionists have the true position, they stand for robust art based on sensation, and that is an honest stand.

Pissarro may have been a little crude in his analysis of works like Gauguin's, and somewhat sanctimonious about the political virtues of his own art. However, he does make out a case for how an art that originates in sensation allows for that experience to remain a part of the transformation that the painting effects. While Pissarro did not deny that art was art, he wanted it to exhibit how it was made out of real experience. Pissarro was the Impressionist who most explicitly espoused the idea that art should exert a critical purchase on an imperfect and unjust reality. The other Impressionists may not have shared his radical politics, but all of them produced work that is poignant because it showed reality transformed. In other words, because the painting showed that it was a painting of a sensation, and at the same time showed that it was a painting (and not just some "map" of the perceived world), it showed how art could represent the world in a new way, and perhaps even offer a vision of what life might be like while it was not.

Bibliography

This book draws extensively on arguments or information contained in the items listed in the bibliography. In particular, the Introduction makes considerable use of Shiff; Chapter One draws in places on Herbert and Wollheim; Chapter Two is much indebted to arguments to be found in Garb and Pollock; and Chapter Three incorporates a large amount of information from House. The works by Lloyd, Wechsler, and Wollheim proved particularly useful in the writing of Chapters Four and Five and the Conclusion.

INTRODUCTION

CLARK, T. J., *The Painting of Modern Life: Paris in the Art of Manet and His Followers* (Princeton, N.J.: Princeton University Press; London: Thames and Hudson, 1985), is a rewarding account of Impressionism and its relationship to history from a theoretical point of view.

HARRISON, CHARLES, "Impressionism, Modernism, and Originality" in F. Frascina, N. Blake, B. Fer, T. Garb, and C. Harrison, *Modernity and Modernism* (New Haven and London: Yale University Press, 1993), presents a sustained, critical discussion of Impressionism in relation to Modernist thinking.

HERBERT, ROBERT L., *Impressionism: Art, Leisure, and Parisian Society* (New Haven and London: Yale University Press, 1988), gives the most comprehensive study of Impressionism from a social-historical perspective.

MOFFETT CHARLES (ed.), *The New Painting: Impressionism 1874-1886* (Geneva, Richard Burton S.A., 1986), contains a valuable series of essays on the Impressionist exhibitions.

NOCHLIN LINDA (ed.), *Impressionism and Post-Impressionism 1874-1904* (Englewood Cliffs, N.J.: Prentice Hall, 1966), collects a valuable set of accounts of their work by the Impressionists and witnesses to their practice.

REWALD, JOHN, *The History of Impressionism* (4th ed. New York: The Museum of Modern Art; London: Secker and Warburg, 1973), is still the most comprehensive factual account of Impressionism and the Impressionists' lives, even if it concentrates on personalities rather than works.

SCHAPIRO, MEYER, "The Nature of Abstract Art" in *Modern Art: 19th and 20th Centuries: Selected Papers* (New York and London: George Braziller, 1978), contains a highly perceptive, early discussion (originally published in 1937) of Impressionism from a Marxist perspective; "The Apples of Cézanne: An Essay in the meaning of Still Life" (originally published in 1968) in the same book is a pioneering account of Cézanne's work in relation to psychoanalysis.

SHIFF, R. L., *Cézanne and the End of Impressionism: A Study of the Theory, Technique and Critical Evaluation of Modern Art* (Chicago and London: University of Chicago Press, 1984), is an indispensable study of the Impressionists' ideas about their own practice and of the theoretical tradition out of which their work emerged.

CHAPTER ONE

BAREAU, J. W., "The Hidden Face of Manet," *Burlington Magazine* CXXVIII, 97 (April 1986), is an indispensable account of Manet's working methods based on X-rays of the paintings.

HAMILTON, GEORGE HEARD, *Manet and His Critics* (New Haven: Yale University Press, 1954), collects and discusses a valuable range of the criticism Manet's work received.

HANSON, ANNE COFFIN, *Manet and the Modern Tradition* (New Haven and London: Yale University Press, 1977), provides perhaps the most comprehensive study of Manet's work in relation to nineteenth-century artistic practice and esthetic theory.

MAUNER, GEORGE, *Manet: Peintre-Philosophe: A Study of the Painter's Themes* (University Park, Pa. and London: Pennsylvania State University Press, 1975), contains some valuable insights, if it is a little eccentric in places.

MOFFETT, CHARLES, FRANÇOIS CACHIN et al., *Manet: 1832–1883* (exh. cat., Paris: Galeries Nationales du Grand Palais; New York: Metropolitan Museum of Art, 1983), is a very thorough and informative catalogue of an exhibition featuring the majority of Manet's major works.

CHAPTER TWO

GARB, T., *Women Impressionists* (Oxford: Phaidon, 1986), provides a clear and accessible introduction to the subject.

—, "Gender and Representation" in F. Frascina, N. Blake, B. Fer, T. Garb, and C. Harrison, *Modernity and Modernism* (New Haven and London: Yale University Press, 1993), presents an overview of late nineteenth-century French art and Impressionism from a more theoretical perspective.

KENDALL, RICHARD, AND GRISELDA POLLOCK (eds), *Dealing with Degas: Representations of Women and the Politics of Vision* (London: Pandora Press, 1992), contains a series of essays analysing Degas's work in relation to the issues of gender and sexuality.

LIPTON, EUNICE, *Looking into Degas: Uneasy Images of Women and Modern Life* (Berkeley and London: University of California Press, 1986), is a vigorous investigation of Degas's work from a feminist position.

POLLOCK, GRISELDA, "Modernity and the Spaces of Femininity" in *Vision and Difference: Femininity, Feminism, and the Histories of Art* (London and New York: Routledge, 1988), offers a challenging series of insights into the effects of ideologies of gender on the activities, experience, and status of women artists.

CHAPTER THREE

HOUSE, JOHN, *Monet: Nature into Art* (New Haven and London: Yale University Press, 1986), is the most richly documented and comprehensive account of Monet's aims and methods.

REWALD, JOHN, AND FRANCES WEITZENHOFFER (eds), *Aspects of Monet: A Symposium on the Artist's Life and Times* (New York: Abrams, 1984), contains some valuable essays on aspects of Monet's practice and theory.

SPATE, VIRGINIA, *The Colour of Time: Claude Monet* (London and New York: Thames and Hudson, 1992), attempts to graft Monet's work into social-historical and psychoanalytical theory, with varying success.

TUCKER, PAUL, *Monet at Argenteuil* (New Haven and London: Yale University Press, 1980), gives a lucid treatment of Monet's paintings of the 1870s from the point of view of the social historian.

CHAPTER FOUR

BRETTELL, R., *Pissarro and Pontoise: The Painter in a Landscape* (New Haven and London: Yale University Press, 1990), is a conscientious study of Pissarro's paintings in relation to their environment in the 1870s.

BRETTELL, RICHARD, FRANÇOIS CACHIN et al., *Pissarro 1830–1903* (exh. cat., London: Hayward Gallery; Paris: Grand Palais; Boston: Museum of Fine Arts, 1980–81), contains a useful catalogue of many of the artist's works and essays on diverse aspects of his production.

LLOYD, CHRISTOPHER, (ed.), *Studies on Camille Pissarro* (New York and London: Routledge & Kegan Paul, 1986), contains pertinent essays on many aspects of the artist's work and career.

REWALD, JOHN (ed.), *Camille Pissarro: Letters to His Son Lucien* (translated by Lionel Abel., 4th ed. London and Henley: Routledge & Kegan Paul, 1980), is the best collection of the artist's letters in English and an invaluable source for Pissarro and Impressionism more generally.

SHIKES, R., AND P. HARPER, *Pissarro: His Life and Work* (New York: Horizon Press, 1980), is a thorough study of the artist's career and production.

CHAPTER FIVE

GOWING, LAWRENCE, et al., *Cézanne: The Early Years 1859–1872* (London: Royal Academy of Arts; Paris: Musée d'Orsay; Washington, D.C.: National Gallery of Art, 1988), is a well-conceived introduction to Cézanne's early painting.

KENDALL, RICHARD, *Cézanne by Himself* (London: MacDonald Orbis, 1988), contains a useful selection of commentaries on his art by Cézanne and by other artists and writers.

REWALD, JOHN (ed.), *Paul Cézanne: Letters* (4th ed. Oxford: Bruno Cassirer, 1976; rev. ed. New York: Hacker Art Books, 1984), is an invaluable collection of the artist's views on art.

RUBIN, WILLIAM (ed.), *Cézanne: The Late Work* (exh. cat., New York: Museum of Modern Art, 1977; London: Thames and Hudson, 1978), contains a useful series of essays on the paintings Cézanne made in the last decade of his life and their relation to his theory of art.

WECHSLER, JUDITH (ed.), *Cézanne in Perspective* (Englewood Cliffs, N.J.: Prentice Hall, 1975), contains a useful selection of commentaries on his art by Cézanne and by some of the artists and writers who visited him in later life.

CONCLUSION

KEMAL, S., and I. GASKELL (eds.), *The Language of Art History* (Cambridge: Cambridge University Press, 1991), contains a number of useful essays on the difference between the effects paintings produce and the language that attempts to describe these.

WOLLHEIM, RICHARD, *Painting as an Art* (Princeton, N.J.: Princeton University Press; London: Thames and Hudson, 1987), is a searching and lucid analysis of the subject.

Picture Credits

Numbers to the left refer to figure numbers unless otherwise indicated.
The following abbreviations have been used:
Coll: Collection
Paul Maeyaert: Fotografie Paul M.R. Maeyaert, Mont de l'Enclus-Orroir, Belgium

Title page Coll. & photo: Musée Marmottan, Paris
1 Coll. & photo: Musée Marmottan, Paris
page 7 detail of 2, Claude Monet, *Impression, Sunrise*, 1873. Coll. & photo: Musée Marmottan, Paris
2 Coll. & photo: Musée Marmottan, Paris
3 Coll: Musée d'Orsay, Paris; photo: RMN
4 Coll. & photo: Sterling and Francine Clark Art Institute, Williamstown Massachusetts
5 Coll: Musée d'Orsay, Paris; photo: Paul Maeyaert
6 Coll. & photo: The Nelson-Atkins Museum of Art, Kansas City, Missouri (Purchase: The Kenneth A. and Helen F. Spencer Foundation Acquisition Fund) F72-35
7 Coll: Musée d'Orsay, Paris; photo: RMN
8 Coll. & photo: Ashmolean Museum, Oxford
9 Coll: Pushkin Museum, Moscow
10 Coll: Musée du Louvre, Paris; photo RMN
11 Coll. & photo: Courtauld Institute Galleries, London
12 Coll. & photo: National Museum of Wales, Cardiff (lent by the Earl of Plymouth, Oakley Park, Shropshire)
13 Coll. & photo: Allen Memorial Art Museum, Oberlin College, Ohio. R.T. Miller, Jr. Fund 1948
14 Coll: National Gallery of Art, Washington, D.C. Collection of Mr and Mrs Paul Mellon; photo © 1994 National Gallery of Art, Washington, D.C.
15 Coll. & photo: Metropolitan Museum of Art, New York
16 Coll. & photo: British Museum, London
17 Coll: Musée d'Orsay, Paris; photo: RMN
page 33 detail of 28, Edouard Manet, *Le Déjeuner sur l'herbe*, 1863. Coll: Musée d'Orsay, Paris; photo: RMN
18 Present location unknown; photo: Calmann & King Archives, London
19 Coll. & photo: Anonymous loan to the Fitzwilliam Museum, Cambridge
20 Coll: Sutton Place Foundation, Guildford; photo: Christies, New York
21 Coll: Musée d'Orsay, Paris; photo: RMN
22 Coll. & photo: National Gallery, London
23 Private collection
page 42 Calmann & King Archives, London
24 Coll. & photo: Ny Carlsberg Glyptotek, Copenhagen
25 Coll: National Gallery of Art, Washington, D.C. (Chester Dale Collection); photo: © 1994 National

Gallery of Art, Washington, D.C.
26 Coll. & photo: Museo del Prado, Madrid
27 Coll. & photo: Bibliothèque Nationale, Paris
28 Coll: Musée d'Orsay, Paris; photo: RMN
29 Coll: Musée d'Orsay, Paris; photo: RMN
30 Coll: Uffizi, Florence; photo: Alinari
31 Coll. & photo: National Gallery, London
32 Coll. & photo: The Walters Art Gallery, Baltimore
33 Coll. & photo: Courtauld Institute Galleries, London
34 photo: Calmann & King Archives, London
35 Coll: Musée d'Orsay, Paris; photo: RMN
36 As 5.
page 59 detail of 45, Eva Gonzales, *A Box at the Théâtre des Italiens*, c. 1874. Coll: Musée d'Orsay, Paris; photo: Paul Maeyaert
37 Coll. & photo: Courtauld Institute Galleries, London
38 Coll: National Gallery of Art, Washington, D.C. (Collection of Mr and Mrs Paul Mellon); photo © 1994 National Gallery of Art, Washington, D.C.
39 Coll. & photo: M. Theresa B. Hopkins Fund, Museum of Fine Arts, Boston
40 Coll: Santa Barbara Museum of Art, Gift of Mrs. Hugh N. Kirkland
41 Coll. & photo: National Gallery, London
42 Metropolitan Museum of Art, New York. H.O. Havemeyer Collection, bequest of Mrs. H.O. Havemeyer, 1929
43 Coll. & photo: The Nelson-Atkins Museum of Art, Kansas City, Missouri (Purchase: Acquired through the generosity of an anonymous donor)
44 Coll. & photo: The Hayden Collection, Museum of Fine Arts, Boston
45 As 5.
46 Coll: National Gallery of Art, Washington, D.C. (Chester Dale Collection); photo © 1994 National Gallery of Art, Washington, D.C.
47 Coll. & photo: Galerie Hopkins Thomas, Paris
page 77 Calmann & King Archives, London
48 Coll. & photo: National Gallery, London
49 Coll. & photo: The Metropolitan Museum of Art, H.O. Havemeyer Collection, bequest of Mrs. H.O. Havemeyer, 1929.
50 Coll: Musée d'Orsay, Paris; photo: RMN
page 83 detail of 59, Claude Monet, *Interior of Saint-Lazare Station*, 1877. Coll: Musée d'Orsay, Paris (Gustave Caillebotte Bequest); photo: Paul Maeyaert
51 Coll: Musée des Beaux Arts, Lausanne; photo MCBA - JC Ducret
52 Coll. & photo: Kunsthalle, Bremen
53 Coll: Musée d'Orsay, Paris; photo: RMN
54 Coll. & photo: National Gallery, London
55 Coll. & photo: Metropolitan Museum of Art, New York
56 Coll. & photo: Courtauld Institute

Galleries, London
57 As 5.
58 Coll. & photo: Philadelphia Museum of Art (John G. Johnson Collection)
59 Coll: Musée d'Orsay, Paris (Gustave Caillebotte Bequest); photo: Paul Maeyaert
60 Coll. & photo: North Carolina Museum of Art, Raleigh
61 Coll: Lyon, Musée des Beaux Arts; photo: Studio Basset, Lyon
page 100 Durand Ruel and Weidenfeld & Nicolson Archives
62 Coll: National Gallery of Scotland, Edinburgh; photo: National Galleries of Scotland
63 Coll. & photo: Museum of Fine Arts, Boston (gift of Misses Aimée and Rosamond Lamb in Memory of Mr. and Mrs. Horatio A. Lamb)
64 Coll. & photo: Museum of Fine Arts, Boston (Juliana Cheney Edwards Collection)
65 Coll: Art Institute of Chicago. Helen Birch Bartlett Memorial Collection, 1926.224; photo © 1995 The Art Institute of Chicago. All Rights Reserved.
66 Coll. & photo: Tate Gallery, London
67 Coll. & photo: Metropolitan Museum of Art, New York (bequest of Lillian S. Timken)
68 As 5.
69 Coll. & photo: Philadelphia Museum of Art (George W. Elkins Collection)
70 Coll: Musée d'Orsay, Paris; photo: RMN
71 Coll: Private collection (On loan to Sheffield City Art Galleries); photo: Sheffield City Art Gallery
page 113 detail of 77, Camille Pissarro, *The Donkey Ride at La Roche-Guyon*, c. 1865. Coll: Mr Tim Rice, London
72 Coll. & photo: National Gallery, London
73 Coll: Musée d'Orsay, Paris; photo: RMN
74 Coll: The Earl of Jersey; photo: Robin Briault, St. Ouen
75 Coll. & photo: Museum of Fine Arts, Springfield, Mass. (James Philip Gray Collection)
76 Coll: The Earl of Jersey; photo: Robin Briault, St. Ouen
77 Coll: Mr Tim Rice, London
78 As 5.
79 Coll. & photo: National Gallery, London
80 As 5.
81 Coll: The Art Institute of Chicago (Mr. & Mrs. Potter Palmer Collection 1922.433); photo 1995, The Art Institute of Chicago. All Rights Reserved.
82 Private collection
83 Coll. & photo: Ashmolean Museum, Oxford
84 Coll: Paul Smith, Bristol
85 Coll: Musée du Louvre, Paris; photo: RMN
86 Coll. & photo: National Gallery of Art, Washington, D.C. (Samuel H. Kress

Collection, 1946)
87 Coll. & photo: The Nelson-Atkins Museum of Art, Kansas City, Missouri (Purchase: Nelson Trust) 33-150
88 Coll. & photo: Museum of Fine Arts, Boston (Bequest of John T. Spaulding)
89 Private collection, Geneva
90 Coll. & photo: Fogg Art Museum, Harvard University Art Museums (Bequest-collection of Maurice Wertheim, Class of 1906)
91 Coll: National Gallery of Art, Washington, D.C. (Chester Dale Collection); photo © 1994 National Gallery of Art, Washington, D.C.
92 Coll. & photo: Musée des Beaux-Arts, Reims
page 143 Roger-Viollet, Paris
93 Coll. & photo: Courtauld Institute Galleries, London

page 145 detail of 104, Paul Cézanne, Portrait of Ambroise Vollard, 1899. Musée du Petit Palais, Paris, photothèque des Musées de la Ville de Paris © DACS 1995
94 Private collection
95 Private collection, Paris
96 Coll. & photo: Courtauld Institute Galleries, London
97 Present location unknown
98 Coll: The Provost and Fellows of Kings College, Cambridge. On loan to the Fitzwilliam Museum, Cambridge; photo: The Fitzwilliam Museum
99 Private collection, Paris
100 Private collection, Paris
101 Coll. & photo: National Gallery, London
102 As 5.
page 154 Sirot and Weidenfeld & Nicolson Archives

103 Coll. & photo: National Gallery, London
104 Coll: Musée du Petit Palais, Paris, Photothèque des Musées de la Ville de Paris © DACS 1995
105 Coll. & photo: Courtauld Institute Galleries, London
106 Coll. & photo: National Gallery, London (Berggruen Collection)
107 Coll. & photo: Courtauld Institute Galleries, London
page 165 detail of 24, Edouard Manet, The Absinthe Drinker, 1858-59. Coll. & photo: Ny Carlsberg Glyptotek, Copenhagen
108 Coll. & photo: Yale University Art Gallery, New Haven, Connecticut (Bequest of Stephen Carlton Clark, BA., 1903)
109 Coll. & photo: National Galleries of Scotland, Edinburgh

Index

Figure numbers are given in Italic.

Absinthe Drinker, The (Manet) 45, 24, 164
Académie des Beaux-Arts 9-10, 84, 129
Académie Suisse 9
Adam, Paul: The Little Directory of Letters and the Arts 136
After the Bath, Woman Drying Herself (Degas) 69, 77, 78, 79-80, 48
Amorous Shepherd, The (Cézanne) 148, 97
Apotheosis of Homer, The (Ingres) 35, 129-30, 85
Artiste, L' 19
Artist's Father, The (Cézanne) see Portrait of Louis-Auguste Cézanne
At the Opera (Cassatt) see Woman in Black at the Opera
At the Theatre (Woman in a Loge) (Cassatt) 71, 73, 43
Autumn Effect at Argenteuil (Monet) 93-5, 56
Autumn, the Haystacks (Millet) 107-8, 67
Avenue de l'Opéra, Sunshine, Winter Morning (Pissarro) 139, 142, 92

Balcony, The (Manet) 57, 17
Balzac, Honoré de 13
Cousine Bette 133
Bank of the Epte (Monet) see Poplars
Banks of the Marne in Winter (Pissarro) 114
Bar at the Folies-Bergère, A (Manet) 53-5, 33-4

Bashkirtseff, Marie 68
Bathing Place at La Grenouillère, The (Monet) 89-93, 54
Baudelaire, Charles 37, 39, 42, 143
The Painter of Modern Life 33, 35-6, 37, 42, 45, 57
"Ragpickers' Wine" (from The Flowers of Evil) 45, 46
"To a Woman Passing By" 40
Bazille, Frédéric 9, 83; Monet to 89, 91
Bazin, A. 36
Bell, Clive 145
Bernard, Emile 158, 161; Cézanne to 22, 31, 110, 129, 146-7, 153, 155
Breton Women in the Meadow 147, 95
Berthe Morisot With a Fan (Manet) 57, 35
Birth of Venus, The (Cabanel) 9, 10, 12, 49, 3
Blanc, Charles 104, 128
Boating (Manet) 69, 42
Bonjour M. Courbet (Courbet) 46
Boudin, Eugène 9
Bouguereau, William Adolphe 24
Nymphs and Satyr 12, 4
Boulevard des Capucines (Monet) 19, 6
Boulevard des Italiens, Morning, Sunlight Effect (Pissarro) 139, 142, 91
Box at the Théâtre des Italiens (Gonzales) 71-3, 45
Breton Women in the Meadow (Bernard) 147, 95

Cabanel, Alexandre: The Birth of Venus 9, 10, 12, 49, 3
Café-Concert (Manet) 52, 32
Caillebotte, Gustave 142
Young Man at his Window 41-2, 23
Camille (Camille in a Green Dress) (Monet) 87, 52
Carolus-Duran: The Woman with the Glove 87, 53
Cassatt, Mary 11, 14, 66, 68, 69
At the Opera see Woman in Black at the Opera
At the Theatre (Woman in a Loge) 71, 73, 43
Five O'Clock Tea 64, 68, 39
Girl Arranging Her Hair see Study
Little Girl in a Blue Armchair 64, 38
Study (Girl Arranging Her Hair) 74, 76-7, 46
Woman in Black at the Opera 71, 73-4, 81, 166, 44
Woman in a Loge see At the Theatre
Castagnary, Jules 19, 22
Cézanne, Paul 7, 15, 22, 23-4, 28, 31, 129, 143, 145-63
The Amorous Shepherd 148, 97
Le Déjeuner sur l'herbe see Luncheón on the Grass
The Dream of Hannibal (poem) 151
The Feast see The Orgy
In the Park of the Château Noir (The Grounds of Château Noir) 156, 158, 162, 103
Jug and Fruit 161-2, 106

The Lake at Annecy (Le Lac d'Annecy) 147, *96*
Landscape: Nature Study 145-6, *94*
The Large Bathers 151, 158, *101*
Luncheon on the Grass (Le Déjeuner sur l'herbe) 150, *99*
Mont Sainte-Victoire (La Montagne Sainte-Victoire) 24, *11*
Mont Sainte-Victoire seen from Les Lauves 108, 110, *69*
The Orgy (The Feast) 150-51, *100*
Portrait of Louis-Auguste Cézanne, the Artist's Father, Reading L'Evénement (The Artist's Father) 28, *14*
Portrait of Ambroise Vollard 158-60, *104*
The Rape 148, *98*
Still Life with Apples, Bottle, Glass, and Chair (Still Life with Apples, Bottle, and Chairback) 162, *107*
Still Life with Melon 162
Still Life with Plaster Cast 150, 153-4, 161, 163, *93*
The Temptation of Saint Anthony 151, *102*
Turn in the Road (Route Tournante) 161, *105*
Château Noir see In the Park of the Château Noir (Cézanne)
Chemin de Sèvres, Vue vers Paris (Corot) see Sèvres-Brimborion...
Chevreul, Eugène 122, 127
colour circle (from On Colours and their Applications) 125, *82*
Clemenceau, Georges 102
Cliff, Etretat, Sunset (Monet) see Sunset, Etretat
Comte, Auguste 21
Corner in a Café-Concert (Manet) 52-3, *31*
Corot, Camille 19, 113, 114, 115, 122, 143
Sèvres-Brimborion, View Towards Paris (Le Chemin de Sèvres, Vue sur Paris) 113, *73*
Côtes Saint-Denis, The (The Côtes des Boeufs) (Pissarro) 121-2, 125, *79*
Courbet, Gustave 88
Bonjour M. Courbet 46
Couture, Thomas 43
Cradle, The (Morisot) 64, *36*

Dancer Looking at the Sole of Her Right Foot (Degas) 80, *49*
Degas, Edgar 11, 14, 36, 69, 76, 77, 79, 80-81, 134, 166

After the Bath, Woman Drying Herself 69, 77, 78, 79- 80, *48*
Dancer Looking at the Sole of Her Right Foot 80, *49*
Place de la Concorde 33, 36, *18*
Suite of Female Nudes Bathing, Washing, Drying... 77-8
Woman Drying Herself see After the Bath, Woman Drying Herself
Women on a Café Terrace, Evening (Women in front of a Café Terrace, Evening) 39, *21*
Déjeuner sur l'herbe, Le see Luncheon on the Grass (Cézanne; Manet)
Denis, Maurice, Cézanne to 156
Dictionnaire de la langue française 21
Dimanche d'été à l'Île de la Grande Jatte, 1884, Un (Seurat) 105, 167, *65*
Donkey Ride at La Roche-Guyon, The (Pissarro) 117, 120, *77*
Durand-Ruel, Paul 102, 139, 142; Monet to 101; Pissarro to 127
Duret, Théodore 8-9, 22, 31, 87

Ecole des Beaux-Arts 9, 10, 35
Etretat (Monet) see Sunset, Etretat
Etretat, Choppy Sea (Monet) 99, *61*
Evénement, L' (newspaper) 28

Factory Near Pontoise (Pissarro) 116, *75*
Feast, The (Cézanne) see Orgy, The
feminist views 14, 60, 66
Fénéon, Félix 127, 128
Five O'Clock Tea (Cassatt) 64, 68, *39*
Formalist approaches 11-12, 145, 146, 148, 154
Fournel, Victor 41
Freud, Sigmund 65
Fry, Roger 145

Garden of the Princess, The (Monet) 24, *13*
Gasquet, Joachim 24; Cézanne to 155, 158
Gauguin, Paul 169
Vision After the Sermon. Jacob Wrestling with the Angel 167, 169, *109*
Girl Arranging Her Hair (Cassatt) see Study (Girl Arranging Her Hair)
Gleyre, Charles 9, 83
Minerva and the Graces 9, 84-5, 87, *51*
Goeneutte, Norbert 11
Gogh, Vincent van 167, 168
The Night Cafe 167, *108*
Gonzales, Eva: A Box at the Théâtre des Italiens 71-3, *45*
Grainstacks series (Monet) 100-2, 105,

107, 108, *62-4*
Green Reflections (Monet) 111, *70*
Grenouillère, La (Monet) 23, 89-91, *55*
Grenouillère, La (Renoir) 23, *9*
Grounds of Château Noir, The (Cézanne) see In the Park of the Château Noir
Guys, Constantin 33, 35, 57
Promenade in the Bois de Boulogne 20

Helmholtz, Hermann von 126, 127
Optics and Painting 156
Henriet, F. 121
Hervilly, Ernest d' 70
Hoarfrost: The Old Road to Ennery, Pontoise (Pissarro) 19, *5*
Hokusai, Katsushika 78
The Sazai Pavilion of the Temple of Five Hundred Rakan 31, *16*
Hoschedé, Alice 99; Monet to 100, 105
Huysmans, Joris-Karl: Modern Art 79

Impression, Sunrise (Monet) 8, 11, 12-13, 14, 15, 19, *2*
Impressionists in 1886, The (pamphlet) 127
In the Park of the Château Noir (The Grounds of Château Noir) (Cézanne) 156, 158, 162, *103*
Ingres, Jean-Auguste-Dominique: The Apotheosis of Homer 35, 129-30, *85*
Madame Moitessier 130, 132-3, *86*

Janin, Jules 13
Japanese influences 31, 69, 77
Jongkind, Johan Barthold 9, 19, 20-21
The Seine and Notre-Dame 19, *7*
View of Notre-Dame 19, *8*
Journal Amusant, Le 55, *34*
Judgement of Paris, The (Cézanne) see Amorous Shepherd, The
Jug and Fruit (Cézanne) 161-2, *106*

Kahn, Gustave 134
Kropotkin, Pierre 136, 137

Lacan, Jacques 65
Lake at Annecy, The (Le Lac d'Annecy) (Cezanne) 147, *96*
Landscape: Nature Study (Cézanne) 145-6, *94*
Landscape with the Funeral of Phocion (Poussin) 24, *12*
Lanterne, La (journal) 120
Large Bathers, The (Cézanne) 151, 158, *101*
Lavater, Johann-Kaspar 39

Leroy, Louis 19
Little Girl in a Blue Armchair (Cassatt) 64, *38*
Littré, Emile 21
Loge, La (The Theatre Box) (Renoir) 60-62, 65, 72, 73, *37·*
Luncheon on the Grass (Le Déjeuner sur l'herbe) (Cézanne) 150, *99*
Luncheon on the Grass (Le Déjeuner sur l'herbe) (Manet) 46, 49, *28*

Mallarmé, Stéphane 67
Manet, Edouard 11, 19, 28, 33, 42, 46, 55, 57, 59, 69, 87, 166
 The Absinthe Drinker 45, *24*
 The Balcony 57, *17*
 A Bar at the Folies-Bergère 53-5, *33-4*
 Boating 69, *42*
 Café-Concert 52, *32*
 Corner in a Café-Concert 52-3, *31*
 Le Déjeuner sur l'herbe (Luncheon on the Grass) 46, 49, *28*
 Berthe Morisot With a Fan 57, *35*
 Music in the Tuileries 42-5
 Nymph Taken by Surprise 46, *27*
 The Old Musician 45, *25*
 Olympia 49-51, *29*
 Profile portrait of Charles Baudelaire 42
Mardi Gras on the Boulevard Montmartre (Pissarro) see *Shrove Tuesday on the Boulevards*
Market at Pontoise, The (Pissarro) 134, 87
Maupassant, Guy de 26, 99
 Bel Ami 54
Maus, Octave 75
Mennipus (Velásquez) 45, *26*
Millet, Jean-Francois: *Autumn, the Haystacks* 107-8, *67*
Minerva and the Graces (Minerva) 9, 84-5, 87, *51*
Mirbeau, Octave, Pissarro to 136, 165
Modernist approaches 11-12, 154
Moitessier, Madame (Ingres) 130, 132-3, *86*
Monet, Claude 8-9, 10, 11, 14, 20, 21, 24, 26-8, 83-111, 115, 142, 143
 Autumn Effect at Argenteuil 93-5, *56*
 The Bathing Place at La Grenouillère 89-93, *54*
 Boulevard des Capucines 19, *6*
 Camille (Camille in a Green Dress) 87, *52*
 Etretat, Choppy Sea 99, *61*
 The Garden of the Princess 24, *13*
 Grainstacks series 100-2, 105, 107,

108, *62-4*
 Green Reflections 111, *70*
 La Grenouillère 23, 89-90, *55*
 Impression, Sunrise 8, 11, 12-13, 14, 15, 19, *2*
 Interior of Saint-Lazare Station 99, *59*
 Poplars series 107, *66*
 The Railway Bridge, Argenteuil (I) 95, 99, *57*
 The Railway Bridge, Argenteuil (II) 95, 99, *58*
 Rouen Cathedral, Sunlight Effect, End of Day 27, 110, *1*
 Rouen Cathedral, the West Portal and the Tour d'Albane, Harmony in Blue 108, 110, *68*
 Sunset, Etretat (The Cliff, Etretat, Sunset) 99, *60*
 Terrace at Sainte-Adresse 31, *15*
 Women in the Garden 84-5, 87-9, *50*
Mont Sainte-Victoire (La Montagne Sainte-Victoire) (Cézanne) 24, *11*
Mont Sainte-Victoire seen from Les Lauves (Cézanne) 108, 110, *69*
Moore, George *34*, 77, 78
Morisot, Berthe 11, 14, 57, 59, 66, 67, 68, 69
 The Cradle 64, *36*
 Summer's Day 67, 68, *41*
 View of Paris from the Trocadero 67, 68, *40*
 Young Woman Drying Herself 76, *47*
Music in the Tuileries (Manet) 42-5

Napoléon III, Emperor 10, 46, 84
Neo-Impressionism 128, 133, 165
Newton, Isaac 125, 127
Night Café, The (Van Gogh) 167, 108
Nymph Taken by Surprise (Manet) 46, 27
Nymphs and Satyr (Bouguereau) 12, *4*

Oise in Spate, The (Pissarro) 116-17, *76*
Old Musician, The (Manet) 45, *25*
Olympia (Manet) 49-51, *29*
Orchard, Côtes Saint-Denis at Pontoise (Pissarro) see *Red Roofs*
Orgy, The (The Feast) (Cézanne) 150-51, *100*

Painter of Modern Life, The (Baudelaire) 33, 35-6, 37, 42, 45, 57
Peasant Women Planting Pea-Sticks (Pissarro) 137, *71*
Perry, Lilla Cabot, Monet to 27, 107
Peupliers au Bord de L'Epte, Les

(Poplars) (Monet) 107, *66*
physiologies 36, 37
Pilgrimage to Cythera (Watteau) 23, *10*
Pissarro, Camille 9, 10, 23, 27, 59, 84, 101, 107, 113-43, 146, 153, 165, 166, 169
 Avenue de l'Opéra, Sunshine, Winter Morning 139, 142, *92*
 Banks of the Marne in Winter 114
 Boulevard des Italiens, Morning, Sunlight Effect 139, 142, *91*
 The Côtes Saint-Denis (The Côtes des Boeufs) 121-2, 125, *79*
 The Donkey Ride at La Roche-Guyon 117, 120, *77*
 Factory Near Pontoise 116, *75*
 Hoarfrost: The Old Road to Ennery, Pontoise 19, *5*
 Mardi Gras on the Boulevard Montmartre see *Shrove Tuesday on the Boulevards*
 The Market at Pontoise 134, *87*
 The Oise in Spate 116-17, *76*
 The Orchard see *Red Roofs*
 Peasant Women Planting Pea-Sticks 137, *71*
 The Poultry Market, Gisors 134, *88*
 Red Roofs (The Orchard, Côtes Saint-Denis at Pontoise) 121-2, 125, *78*
 The Seine at La Grenouillère 115, *74*
 Shrove Tuesday on the Boulevards (Mardi Gras on the Boulevard Montmartre) 139, 143, *90*
 The Social Turpitudes 139, *89*
 View from Louveciennes 113-14, *72*
 View From My Window, Eragny (View From My Window, Overcast Weather) 125, 127, *83*
 Young Peasant Girl Drinking Coffee 125, *81*
 Young Peasant Girl with a Stick (The Shepherdess) 125, 134, 136, *80*
Pissarro, Georges, Camille Pissarro to 139
Pissarro, Lucien, Camille Pissarro to 23, 121, 122-3, 128, 129, 134, 136, 142, 143
Place Clichy (Renoir) 33, 40, 60, *19*
Place de la Concorde (Degas) 33, 36, *18*
Poe, Edgar Allan 44-5
 "The Man of the Crowd" 37, 39, 42
Poplars (Bank of the Epte) (Monet) 107, *66*
Porte St. Denis, Paris (photograph) 143
Portrait of Louis-Auguste Cézanne, the

Artist's Father, Reading
 L'Evénement (Cézanne) 28, *14*
Portrait of Ambroise Vollard (Cézanne)
 158-60, *104*
Positivism 21
Post-Impressionism 145
Poultry Market, Gisors, The (Pissarro)
 134, *88*
Poussin, Nicolas 24, 31
 Landscape with the Funeral of
 Phocion 24, *12*
Promenade in the Bois de Boulogne
 (Guys) 33, 35, *20*
Proudhon, P.-J. 120, 136, 137
 On Justice in the Revolution and
 the Church 128-9
Proust, Antonin 19
psychoanalytical approaches 15, 65,
 148, 150-51, 153

Raffaëlli, Jean-Francois 11
Railway Bridge, Argenteuil, The (I)
 (Monet) 95, 99, *57*
Railway Bridge, Argenteuil, The (II)
 (Monet) 95, 99, *58*
Rape, The (Cézanne) 148, *98*
Red Roofs (The Orchard, Côtes
 Saint-Denis at Pontoise) (Pissarro)
 121-2, 125, *78*
Régnier, J. D.: On Light 154
Renoir, Auguste 9, 10, 11, 14, 83,
 84, 89, 115
 La Grenouillère 23, *9*
 La Loge (The Theatre Box) 60-62,
 65, 72, *37*
 Place Clichy 33, 40, 60, *19*
 The Umbrellas 39-40, 59, *22*
Révolte, La (newspaper) 142
Richepin, Jean 134
Rood, Ogden: Théorie scientifique des
 couleurs 127, 128, *84*
Rouen Cathedral, Sunlight Effect, End of
 Day (Monet) 27, 110, *1*
Rouen Cathedral, the West Portal and
 the Tour d'Albane, Harmony in
 Blue (Monet) 108, 110, *68*
Route Tournante (Cézanne) see Turn in
 the Road
Ruskin, John 153
 The Elements of Drawing 28

Saint-Lazare Station, Interior of
 (Monet) 99, *59*
Sazai Pavilion of the Temple of Five
 Hundred Rakan, The (Hokusai)
 31, *16*

Seine and Notre-Dame, The (Jongkind)
 19, *7*
Seine at La Grenouillère, The
 (Pissarro) 115, *74*
Sensier, Albert 107
Seurat, Georges 128
 Un Dimanche d'été à l'Île de la
 Grande Jatte, 1884 (Summer
 Sunday on the Island of the
 Grande Jatte, 1884) 105, 167, *65*
Sèvres-Brimborion, View Towards
 Paris (Corot) 113, *73*
Shepherdess, The (Pissarro) see Young
 Peasant Girl with a Stick
Shrove Tuesday on the Boulevards 139,
 143, *90*
Signac, Paul, Pissarro to 133
Sisley, Alfred 9, 83, 84
Social Turpitudes, The (Pissarro)
 139, *89*
Stendhal (Marie Henri Beyle) 22
Still Life with Apples, Bottle, Glass, and
 Chair (Still Life with Apples,
 Bottle, and Chairback) (Cézanne)
 162, *107*
Still Life with Melon (Cézanne) 162
Still Life with Plaster Cast (Cézanne)
 150, 153-4, 161, 163, *93*
Stop: caricature 55, *34*
Study (Girl Arranging Her Hair)
 (Cassatt) 74, 76-7, *46*
Sue, Eugène: The Mysteries of Paris 42
Suite of Female Nudes, Bathing,
 Washing, Drying, Wiping
 Themselves... (Degas) 77-8
Summer's Day (Morisot) 67, 68, *41*
Summer Sunday on the Island of the
 Grande Jatte, 1884 (Seurat) see
 Dimanche d'été à l'Île de la
 Grande Jatte, 1884, Un
Sunset, Etretat (Etretat; The Cliff,
 Etretat, Sunset) (Monet) 99, *60*
Symbolists 136, 156, 165

Taine, Hippolyte 21, 153
 De l'intelligence 21, *28*
Temptation of Saint Anthony, The
 (Cézanne) 151, *102*
Terrace at Sainte-Adresse (Monet) 31, *15*
Theatre Box, The (Renoir) see Loge, La
Thénot, Professor: The Rules of
 Perspective Made Simple 147
Thoré, Théophile 133
Titian (Tiziano Vecelli): Venus of
 Urbino 49, *30*
Toits Rouges, Les (Pissarro) see Red

Roofs
 Turn in the Road (Route Tournante)
 (Cézanne) 161, *105*

Umbrellas, The (Renoir) 39-40, 59, *22*

Van Gogh see Gogh, Vincent van
Velàsquez, Diego 43, 45
 Mennipus 45, *26*
Velde, Henri van de, Pissarro to 133
Venus of Urbino (Titian) 49, *30*
View from Louveciennes (Pissarro)
 113-14, *72*
View From My Window, Eragny (View
 From My Window, Overcast
 Weather) (Pissarro) 125, 127, *83*
View of Notre-Dame (Jongkind) 19, *8*
View of Paris from the Trocadero
 (Morisot) 67, 68, *40*
Vision after the Sermon. Jacob
 Wrestling with the Angel
 (Gauguin) 167, 169, *109*
Vollard, Ambroise 158-60, 166
 portrait (Cézanne) 158-60, *104*

Waterlilies (Monet) 110, 111
Watteau, Antoine 23
 Pilgrimage to Cythera 23, *10*
Woman Drying Herself (Degas) see
 After the Bath, Woman Drying
 Herself
Woman in Black at the Opera (At the
 Opera) (Cassatt) 71, 73-4, 81, 166, *44*
Woman in a Loge (Cassatt) see At the
 Theatre (Woman in a Loge)
Woman with the Glove, The (Carolus-
 Duran) 87, *53*
Women in the Garden (Monet) 84-5,
 87-9, *50*
Women on a Café Terrace, Evening
 (Women in front of a Café
 Terrace) (Degas) 39, *21*

Young, Thomas 126, 127
Young Man at his Window
 (Caillebotte) 41-2, *23*
Young Peasant Girl Drinking Coffee
 (Pissarro) 125, *81*
Young Peasant Girl with a Stick
 (The Shepherdess) (Pissarro) 125,
 134, 136, *80*
Young Woman Drying Herself
 (Morisot) 76, *47*

Zola, Emile 13, 20-21, 28, *28*, 114
 The Masterpiece 28

Date Due